WOMEN PHOTOGRAPHERS

AT NATIONAL GEOGRAPHIC

Cathy Newman

WOMEN PHOTOGRAPHERS

AT NATIONAL GEOGRAPHIC

Cathy Newman

NATIONAL GEOGRAPHIC

Washington, D.C.

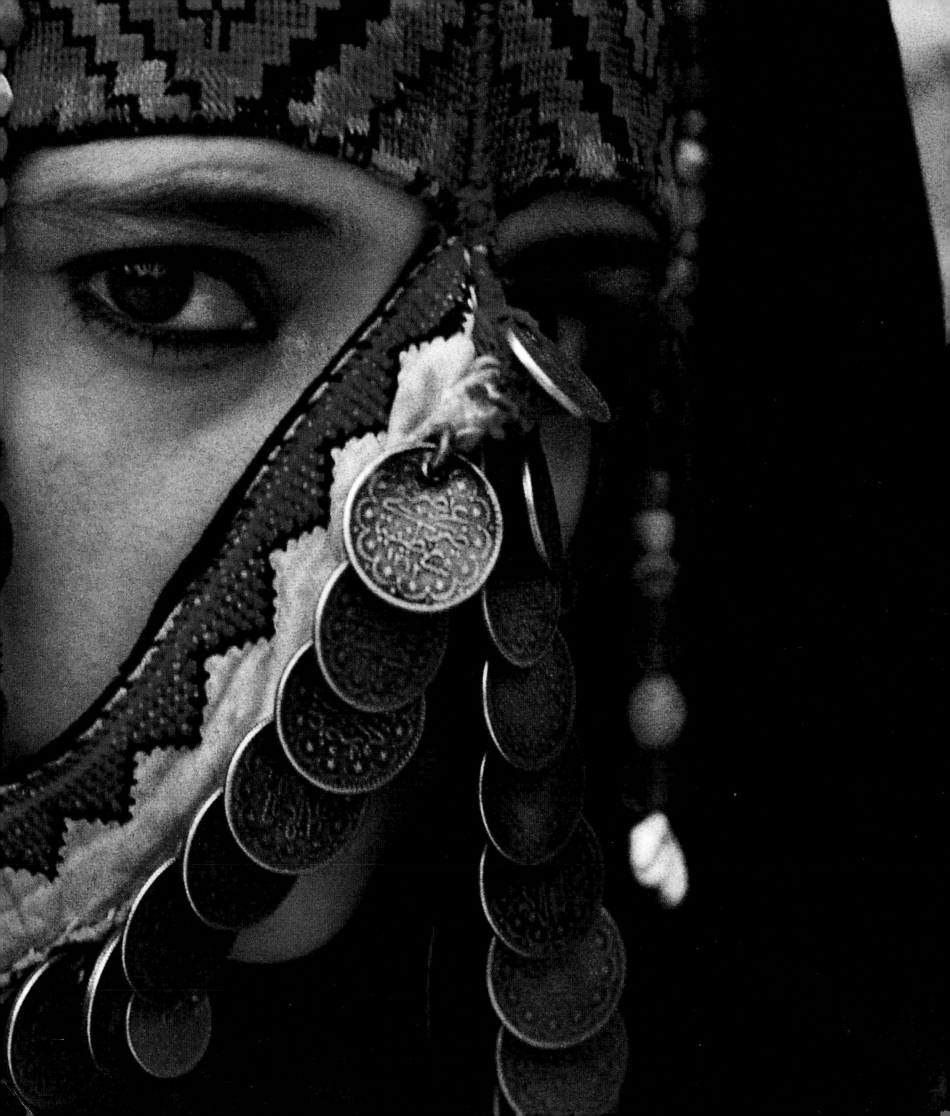

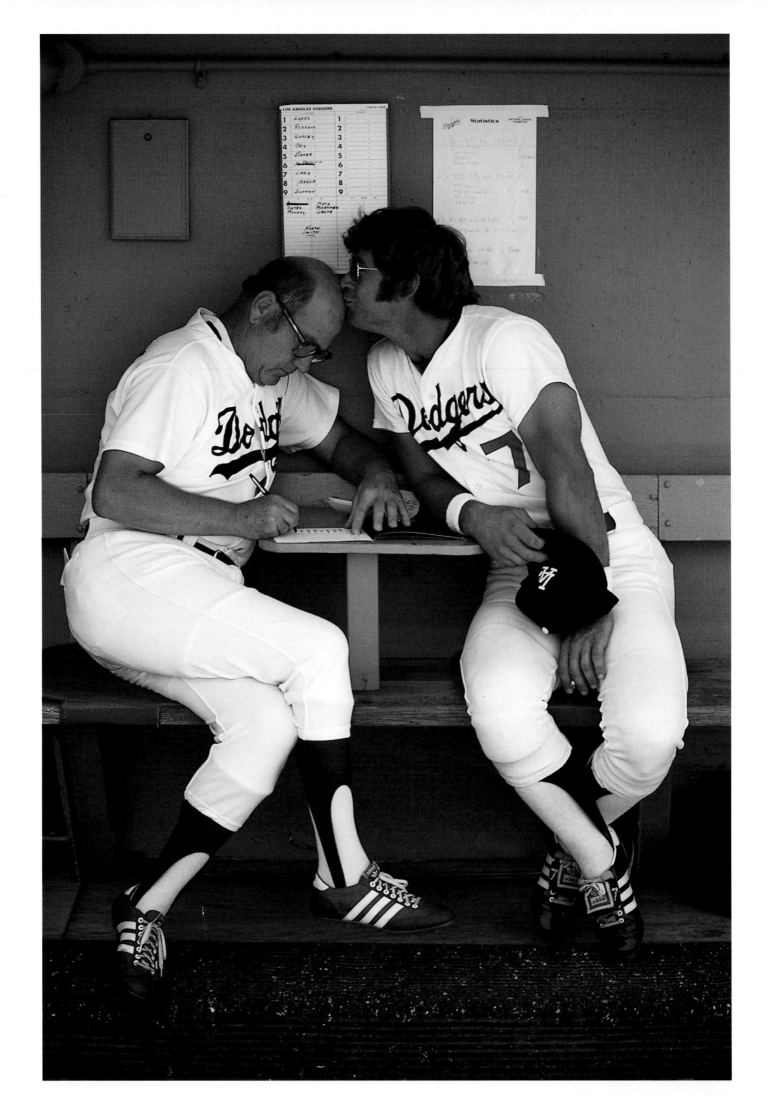

TABLE OF CONTENTS

Foreword by Tipper Gore
Introduction by Naomi Rosenblum

JOANNA PINNEO • JORDAN 1992
A young woman models the traditional finery of her Palestinian culture.

JODI COBB • LOS ANGELES 1979
Fair play: Los Angeles catcher Steve Yeager gives coach Monty Basgall a big smooch on the head.

PORTFOLIO: SUSIE POST • ARAN ISLANDS 1995 A setting sun heightens the Irish beauty of Maírín Ní Fhlatharta.
JODI COBB • NICE 1998 Finalists in the Elite Model Look compete in the search for a new look and fresh face.
ANNIE GRIFFITHS BELT • WYOMING 1997 Yellowstone National Park in winter turns into a bare-bones landscape.
JODI COBB • HONG KONG 1991 A Vietnamese child peers through the wire mesh walls of a refugee camp.
DES AND JEN BARTLETT • NAMIBIA 1983 A herd of elephant cows and their young drink at a
watering hole at Etosha National Park.

NEVER BEFORE IN THE HISTORY of the National Geographic Society has the organization published a book devoted exclusively to its women photographers. This book marks an important milestone for photography in America. I can think of no better way to begin the new millennium than by taking this exciting look at *Women Photographers at National Geographic.*

Photography is an indispensable art that can be used to record our public and private lives. For 25 years, I have freelanced as a photographer and have come to understand the challenges faced by any photographer who seeks to capture the human experience in her work.

In my public life, I have had unique opportunities to photograph world events as they happen. I've had a front row seat at the Middle East peace signing ceremony and the inauguration of Nelson Mandela, and I have traveled to Central America to support hurricane recovery efforts. Such events unfold in the public eye and dramatize our collective triumphs and tragedies. I have also spent considerable time photographing individuals whose stories are rarely told or understood. Their intimate and highly personal experiences may not make news, but they are as powerful as the great moments in history and have provided some of the most rewarding experiences of my life. I imagine that the great photographers in this book feel the same.

Rarely are photographers as famous as their subjects, and often little is known about them. This book allows the reader to peer into the lives of the women behind the camera. It chronicles the adventures of some 40 uniquely talented photographers whose work has captured the spirit and strength of women everywhere.

The special portfolios by Annie Griffiths Belt, Sisse Brimberg, Jodi Cobb, Karen Kasmauski, and Maria Stenzel exemplify the wealth of talent among women photographers and our ability to tackle any assignment, from adventurous to intimate.

Photographs taken by women have a unique perspective on human

interaction. What is revealed through the feminine eye is an artful unveiling of the spirit and a deeper understanding of the human experience.

While National Geographic has employed many women as freelance photographers, since 1953, only four have held full-time staff positions. Naomi Rosenblum's introductory essay puts this reality in its historical context and helps us understand more about the contributions of women to photography, dating from the early days of the invention of the camera. Author Cathy Newman and picture editor Kathy Moran weave the text and pictures around unifying themes to bring these stories alive.

I salute National Geographic for supporting these photographers and this endeavor. This important book written by women and about women, affirms our admiration for all those who transcend barriers to make their dreams come true.

Tipper Gore
Washington, D.C.

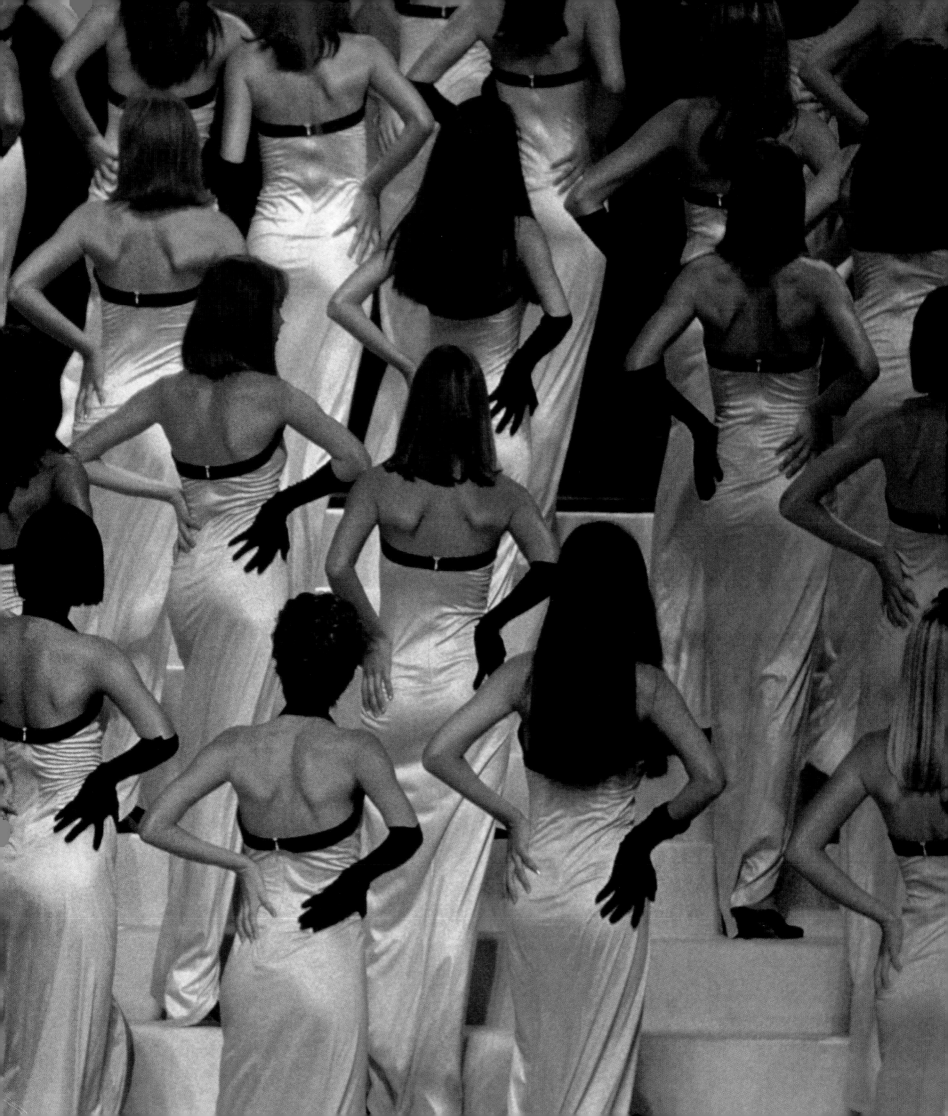

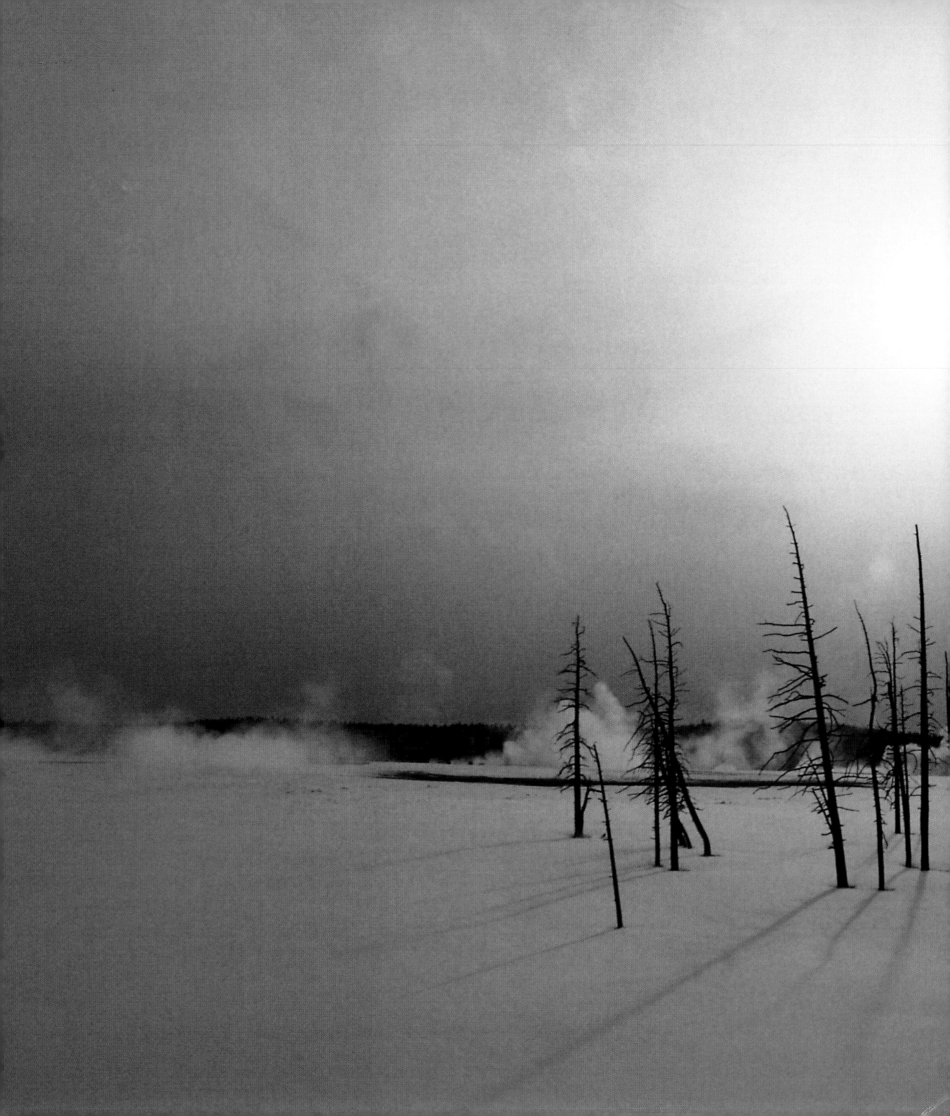

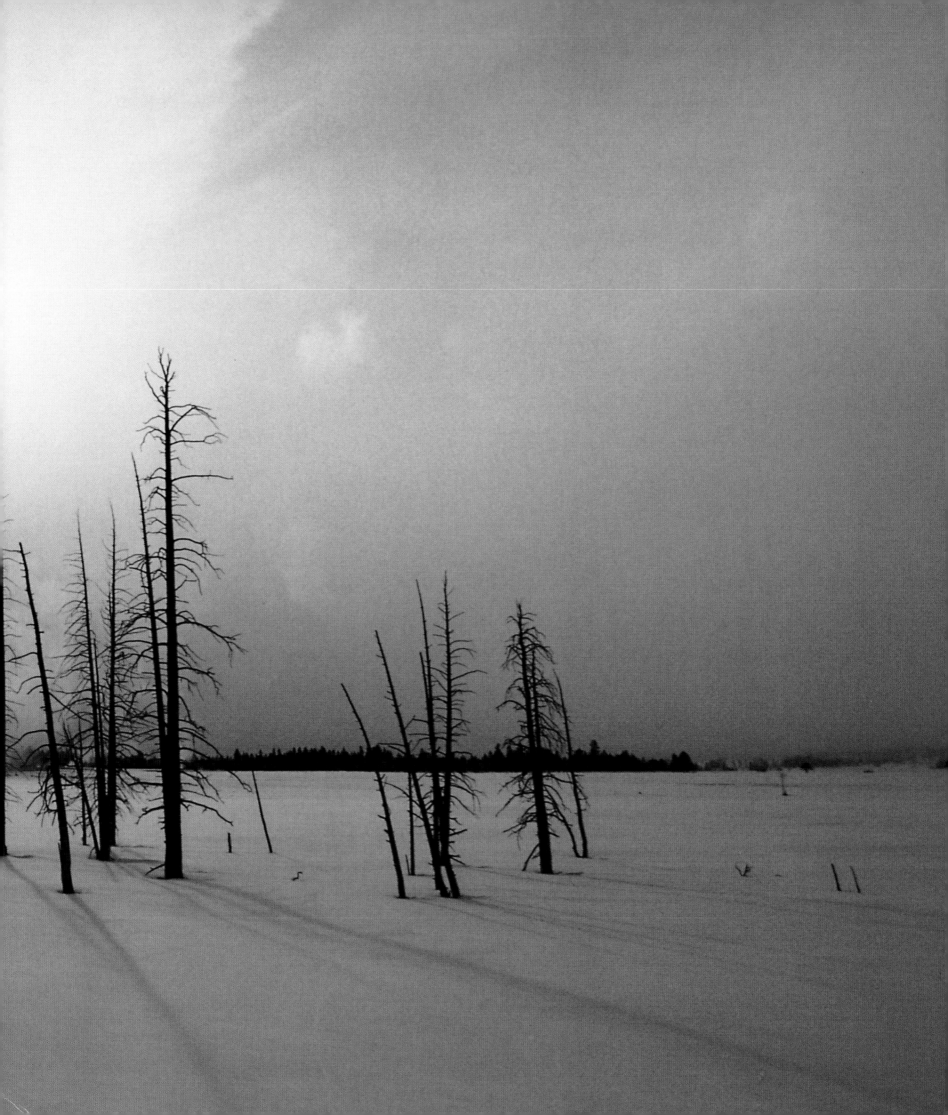

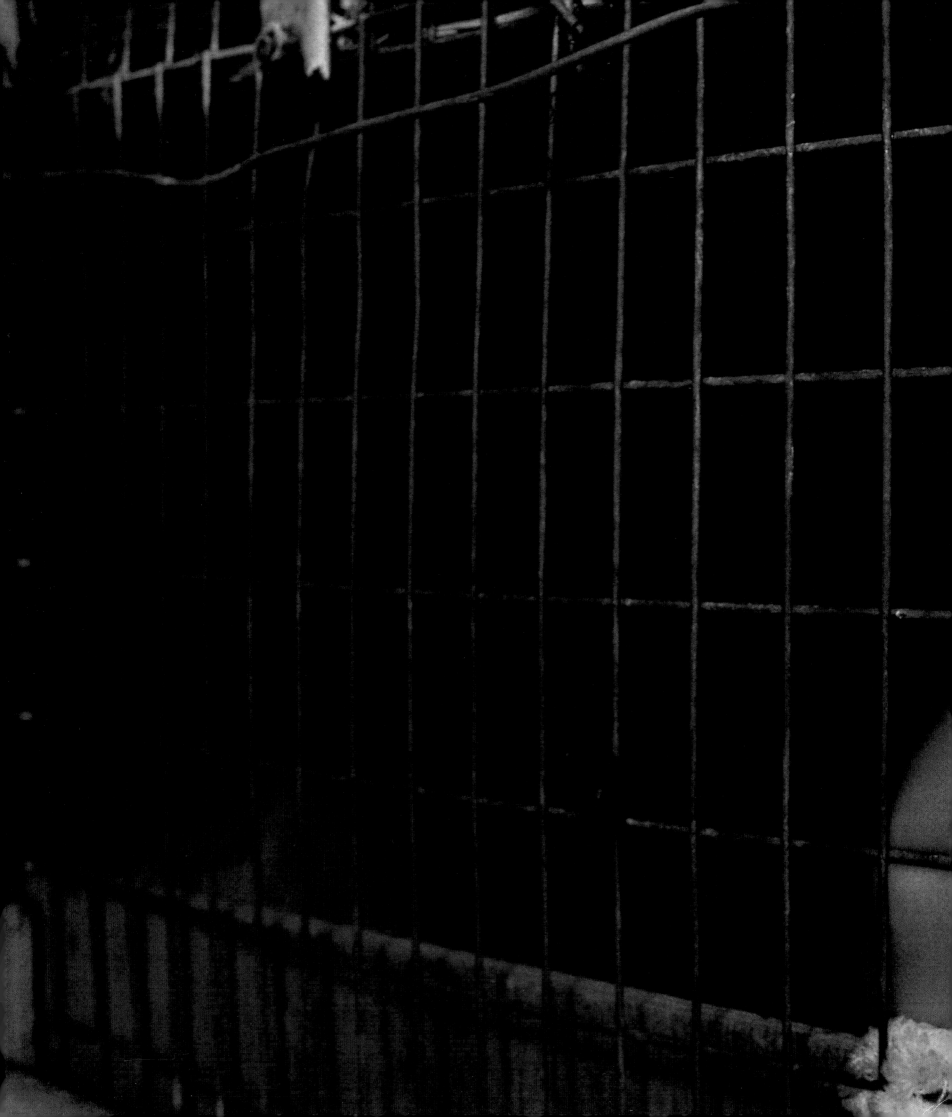

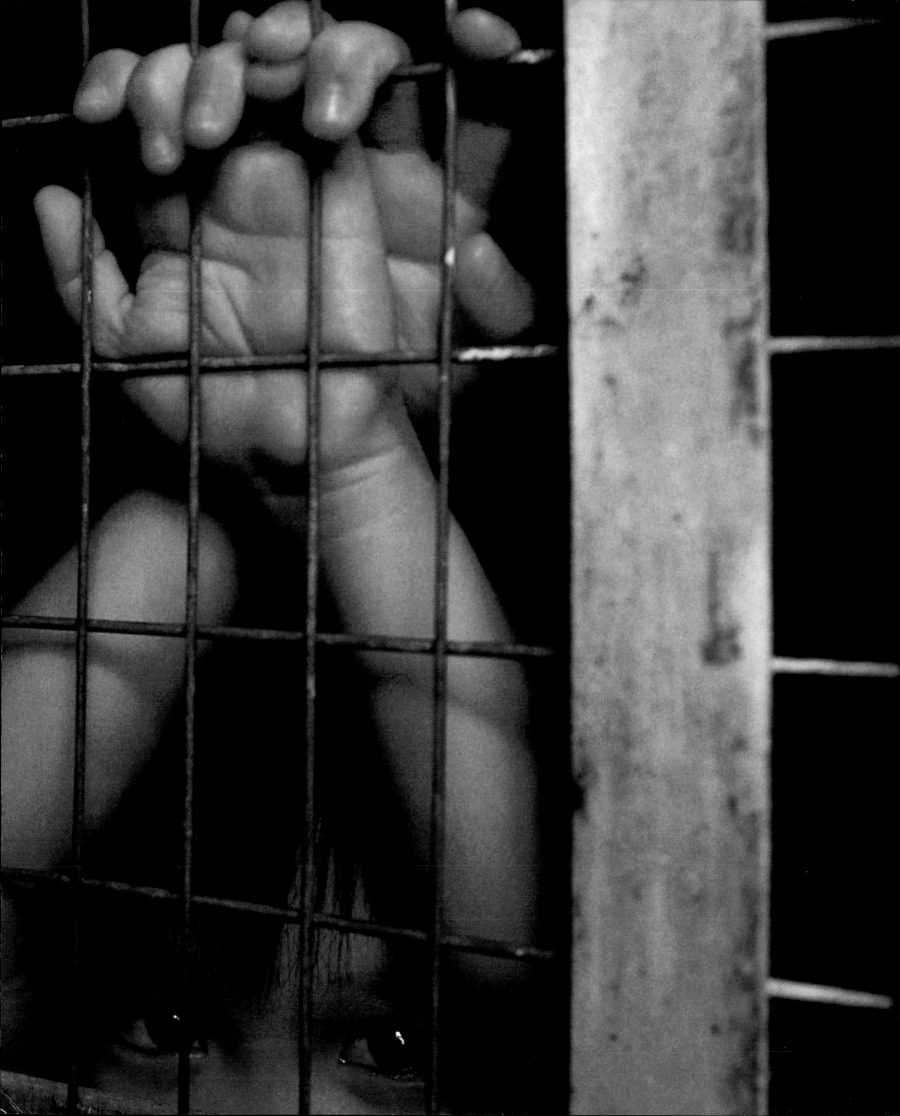

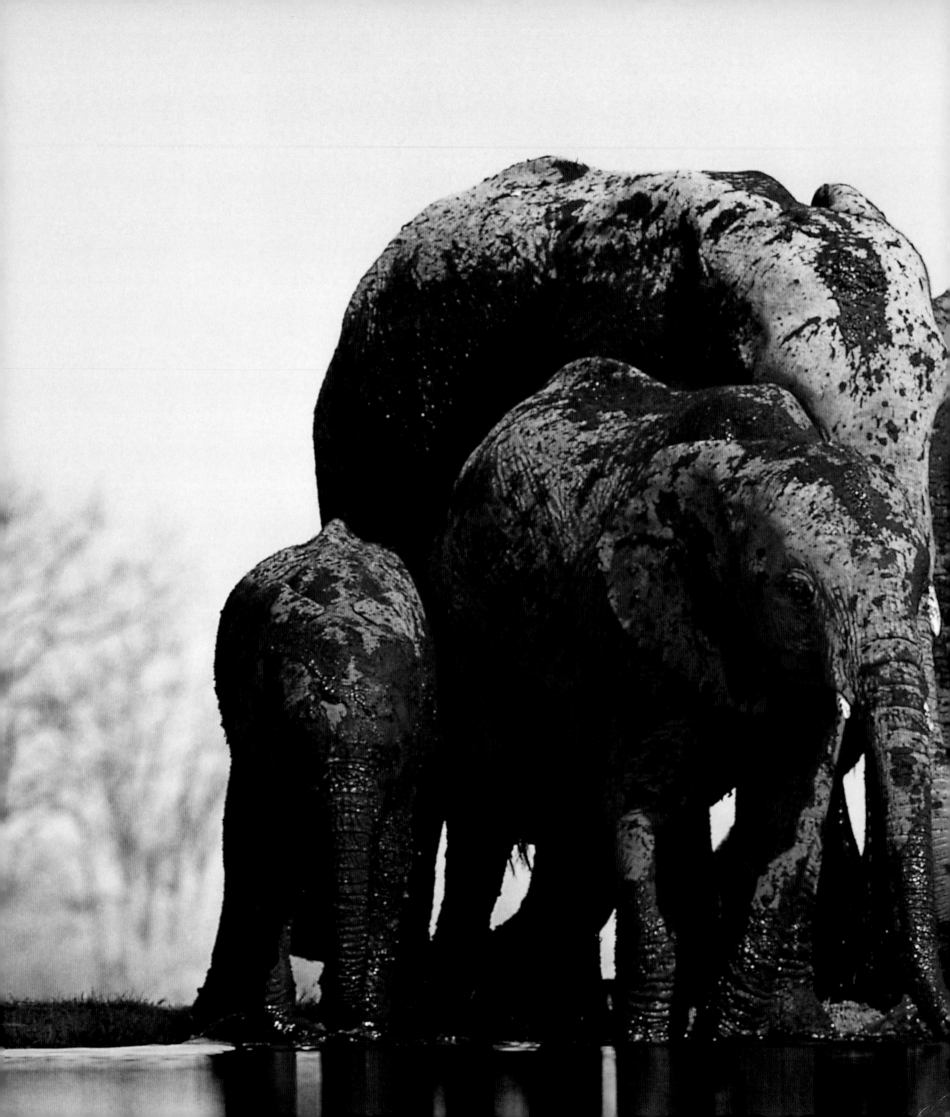

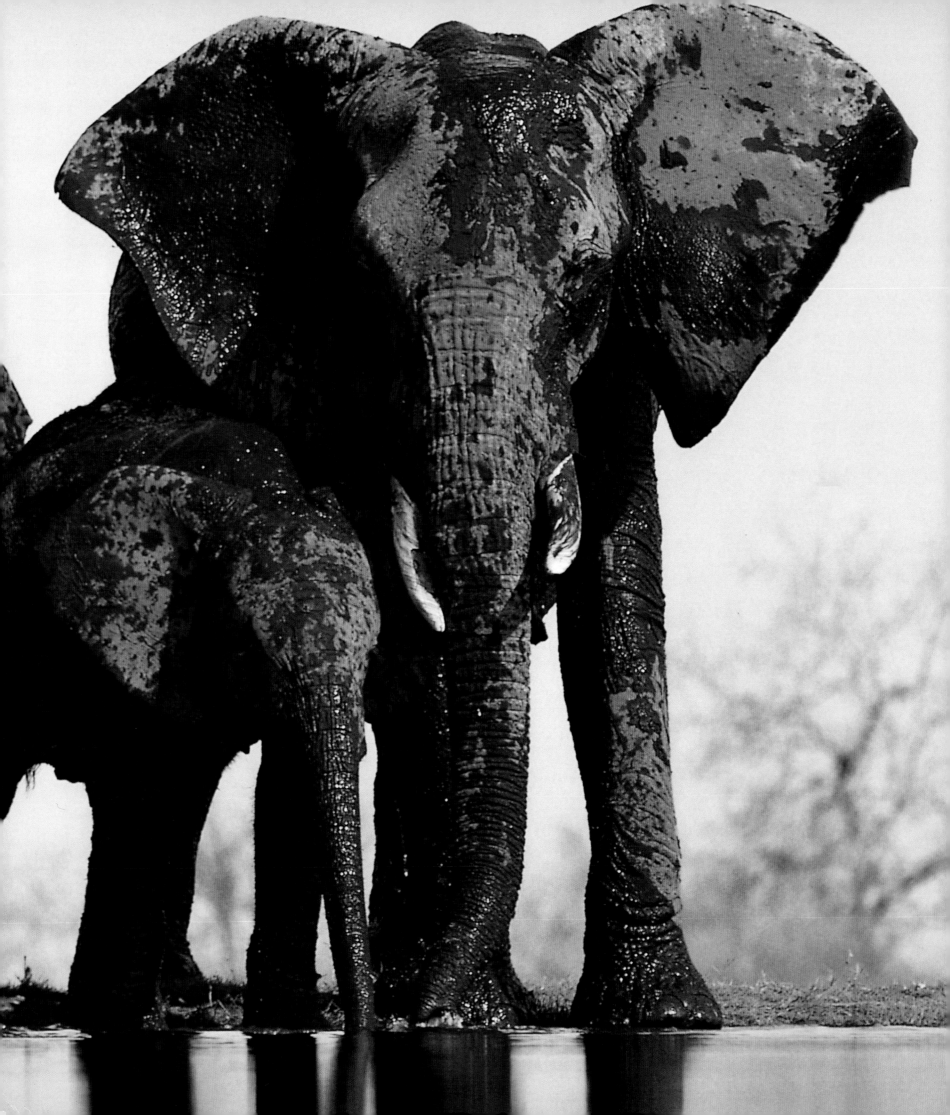

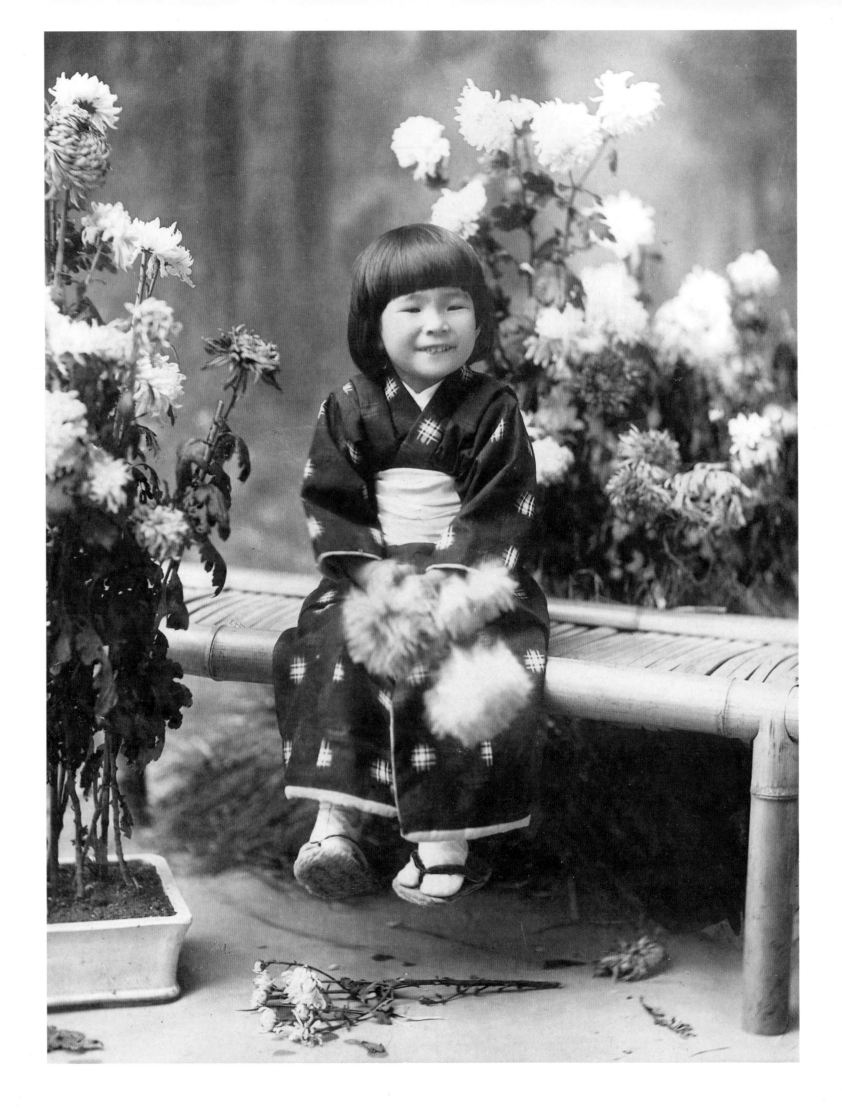

Introduction
by Naomi Rosenblum

IN A PHOTOGRAPH TAKEN IN 1967 and inscribed "greatest photographic team in the world," 25 properly suited men are gathered around the desk of NATIONAL GEOGRAPHIC Editor Melville Bell Grosvenor. The image suggests that the universal language of the photograph upon which this publication (and many others) depended was solely a contribution of the male eye and mind. Such a conclusion would be misleading, in part because women photographers had already been making images for NATIONAL GEOGRAPHIC for more than 50 years, and in part because camera work by professional women had become increasingly visible in exhibitions and magazines. Some 30 years earlier, the photographs for the cover and for a feature article in the first issue of *Life* had been taken by a woman—the then renowned Margaret Bourke-White.

American women had become actively involved with making camera pictures in the late 1880s, but long before that a few women were devotees to the medium. Of the two processes that were announced almost simultaneously in 1839, one—the negative-positive process (first using paper for negative and print, and later glass for the negative and albumen-coated paper for the print)—appealed especially to upper-class British women. These "ladies" had the leisure time and, one presumes, the interest in both art and science to occupy themselves with what then was a messy and untried picture-making technique. Despite the fact that photographic chemicals stained clothing and flesh, the women used the new medium to record family, friends, and landscapes. One, Julia Margaret Cameron, was renowned in her own time, and today is considered among the most gifted of the 19th-century practitioners of the medium. Her exploration of the aesthetic dimensions of photography by staging scenes and controlling focus and lighting still resonates in contemporary photographic practice.

The other discovery, the short-lived French daguerreotype process, resulted in a fine-toned image on a silver-coated metal plate. It was attractive for its commercial possibilities in portraiture. Women in Canada, Denmark, Germany, France, and America, with spouses or on their own, opened studios or traveled as itinerant portraitists, although it is impossible to verify their numbers or to recuperate much of their work.

The daguerreotype also was harnessed to the newly awakened desire among middle-class for pictures of faraway places and monuments, whether natural or built. As a unique image, and one that usually was small and difficult to read, it had to be reproduced (commonly by lithography) to reach this public. The earliest compendium of such imagery, *Excursions daguerriennes: Vues et monuments le plus remarquable du globe,* issued in the 1840s, comprised images by a number of photographers, all male. However, in 1845, Franziska Möllinger undertook a similar although far less ambitious project when she traveled throughout her native Switzerland daguerreotyping its monuments and scenery, which she turned into an album of lithographed views.

Despite such activity, women held a minor place in professional and leisure photography until the late 19th century. Then, in the late 1880s, new equipment and different processing methods allowed them a greater role as recreational camera-users and, soon, as professionals. The portable, fixed-focus camera, notably the Kodak, and the fact that the chemical aspects of the medium—developing and printing—could be done elsewhere and by others attracted amateurs of both genders. But it was to women that the Eastman Company directed much of its advertising of their Kodak in the hope that the simplified apparatus would widely be used to record domestic life. Having jumped the initial technological hurdle, women soon progressed to more complex equipment. Noted one commentator, "The woman who began with the Kodak . . . is seldom satisfied until she is mistress of larger boxes and expensive lenses."

Of course, advances in camera technology would have had little effect had not other changes occurred at the same time. In the last decades of the 19th century, American middle-class women in particular were experiencing new situations, both physical and psychological. Factory-produced foods and clothing and immigrant household help meant more time could be spent in non-domestic pursuits such as bicycling and photography—sometimes in tandem. The claims made by suffragists that besides being the caretakers of families, women also had "duties to themselves," had considerable resonance. Furthermore, numbers of women had had some training in the arts, with little prospect of being able to devote themselves to both raising a family and pursuing an all-encompassing career as artist.

Photography, it appeared, might be a substitute artistic enterprise. As a visual medium that was less rigorously inscribed, it was not all-consuming in terms of committing large blocks of time to its pursuit, an important consideration for women with domestic obligations. Photography could be taken up with seriousness or only practiced on occasion. It could be aesthetically challenging and commercially viable.

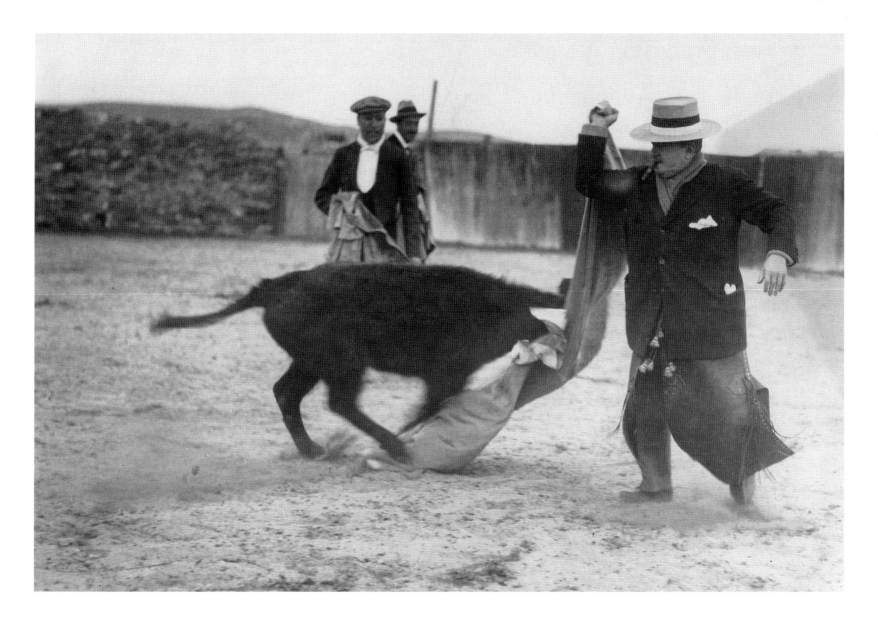

HARRIET CHALMERS ADAMS • SPAIN 1924

A cow is tested for aggressiveness to determine whether it should join the breeding stock for bulls bred for the ring.

PREVIOUS PAGE

ELIZA SCIDMORE • JAPAN 1914

A young Japanese girl sits on a bench in a hand-tinted black-and-white photograph made by Scidmore,
probably the first woman to have photographs published in NATIONAL GEOGRAPHIC.

It allowed its user broad social latitude, enabling women to photograph in the home,
in studios, and in urban and rural settings. For women who looked upon it as a source
of income, it had the advantage of not being markedly competitive in monetary terms
with male-dominated professions. As a writer in *The Woman's Book* noted, photography
should appeal to women "content with a small income."

By the first decade of the new century, American women had become
acknowledged as important participants in applied and recreational photography.

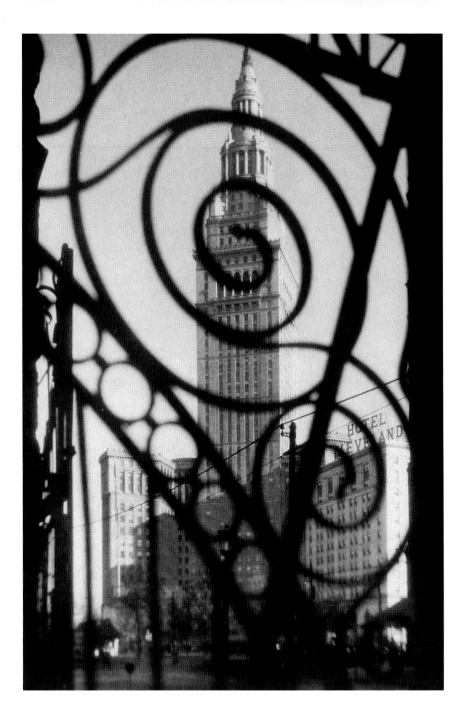

MARGARET BOURKE-WHITE • CLEVELAND 1933

A view of Union Station Tower taken from across the public square. Although
acquired for the magazine's archives, this picture was never published.

Gertrude Käsebier, who took up photography after her children were grown, and Eva
Watson-Schutze were among the women who kept classy portrait salons catering to the
carriage trade, with women and children as the main clients. They were acclaimed for
raising standards in a business notable for dreary facial mapping rather than artistry.
Portraying motherhood and the young was considered suitable for women because only
they were believed able to capture familial love on the light-sensitive plate. In a society
dedicated to the proper upbringing of children, this was deemed an important gift.

This feminine sensibility, which turn-of-the-century America believed to be intrinsic to women, led a number of them to consider photography a medium capable of personal expression, like etching or painting. Some who embarked on creating photographic art patterned their choice of subject and their treatment on the works of late 19th century genre painters; others chose to photograph flowers and religious themes; still others looked to more up-to-date themes and treatment. One who believed that photographs could evoke transcendent emotions was West Coast photographer Annie W. Brigman, a member of the avant-garde Photo-Secession group. Her images, often softly focused and with applied handwork, were meant to express her deepest feelings about the interrelationship of nature and womanhood.

With the discovery near the end of the 19th century of the half-tone printing process, the camera image for the first time could be printed directly on the page along with the text. As a result, photographs began to displace hand-drawn illustrations in periodicals, books of verse, travel stories, and social instruction. By 1908, more than half the illustrated pages of NATIONAL GEOGRAPHIC comprised photographs; by 1910, the magazine included 24 pages of color photographs, achieved by hand tinting original black-and-white images; a group similarly colored by Eliza Ruhamah Scidmore, the first woman on the Society's Board of Managers, appeared in 1914.

One of the first to specialize in this genre was a woman. Frances Benjamin Johnston, whose work appeared in magazines before 1900, described herself as "making a business of photographic illustration . . . for magazines, illustrated weeklies and newspapers." She focused on working people in mining communities and shoe factories, documented life aboard Navy ships sailing to the Caribbean, and portrayed Hampton Institute and the Washington, D.C., public schools. In some ways, these commissions, which required commitments of time as well as photographic ability, forecast the kinds of assignments that would be given women working for NATIONAL GEOGRAPHIC.

Johnston's choice of documentation as a genre was unusual but not unique. Women throughout the United States began to venture out of their homes with cameras to document life for pleasure or profit. In the early 1900s, Chansonetta Stanley Emmons in Maine, Frances and Mary Allen in Massachusetts, Nancy Ford Cones in Ohio, and Evelyn Cameron in Montana, among others, photographed life in their communities, to sell either as reproductions in print media or as individual prints in platinum or silver. A rare few peered beyond their immediate surroundings. E. Alice Austen, who photographed the genteel activities of her upper-class precincts in Staten Island, also traveled across New York Bay on the new ferry service to capture street life

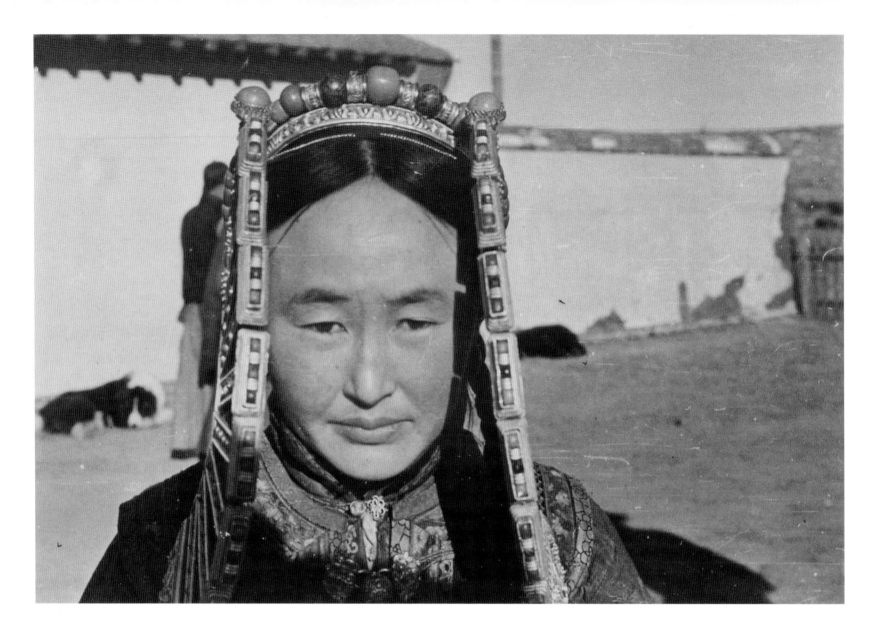

ELLA MAILLART • MANCHURIA 1939

On a seven-month journey from Beijing to Kashmir, Swiss adventurer and journalist Maillart photographed this Mongolian princess.

in such unladylike urban terrain as the immigrant neighborhoods of lower Manhattan.

The distinctive presence of American women in photography seemed less apparent in the decades after World War I; in fact, their involvement with the medium had expanded. During the 1920s and '30s, they were quietly employed behind the scenes documenting archaeology, science, and theater. Several, most notably Wynn Richards and Margaret Watkins, became active in the newer areas of fashion and consumer product photography. In the late 1920s, Margaret Bourke-White demonstrated that women could produce energetic images that celebrated industrial power, while later she exemplified women's capacity to travel anywhere and to overcome dangers and difficulties in pursuit of a picture story.

Sensitivity still remained at the core of some women's approach. While

24

requiring skill, stamina, and travel, the work done by Dorothea Lange for the Farm Security Administration and other government agencies was considered the most persuasive of the images commissioned for this vast photographic documentation of life in agricultural America in the 1930s. It was acclaimed for its power to make people react emotionally to the social displacement and distress that the images depicted.

During these years, Bourke-White, Lange, and others demonstrated that women photographers could deal with professional demands and with derisive male attitudes toward them and their work. For example, while photographing in the South, F.S.A. photographer Marion Post (later Wolcott) was admonished by the agency's director to behave like a "lady." Magazine photographer Constance Bannister, on assignment in Florida, developed her negatives in hotel bathrooms rather than risk having male colleagues deface her work because they felt photojournalism was a man's prerogative.

One area where few women were visible during the 19th century was in travel photography, although some worked with spouses on such enterprises. In 1858, Harriet and Robert Christopher Tytler for six months documented the Indian terrain devastated by the Mutiny there. Their work was praised by the Photographic Society of London, but her name was later dropped from the records. At the end of the century, women began to "kodak" on trips to exotic places, sometimes using the images to illustrate stories of their travels. Others used sophisticated apparatuses to express a combined interest in ethnology and photography, providing images of non-Western peoples and their customs. During the first decade, Kate Cory, hoping to start an artists colony in Arizona, photographed Hopi communities; later Gertrude Blom, with archaeologist husband Franz Blom, documented life in Lacondon villages in southern Mexico.

European women had a slow start in photography both as recreation and as a profession before World War I, but in the 1930s they became especially active in the medium. A number devoted themselves to the kind of magazine illustration that required an unencumbered life and the freedom to travel. During the war, many people had been forced to flee their homes and to lead a footloose existence; some women transformed this rootlessness into the occupation generally called photojournalism. Here, clarification is helpful because there has never been a clear distinction between the different kinds of work done on assignment for magazines and newspapers, whether it be travel photography, cultural documentation, or the portrayal of newsworthy events.

Photographers working on timely news stories are expected to cover their assignments expeditiously and to capture the scenes that best evoke the essence of the happening. Those working for magazines such as NATIONAL GEOGRAPHIC may also be

interested in timely events, but their main objective is to present a series of images that reveal a more detailed and insightful description of little known places, customs, and cultural habits—a goal that requires spending considerable time in one place. In some respects, this kind of photography also entails knowledge of how people live and, as such, is allied with social documentation. Although usually called photojournalism, it is in essence a hybrid genre.

In the mid-1930s, European women in particular seemed drawn to the peripatetic life of the photojournalist. Swiss photographer Ella Maillart became an inveterate traveler, seemingly always on the go, but she also stayed put in various places long enough to provide publications (including NATIONAL GEOGRAPHIC) with revealing images of life in Kirghiz, Samarkand, and Manchuria. Marianne Breslauer traveled in Europe, North Africa, and the Near East on magazine assignments; Hélène Hoppenot worked in China, Therese LePrat and Denise Colomb in Indochina. These women obviously were a new breed, unfettered by domestic duties; their lives and work forecast the attitudes and roles that would later be taken on by women working for publications such as NATIONAL GEOGRAPHIC.

The onset of the Second World War in 1939 created even more opportunities for adventuresome women professionals to travel and photograph in unusual situations. Even before the war began in central Europe, Gerda Taro had photographed (and was killed) on the front lines during the Civil War in Spain—as would happen later to Dicky Chapelle in Vietnam while photographing for NATIONAL GEOGRAPHIC. American, British, Norwegian, and Russian women experienced considerable drama covering wartime events in Europe, the Far East, and North Africa. For *Life* magazine, Bourke-White photographed the German bombardment of Moscow and the invasion of Italy; for *Vogue,* Lee Miller followed the American Army's trajectory through France and Germany, sending back the first images of concentration camp victims that many would see. A number of the women photographers employed by magazines—*Life,* in particular—were refugees from Europe; their gutsiness made for exciting visual stories and prepared the way for greater numbers of women to find staff jobs and freelance assignments in the media in the post-war years.

Today, women photograph wherever men do, although not yet in the same numbers. They work in Arctic and desert regions, and in forests and jungles. They capture moments of anguish on battlefields and behind the lines; they venture into remote villages; they and their cameras look down upon the earth from the air.

NATIONAL GEOGRAPHIC magazine has played a role in making possible

Children trudge up a Shaftesbury street. Revis was the first woman to be hired for the magazine's photographic staff.

this enlarging of women's fields of observation, although its initial steps in this direction were hesitant. From its earliest publication of photographs by Eliza Scidmore, up to the present, the magazine has provided opportunities for women to travel and photograph. In the early days, some went as assistants to husbands, some as journalists with cameras, and in 1953 a woman, Kathleen Revis, was invited to join the photographic staff.

Since then, although their numbers on staff have been limited, women photographers at NATIONAL GEOGRAPHIC, whether staff or freelance, have been given the gift of time: to study their subjects, to learn from people and make conversation with them, and to establish relationships that have resulted in natural-looking, empathetic pictures. Thus NATIONAL GEOGRAPHIC can be considered one of the enabling forces that have made possible the high professional stature of women in photojournalism. ■

INSIGHT

MAGGIE STEBER ◆ MIAMI BEACH 1992

With an exuberance as sassy as her convertible, artist Laura De Pasquale glories in the sun-soaked scene along Ocean Drive in South Beach.

PREVIOUS PAGE

JODI COBB ◆ JAPAN 1995

Sealed lips symbolize the enigmatic beauty of the Japanese geisha. The art of the geisha has been practiced for 250 years; today they number no more than a thousand.

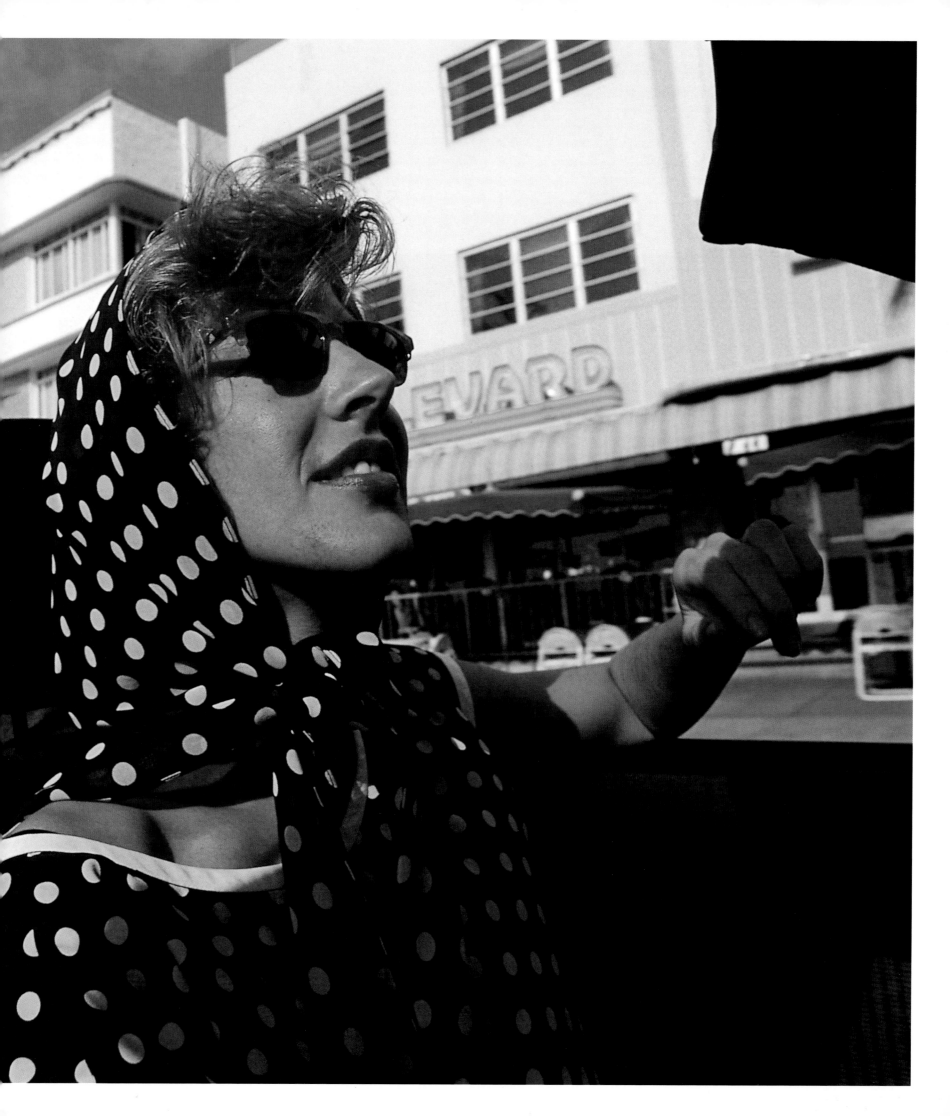

LYNN ABERCROMBIE • NORTH YEMEN 1985

Designs traced in henna decorate a woman's
hand. To preserve the woman's anonymity,
Abercrombie asked her to remove her rings.

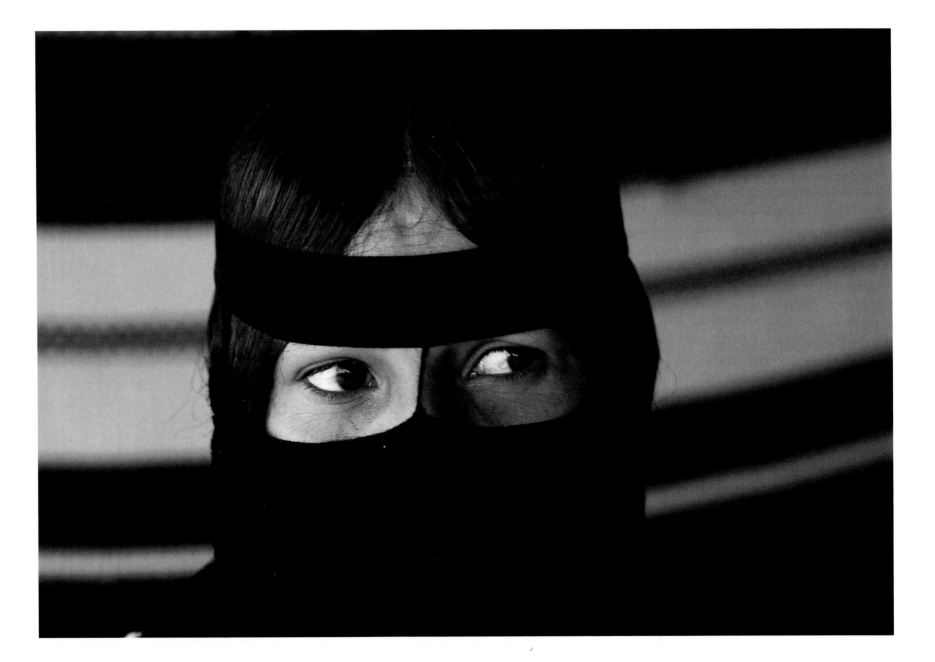

JODI COBB • SAUDI ARABIA 1987

Metaphor of the hidden world of Islamic women,
a veil betrays only its wearer's eyes. She will
remain covered to men outside her family.

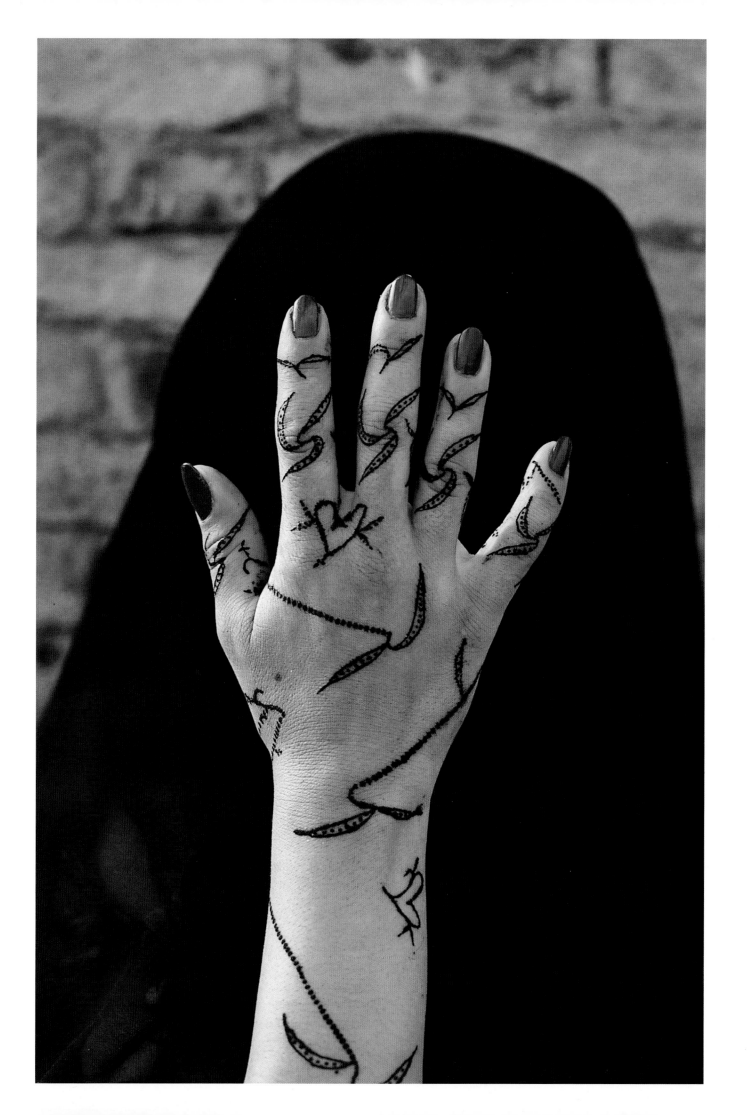

ALEXANDRA AVAKIAN is a tall, striking woman with an aquiline nose and a face made only more arresting by the distinctive gap between her teeth. She has the calm self-assurance of more than a decade at the top of a brutally competitive profession—photojournalism. She has stunning images from such pivotal world events as the fall of the Berlin Wall, the *intifada* in the West Bank and Gaza, and the collapse of the Soviet Union, as well as stories on Iran, the Gaza Strip, and Romania in NATIONAL GEOGRAPHIC.

But 18 years ago, as a graduate of Sarah Lawrence College, she still had a long way to go. In putting together a portfolio of her work for her agent to send around, she edited a selection of her pictures and carefully stamped on it the name "Alex Avakian."

"I didn't want gender to be an issue," she explains. "I didn't want them to say, 'We can't send her to cover that—she's a girl.'"

Of course, the portfolio spoke for itself loud and clear. Here was a fresh and undeniable talent. But the point is this: It is a struggle for anyone to be taken seriously in the early days of a career. It is even more so for a woman. Consider George Eliot (Mary Ann Evans) and George Sand (Aurore Dudevant), who, wishing to be taken seriously as artists and to avoid the condescending "Not bad for a woman," chose to cloak themselves under the nom de plume of a man.

For Avakian, the issue of gender never quite disappeared.

Once, on assignment for a newsmagazine, Avakian walked into the office of a sullen, over-decorated Soviet general to make a portrait. "He looked me up and down and sneered, 'You must be the secretary,' then glowered at me during the session," she recalls.

At the start of her career, as a preemptive strike against such dismissal, Avakian dressed boyishly. "I downplayed my femininity," she concedes. "I didn't want to be seen as too feminine to handle a tough job." She smiles wryly and rearranges the folds of a skirt as voluminous as a gypsy dancer's.

"Later I realized I didn't have to do that. I could just be myself."

To be a photographer—to be any photographer—is to struggle with camera and film and shutter speeds and being in the right place at the right time with the right piece of equipment. To be a photographer for NATIONAL GEOGRAPHIC raises the bar. The GEOGRAPHIC and photographic excellence are synonymous. In its infancy, the magazine, founded in 1888 as the official journal of the National Geographic Society, was austere-looking, technical, and drab. It was Alexander Graham Bell, the second President of the Society, who instinctively articulated the true mandate of the magazine when he directed Gilbert H. Grosvenor, then Managing Editor, to go to Martinique following the eruption of Mount Pelée in 1902 and return with "details of living interest beautifully illustrated by photographs." GHG understood the power of photographs in advancing the Society's mission to "increase and diffuse geographic knowledge." By the end of his own 25-year-long reign as President, GHG had transformed the GEOGRAPHIC into a popular magazine that opened the wonder of the world to millions through its lush photography. "The magazine's life depends on getting better and better pictures," GHG once explained to a staffer. For more than a century, the magazine's photographers have done just that.

To get the picture, first you must get to your assignment—by trekking up the Himalaya or sinking to the bottom of the ocean in a submersible or sailing to Antarctica on an icebreaker.

Then the real work begins. The picture must be technically perfect. It must be riveting beyond belief. It must, above all, tell a story. There are, along with unusual locales, unusual risks. There are dangers large: charging hippos and great white sharks. There are dangers small: poisonous snakes and killer bees. There are dangers you can't even see, like deadly parasites and radiation, not to mention the more mundane perils of fires, floods, mobs, and government bureaucrats. There is the intense, protracted nature of the work. An assignment can devour your life. A photographer for NATIONAL GEOGRAPHIC may be away from friends and family for months. It is a lonely existence that can strain these bonds to the breaking point.

To be a woman photographer for the NATIONAL GEOGRAPHIC is to complicate the complicated. For one thing, there are not that many. Of 70 photographers who regularly shoot for the magazine, 14 are women. Most of these women are freelance—that is to say, they work on a story-by-story basis. Seven photographers on the magazine hold coveted slots as staff photographers; there is only one woman, Jodi Cobb, among them.

Women with families who shoot for NATIONAL GEOGRAPHIC are even more few and far between. They are the true rarities, tightrope walkers in heels. There is no template for how to choreograph the balance between job, spouse, and most difficult of all, children. Those—and there are less than a handful—who steer their way through the process write their own instruction manual as they go.

The history of women at the Society has traditionally been one of exception rather than rule. Until the 1970s (and some might say beyond) the National Geographic was the publishing equivalent of a private men's club. Women worked at the Society, but nearly always as secretaries or clerks. Men and women ate in separate dining rooms. In an unspoken but tacitly acknowledged code of behavior, ladies wore dresses and stockings, never pants, and gentlemen never dreamed of shucking their coats and ties. Nameplates were always prefaced with Miss, Mrs., or Mr. "The Society was considered by many of Washington's best families as a fine, safe place for a postdebutante daughter to put in a few years dabbling in secretarial work before marriage," wrote Anne Chamberlin in *Esquire* magazine in 1963.

Amidst the air of gentility that prevailed during the first six decades of the magazine's existence, the work of women sometimes came in over the transom and was published, but a woman would not be put on the photographic staff until Kathleen Revis (the Editor's sister-in-law, but more about her later) in 1953. It would be 21 years until the next one, Bianca Lavies, made her appearance. Jodi Cobb would follow three years later; then another 18 years would pass until Sisse Brimberg joined the staff. The total number of male staff photographers stands around 50. The all-time total of woman staff photographers is four.

In an ideal world, gender would be irrelevant. It would not matter whether a photograph were taken by a man or a woman. The only thing that would matter would be the photograph. We are not there yet. The discussion continues. "Do Women Photographers See Differently Than Men?" asked *American Photo* in a special issue on women in photography published in March 1998. Answer: It depends on whom you ask. *Cosmopolitan* magazine guru Helen Gurley Brown thought not. The fashion photographer Helmut Newton said women do see differently. Photographer Merry Alpern wondered, "How can you tell?"

At the National Geographic, when the subject of this book was proposed, a number of photographers and editors—several women among them—wondered why women photographers should be written about as if they were a subset species of photographer. Hadn't Laura Gilpin, noted for her photographs of the American Southwest, said: "Either you're a good photographer or you're not"?

"I sometimes hear myself referred to as a "great woman photographer," muses Maggie Steber, whose work for NATIONAL GEOGRAPHIC includes stories on Miami and Quebec. "Would you ever hear anyone referred to as "a great man photographer?"

Said a female illustrations editor, "I don't think of any of them as women photographers. They're just photographers who happen to be women."

Finally, there was the male photographer on the magazine staff who commented, "Women photographers? It'll be a short book."

Hopefully, not. Surely to write about women as photographers is to celebrate them both as photographers and as women. If the eye that frames a picture is as distinctive as the voice of a writer's pen, then the photographer as woman, and her experience and identity as a person, relates to the pictures she creates. Men and women do speak different languages, do see things differently, and do respond to them differently. *Vive la difference.* And yet, along with confusion, exasperation, and, sometimes, hurt, in difference there is abundant joy.

In photography as in life, gender does matter. It matters less in some ways, more in others. Alexandra Avakian seems to agree. "Once I didn't think women as photographers was a topic of discussion," she says, "but now I think we should talk about it."

Okay. Let's talk.

Line up a dozen photographs, half of them taken by women, half taken by men. Can you tell who took which? Probably not, but neither can the experts. Don't expect subject matter to reveal any clues. Karen Kasmauski has covered stories on nuclear waste, radiation, and the Alaska oil spill for NATIONAL GEOGRAPHIC. Staff photographer Sam Abell's subjects are softer: hedgerows, gardens, Lewis Carroll. Both create striking and beautiful images.

On the other hand, gender can affect the story a woman photographer gets by virtue of access. Closed cultures are an example of a story where assigning a woman, in the words of Kent Kobersteen, director of photography at NATIONAL GEOGRAPHIC, can sometimes be a "no-brainer." Jodi Cobb's coverages on geisha and Saudi women, and Karen Kasmauski's story on Japanese women probably could not have been done by a man, or at least, in all probability, not with the same degree of intimacy. Or take Doranne Wilson Jacobson's 1977 NATIONAL GEOGRAPHIC article "Purdah in India," about the centuries-old Hindu custom of secluding women from men. "You'd never get a man to do that one," points out Mary Smith, a retired senior assistant editor and picture editor. The culture would never allow it. Suggests another illustrations editor: some of the most powerful images in the magazine are pictures of women taken by women. Which doesn't surprise Kasmauski at all. "They're female; we're female. We can more easily bond."

The door often opens more readily to a woman. Rules fall away. Sometimes in a foreign culture, says Sisse Brimberg, who has photographed more than three dozen stories for the magazine, it's as if you are forgiven for being female—if only for a short time. Brimberg, whose English bears the

lyrical lilt of her native Denmark, recalls a trip to Gaza and a visit to a Bedouin camp where she sat on carpets in a tent and was served tea together with the men. "I could see the women outside the tent," she says. "Their eyes followed every move I made, and I knew I was in a special situation, because of my profession." In circumstances like that, observes a colleague, the men just don't know what to do with you. Your status as a woman is temporarily suspended.

Sometimes the culture itself conspires to help. In Africa, people want to protect and safeguard you, says Carol Beckwith, who with collaborator Angela Fisher has photographed the people of that astonishing continent for 25 years. The Masai, she explains, originated in the Nile River Basin, and swept southward killing every male enemy in sight, absorbing the women and children. "You're entering a society where the idea that women are to be protected is embedded in peoples' genes," she says. "Working there was like having parents, and being told, 'you can't move without our permission, or at least we have to come with you if you want to get in your Jeep and go to another area.'"

Sometimes the door doesn't open at all. An assignment in Cairo turned out to be an exercise in frustration for staff photographer Jodi Cobb. Under normal circumstances, Cobb has a knack for getting people to cooperate. Some years ago while doing a story on Jordan, she somehow convinced the late King Hussein to take her up in his helicopter. She is likeable and enthusiastic about the work, which appeals to her subjects. And she is gutsy. She may appear vulnerable, a colleague says, but watch out. She keeps shooting, even when it gets uncomfortable for her subjects and for herself.

But Cairo, being in a Muslim country, wasn't a normal circumstance for any woman, let alone one trying to do photography. Subjected to incessant verbal and physical abuse while trying to shoot on the streets, Cobb finally, and reluctantly, realized it wasn't going to work. "It was intolerable," she recounted, "—people rubbing up against me, sticking me with needles, grabbing me in the street." For the first time in 20 years of shooting, she asked to be taken off a story. The next photographer assigned to the story, a man, did no better, and quit. A third try with an Arabic-speaking photographer who could melt into the culture finally met with success.

Sometimes you enter through a side door. While shooting a story in Israel about the Sea of Galilee, Annie Griffiths Belt hoped to photograph a Hasidic holiday in which everyone lights bonfires and fathers bring their three-year-old sons for their first haircut. But women were not allowed at the Orthodox Jewish ceremony.

Belt was stubborn and refused to be deterred, so set herself the task of getting around the simple fact of gender. If women weren't allowed to attend, well, then, why not go as a man? she wondered.

"I love this idea," her advisor, an Orthodox Jew, responded.

Belt, who has a slender frame anyway, dressed boyishly, cut her hair short, tucked the rest of it under a baseball cap, and got the pictures that way. Was such a gender-bending ploy kosher? "My goal was not to deceive or disturb," she responds. "It was to do my job without being noticed."

There are many ways of doing the job of photography. Street shooting is one. The photographer walks down the street, hoping for what the famous French photographer Henri Cartier-Bresson called "the decisive moment." There is no interaction with the subject; the photographer waits and watches and hangs out, hoping that subject, light, and composition will coalesce in a single wonderful instant. Jodi Cobb's evocative photograph of a steam-and-fog shrouded Broadway at night,

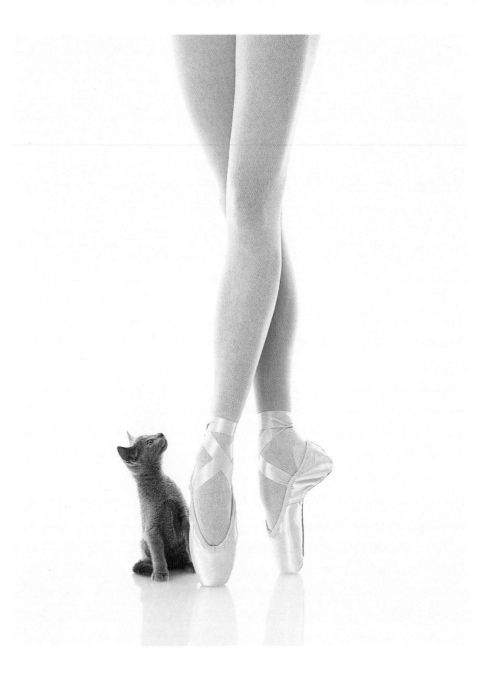

KAREN KUEHN • NEW YORK 1997

Grace defers to grace as a Russian blue kitten evokes choreographer George Balanchine's
directive to his dancers: "Land like a pussycat."

Alexandra Avakian's haunting image of a nun patiently sweeping the stone pavement of her convent in Romania, and Annie Griffiths Belt's image of a young Hasidic boy sneaking a cigarette on a Jerusalem street are all examples of where magic happened and the camera caught it.

All photography is more or less voyeuristic; street photography is more so. Not surprisingly, many women find that uncomfortable. "I'm not at ease doing street shooting," says Karen Kasmauski. "As a single woman, particularly in a foreign country, I feel I'm too noticeable, too vulnerable." Kasmauski, who is intrinsically shy, hates being the center of attention. After a day in the field, she would rather order room service than go out for a meal by herself. "Street shooting just grates too much against my personality," she says. "It feels like I'm barging in."

Not everyone agrees. Although she is equally comfortable shooting pictures in the

intimate setting of a family home, Maggie Steber revels in street photography, as evinced by her photograph of two young Hispanic brothers standing on a scruffy stretch of Miami's Biscayne Boulevard as a homeless man wheels his cart of possessions in the background. "To me it's sheer theater," she says. Perhaps it helps that Steber is unreservedly outgoing and whimsical in addition to being dead serious in how she approaches her work.

Kasmauski, by contrast, is only truly comfortable working stories from the inside. She'll spend time with a family, then, by winning their trust, be able to get the intimate, behind-closed-door shots that help define her work in stories with subjects such as Japanese women or viruses. Melissa Farlow, who has published photographic coverage of the Okefenokee Swamp and the New Jersey meadowlands, has a similar approach. "My stronger images come when I'm comfortable with the people I'm with. I need to understand them. I'm not as comfortable just photographing a stranger on the street."

Adds Farlow's husband, Randy Olson, who also shoots for NATIONAL GEOGRAPHIC: "It's like getting into a swimming pool. I dive right in. I'm afraid things are going to disappear, so I tend to move faster. Melissa puts her toe in. Then her foot. Eventually she's in the pool. By that time, I'm kind of exhausted, whereas Melissa's in for the long haul. Everyone in this pool of people has to understand what she's doing and why. And then she works."

There is a flip side to the equation of street shooting. "Certainly, on the street it helps being male," says staff photographer David Alan Harvey. Males are less likely to be harassed. "However, the minute you walk in the door and into a family situation, you're better off being a woman. In certain villages, if you're a single man, you're the biggest threat going. When I go to see a family in that kind of a situation, I often have a woman as an assistant just for that reason." He pauses and adds, "We all would like to be able to flip a switch sometime."

Even in a post-feminist, politically-correct era of women astronauts, Supreme Court justices, and women's World Cup soccer, being a woman photographer is not unrelated to how others define your role as a woman. The stereotype of the "second sex" persists.

"And when will your photographer arrive?" Sisse Brimberg has been asked, after lugging a half a dozen or so cases full of lighting equipment through a museum door in preparation for shooting artifacts.

"She *has* arrived," is Brimberg's stock reply.

Is the bar set higher for women? "I know it is tougher for my female colleagues," says David Alan Harvey. He and Jodi Cobb started as staff photographers on the same day in 1977. ("I said to myself, 'That gal can shoot people,'" says Bob Gilka, the retired director of photography who hired her.) The women's movement was in full bloom, and Cobb was exquisitely aware of being in the "only woman" slot. "I never had the luxury of taking a chance that could result in failure," says Cobb. "I had to play it safe in so many ways. I had to do a lot of jobs that didn't interest me just to prove I could do the stuff that the guys did. I could hang out of a helicopter; I could go underwater; I could go by horseback or whitewater raft. I could do that if that's what the job took. It wasn't where I was as a photographer, but I felt I couldn't stand up and say, 'I don't want to do that,' because I felt that would limit more women's chances."

To be sure, patronizing behavior and speech are not the exclusive domain of men.

Women can claim equality there as well. In a *Ladies' Home Journal* article published in the late 19th century entitled "What a Woman Can Do With a Camera," Frances Benjamin Johnston, best known for her work as a documentary photographer, wrote: "Even a person of average intelligence can produce a photograph." Presumably some are even men.

"Can a Woman Photograph Women?" *Modern Photography* asked in a 1953 article. According to a female fashion photographer who went by the name of Sharland and who worked in the 1950s, "It takes a woman to do justice to another woman." A man, she went on to proclaim, "experiences an emotional reaction when he first sees a woman he has been assigned to photograph. If he finds her unattractive, he can seldom develop enough interest to discover why she was selected by an editor to be photographed."

Such cliches aside, women really are less threatening, suggests Lynn Johnson, who has covered such subjects as the Russian poet Alexander Pushkin and the Dutch painter Vincent Van Gogh for National Geographic. "People take you for granted. They take you lightly, and I am happy as a clam to take advantage of that. I understand it is not necessary to go into a scene and announce your presence." Johnson, one of the most thoughtful and introspective photographers working for the magazine, wears her shyness like camouflage.

Zen and the art of covering a story. It's about holding still and melding into the scene. It's about pulling on the mantle of camouflage and becoming part of the foliage. It's not always that way. There are instances when the photographer is most definitely present. But often, not being there while being there is better.

"I'm a small person, and I carry a Leica, which is a small camera," Johnson says. "I really can melt into the background." The key, she says, is to move within an environment, particularly a family situation, almost without being present.

Is stillness the birthright of women? Of course it's not. It's the stock in trade of any photographer. Photography has everything to do with watching and waiting. But perhaps, suggests Rich Clarkson, a former director of photography at National Geographic, women have a bit more patience; they take a little more time; they're a bit more Debussy than Wagner.

What happens after the film gets shipped back to headquarters in Washington to be reviewed by the illustrations editor who helps direct the coverage? Again, generalizations are to be taken with a grain of skepticism; there are no absolutes. On the other hand….

"Women agonize more," observes Susan Welchman, an illustrations editor for the magazine. "'This is the picture,' they'll say. 'It's not as good as it should be.' They'll let their vulnerability show. Men often bring their pictures in, slapping each other on the back. Women seem to be more isolated, more independent. It could be maybe that women are so divided with so many things to do, they haven't got time for schmoozing. Women will say, 'Well, I've got that picture. I've got to go take care of my child or clean the house.'"

"It's not a matter of self-confidence," adds Elizabeth Krist, another illustrations editor. "Anyone who works at National Geographic has to be titanium-tough.

"Women tend to find more fault in themselves," Krist says. "They are more willing to blame themselves, whereas men seem to go through every twist and turn to rationalize. The men also tend to objectify and intellectualize their work more, whereas the women seem to want to talk more

about the experience and the relationship with their subjects."

Biology may or may not be destiny, but the issue remains a topic of discussion. Perhaps, a woman photographer suggests, if there were enough women in the profession, the stereotypes would disappear. Instead of women photographers and men photographers, there would just be photographers who take pictures.

"Where I was born and where and how I have lived is unimportant," the American painter Georgia O'Keeffe once wrote. "It is what I have done with where I have been that should be of interest."

It is the picture that should captivate us, nothing else, O'Keeffe seems to be saying. Take no notice of the young girl who grew up on the long, flat expanse of the prairie, or the old woman's preference for isolation. Ignore the artist's love for the burnt red hills of New Mexico and don't even think about the fact that a tough, blunt woman created these tough, blunt paintings.

One might say the same of the work of women photographers at NATIONAL GEOGRAPHIC. The work—by turns, stunning, exciting, and often moving—speaks for itself. Why look beyond the frame?

Because to know the woman behind the work—to know how she thinks, what she feels, why she photographs, can only deepen our appreciation, that's why. The stories these photographers have to tell can teach. They may even inspire.

"I wanted to be in the human heart," Jodi Cobb says in explaining why she became a photographer. In an image from her story "The Enigma of Beauty," a young girl with anorexia sits in front of a white plate on which rests a solitary green apple. Shadows fill the room. It is a still life of sadness. The girl's face is dark with fatigue and despair that may or may not turn into hope in the setting of the clinic where she is being treated. It is a heart-bruising photograph, full of quiet pain.

"One time in Buenos Aires I had to do something in a hurry. I had to take pictures of a poor woman in her house in a barrio," says Joanna Pinneo in speaking about the emotional complexities of shooting a picture in haste. "I ran in, shot the picture, and ran out. I felt bad. I thought, 'She didn't know me; I didn't know her.'" It is years later and Pinneo is still haunted by remorse at the contact too rushed to ripen into a relationship. Ideally, it is otherwise. In a photograph from her story on the Basques, a father and son share a moment of affection. The son wraps an arm around the older man's shoulder. The father's face radiates happiness. It is a tender image, full of love and connection between father and son and between the photographer and her subjects. It is the result of spending days—not minutes—with the family.

How richer we are for knowing these things. The images made by the women who work for NATIONAL GEOGRAPHIC are to be admired on many levels. Though looking is its own reward, to understand the photographer is to better understand the photograph. Character is style. Experience is point of view. It is also hopefully, and most of all, insight. ∎

ALEXANDRA AVAKIAN • GAZA 1996

The family of a newly married bride
in Gaza carries its joy to the streets,
a sign of hope in a landscape otherwise
marked by violence and fear.

FOLLOWING PAGES

JODI COBB • NEW YORK 1998

Pencil-sharp high heel shoes punctuate
the fashion statement made by designer
Isabel Toledo at a runway show during
designer week in New York City.

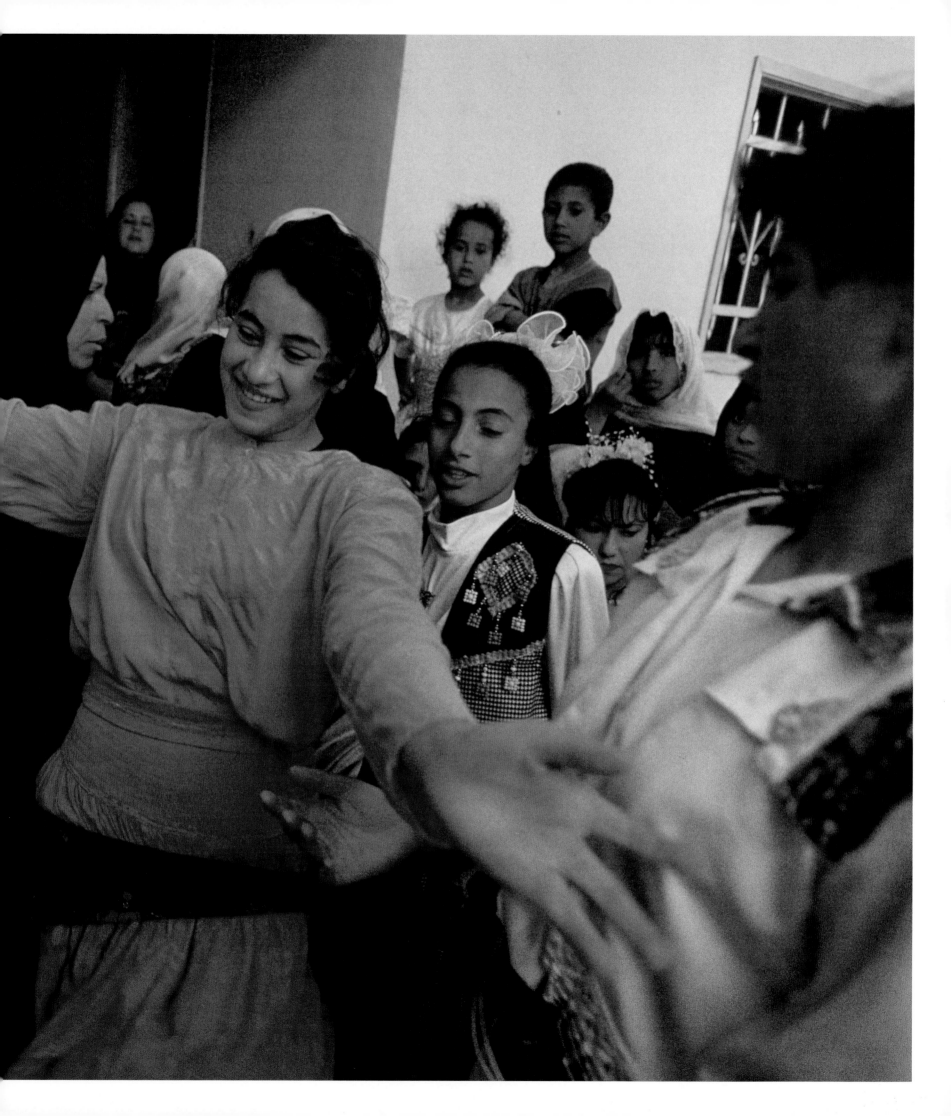

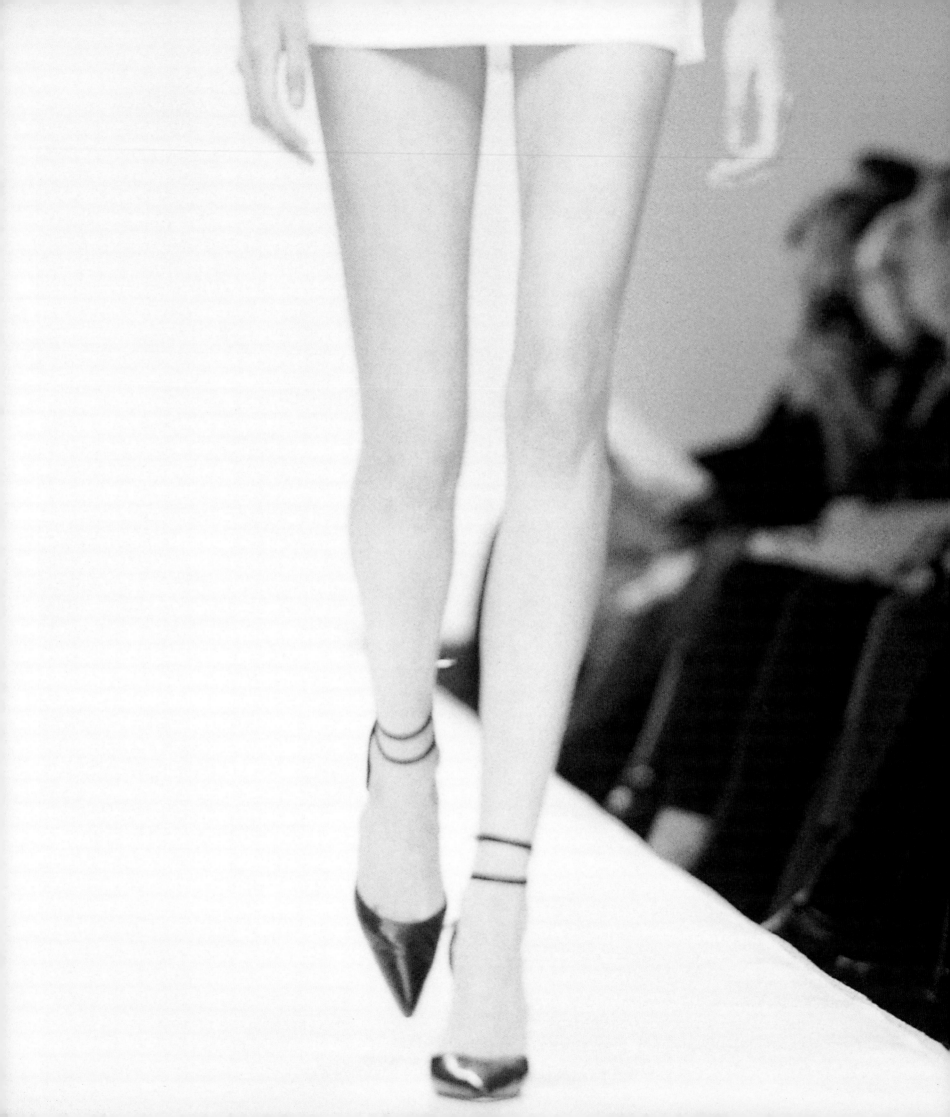

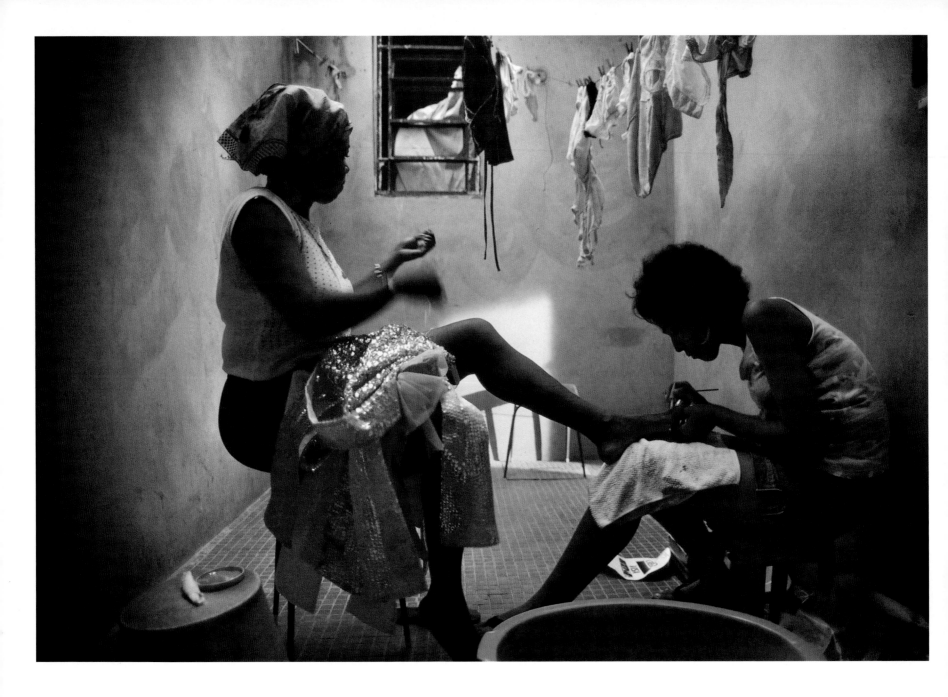

STEPHANIE MAZE • RIO DE JANEIRO 1985

Family members prepare for Carnival
in a Rio slum. The women make their
own costumes for the no-holds-barred
celebration, which marks the high point
of the year.

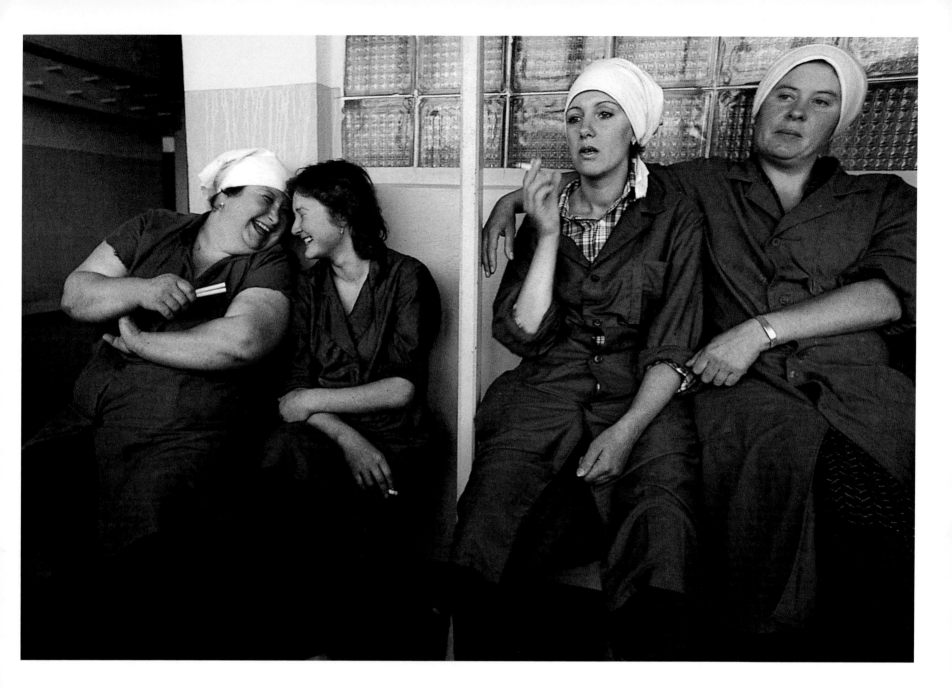

NATALIE FOBES • PORONAYSK, RUSSIA 1990

Women at a salmon processing
plant break from the tedium of work.
The cannery operates as part of a
collective and pays workers according
to their team's production.

HARRIET CHALMERS ADAMS • SPAIN 1924

Spectators attend a bullfight in the
south of Spain. Adams published 21
stories in NATIONAL GEOGRAPHIC.
In addition to crossing Haiti on horse-
back in 1910 and climbing to 19,200
feet in the Peruvian Andes, she was,
as an obituary remembers her, a
"confidant of savage head hunters."

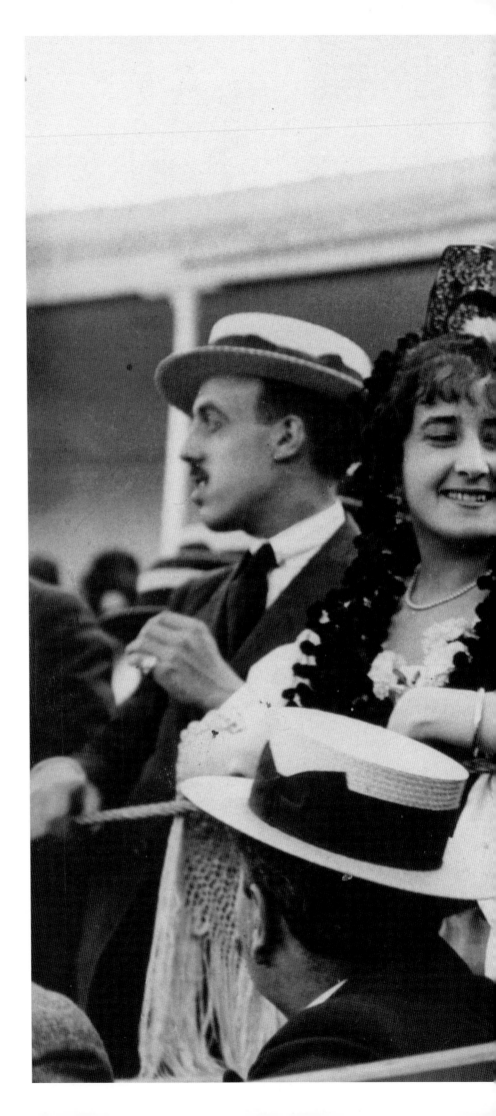

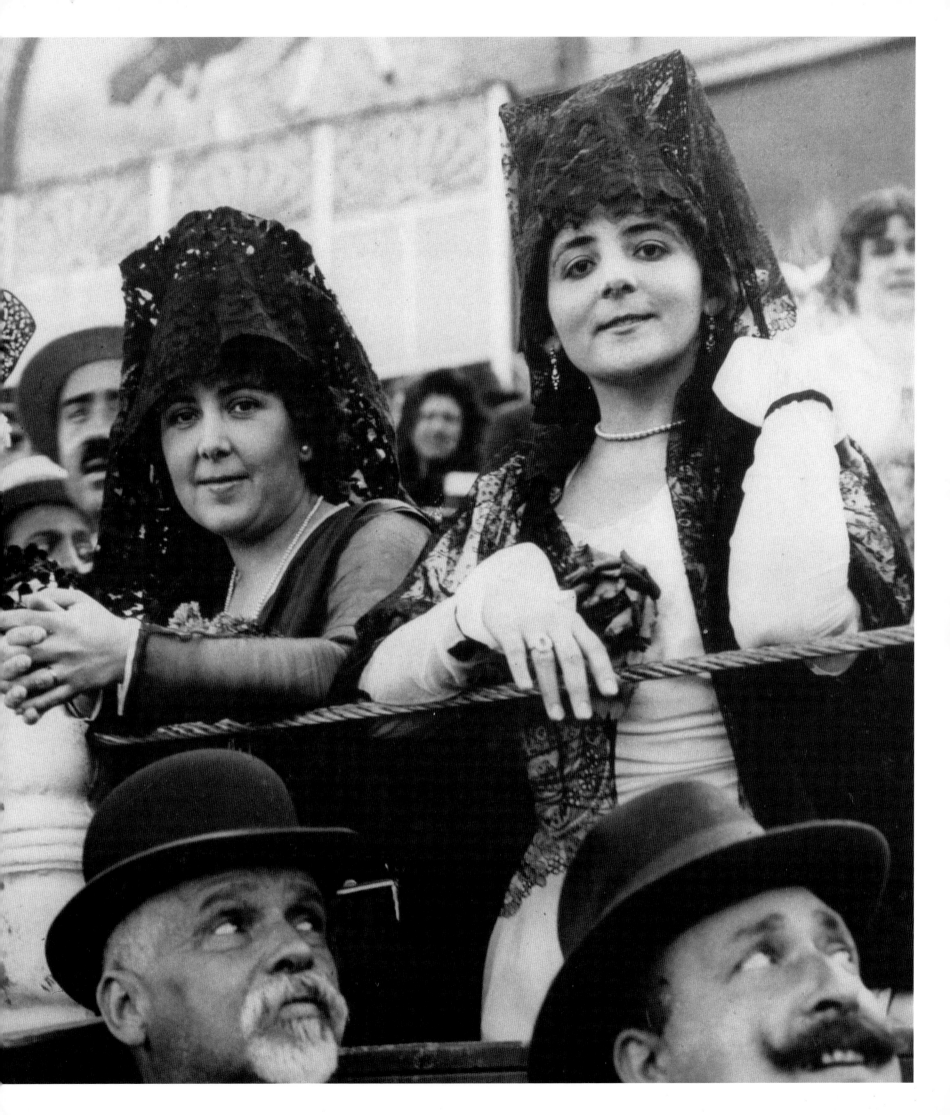

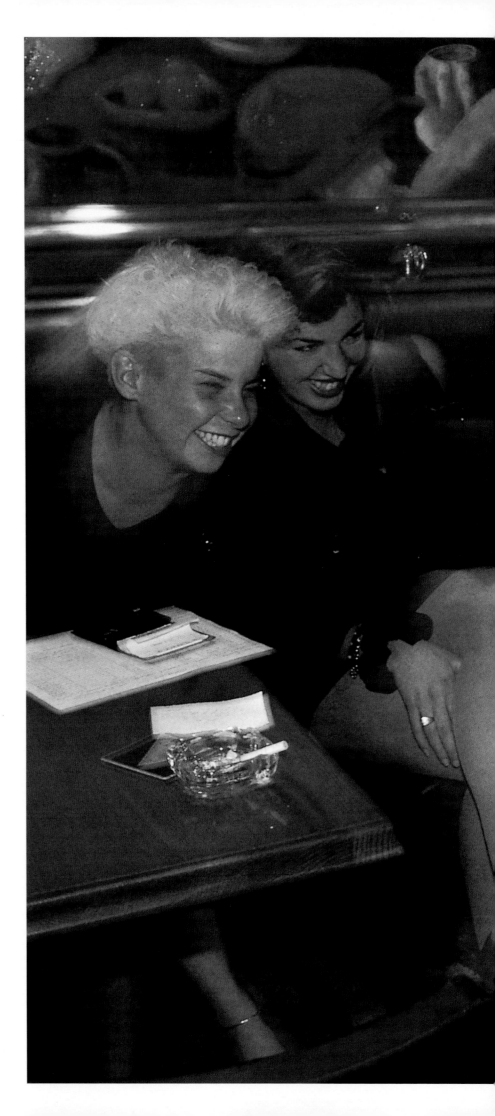

SISSE BRIMBERG • MONTREAL 1991

Giddy after a hard night's work,
French-Canadian waitresses in a Quebec
restaurant unwind with laughter.

MARY ELLEN MARK • SYDNEY, AUSTRALIA 1988

Abuse blackens the eye of an Aboriginal woman,
with her friend in a Sydney slum. She has been
kicked in the face by her boyfriend.

LYNN JOHNSON • ODESSA 1992

A client embraces a prostitute in a walk-up.
The photograph evokes the life of Russian poet
Alexander Pushkin, a womanizer and gambler.

JODI COBB • HELSINKI 1981

Ella Eronen, one of Finland's most
beloved actresses, poses in the costume
of "Madame," an actress who felt lost
unless she had a role to play.

FOLLOWING PAGES

ALEXANDRA BOULAT • KOSOVO 2000

Young Kosovar Albanians greet NATO
peacekeepers on the road to Prîstina
with flowers and cautious hope. In the
background burns a blaze of revenge—
a Serb house torched by Albanians.

JODI COBB • SAUDI ARABIA 1987

The somber black of the veil worn by
a woman stands in stark contrast to the
bright colors worn by two youngsters
on a Jiddah beach. Puberty is the time
when most girls put on the veil.

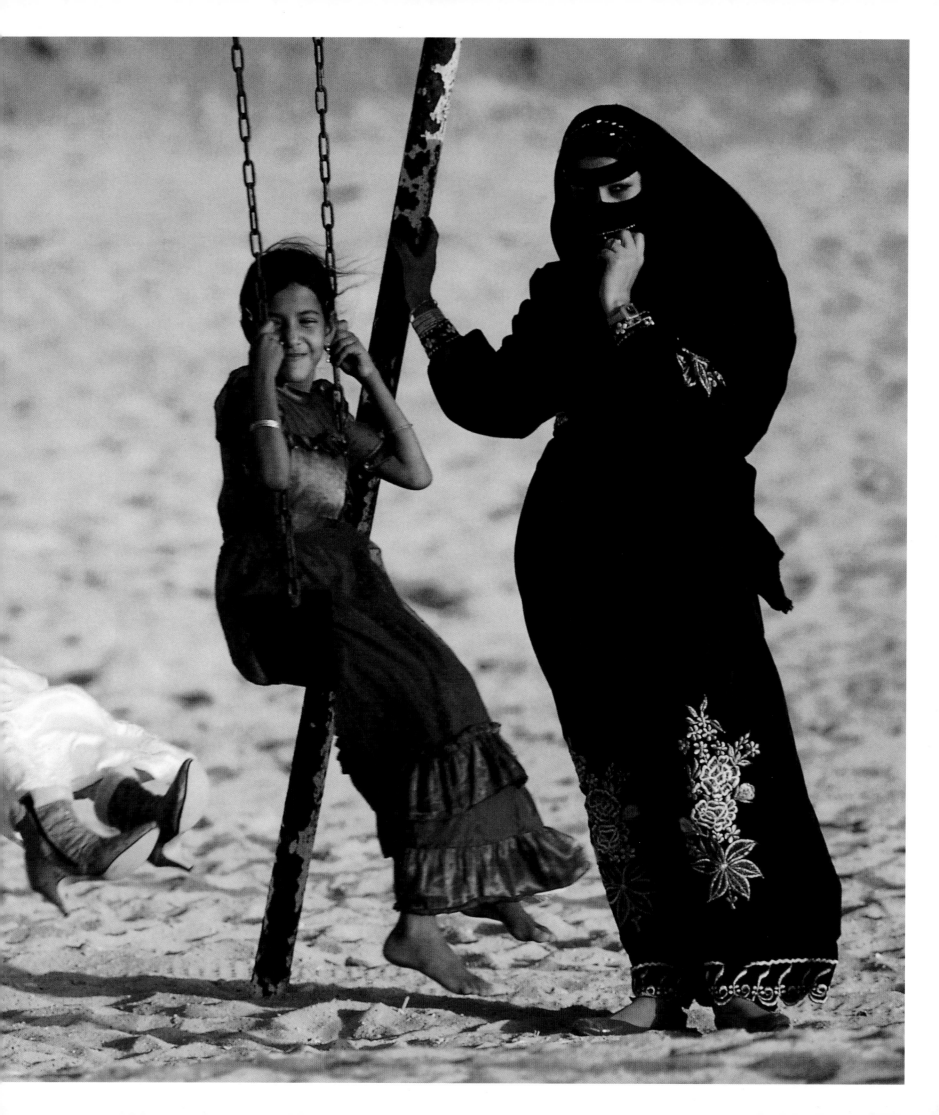

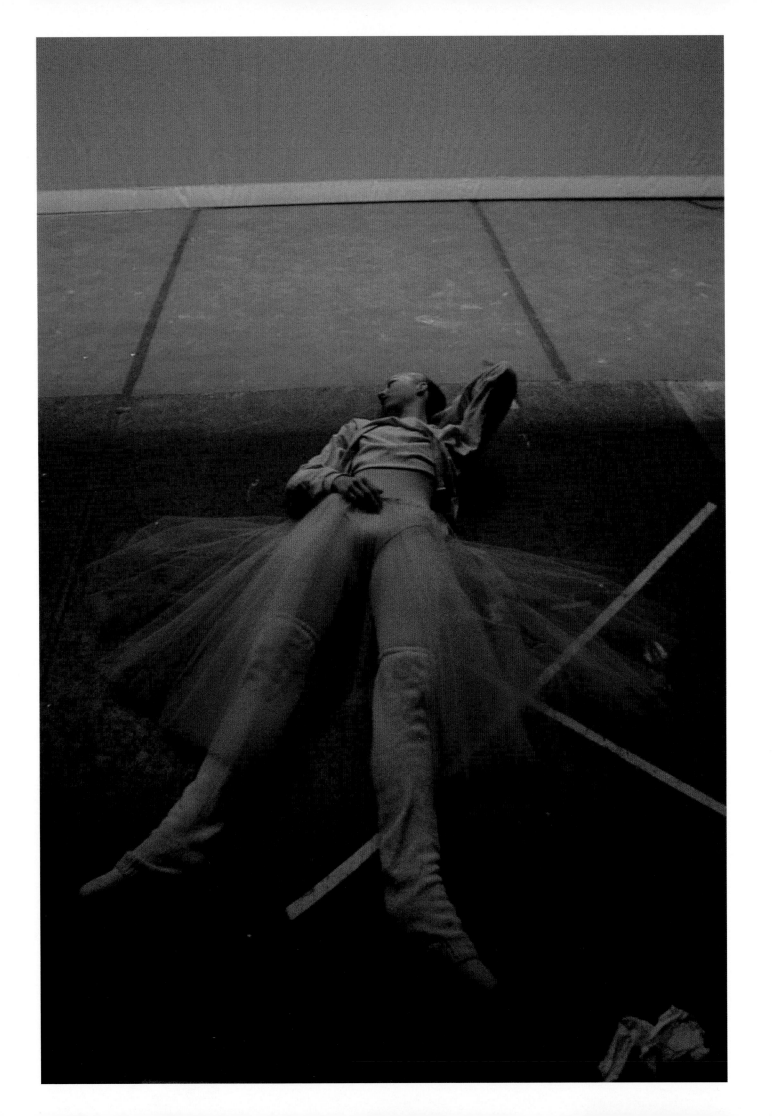

JODI COBB • MONACO 1996

A ballerina takes a break during a rehearsal at the Académie de Dance Classique Princesse Grace.

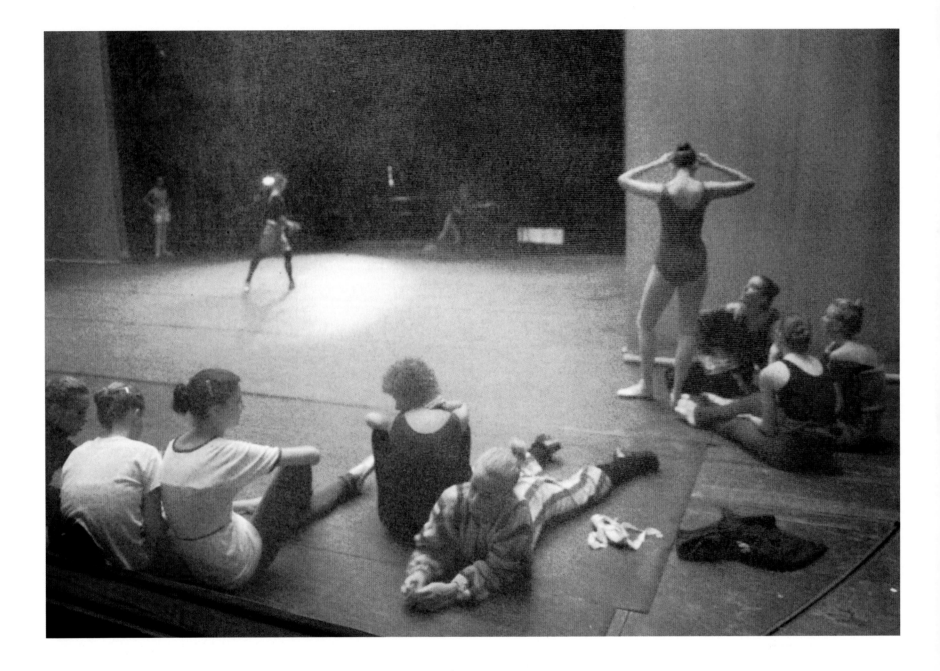

SISSE BRIMBERG • COPENHAGEN 1979

The Royal Danish Ballet rehearses in Copenhagen's Royal Theater.

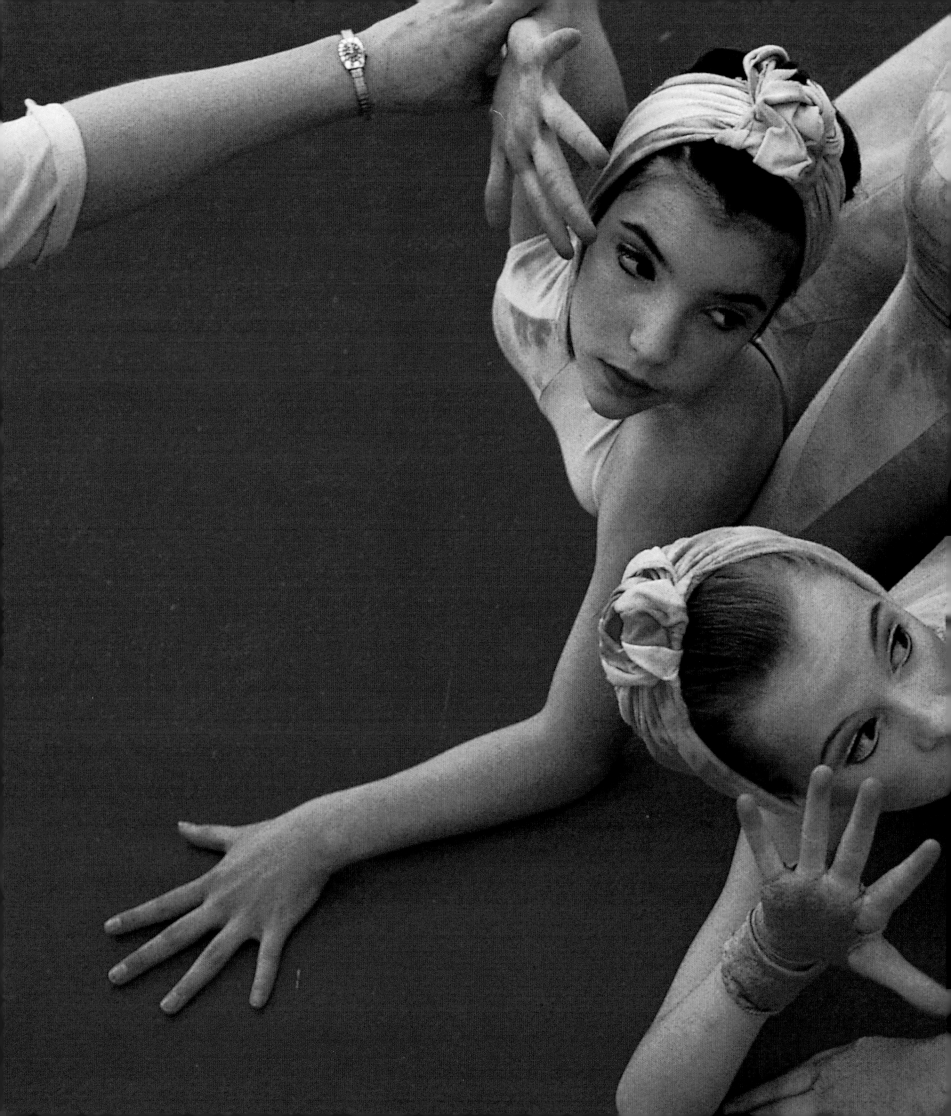

JODI COBB • LONDON 1999

A young woman pauses for coffee and
reflection in London, Europe's magnet
for the young, hip, and hopeful.

PREVIOUS PAGES

SISSE BRIMBERG • MONTREAL 1991

Three contortionists from the Cirque
du Soleil are twisted into shape by
their instructor, whose steadying
hand appears in the upper left corner
of the photograph.

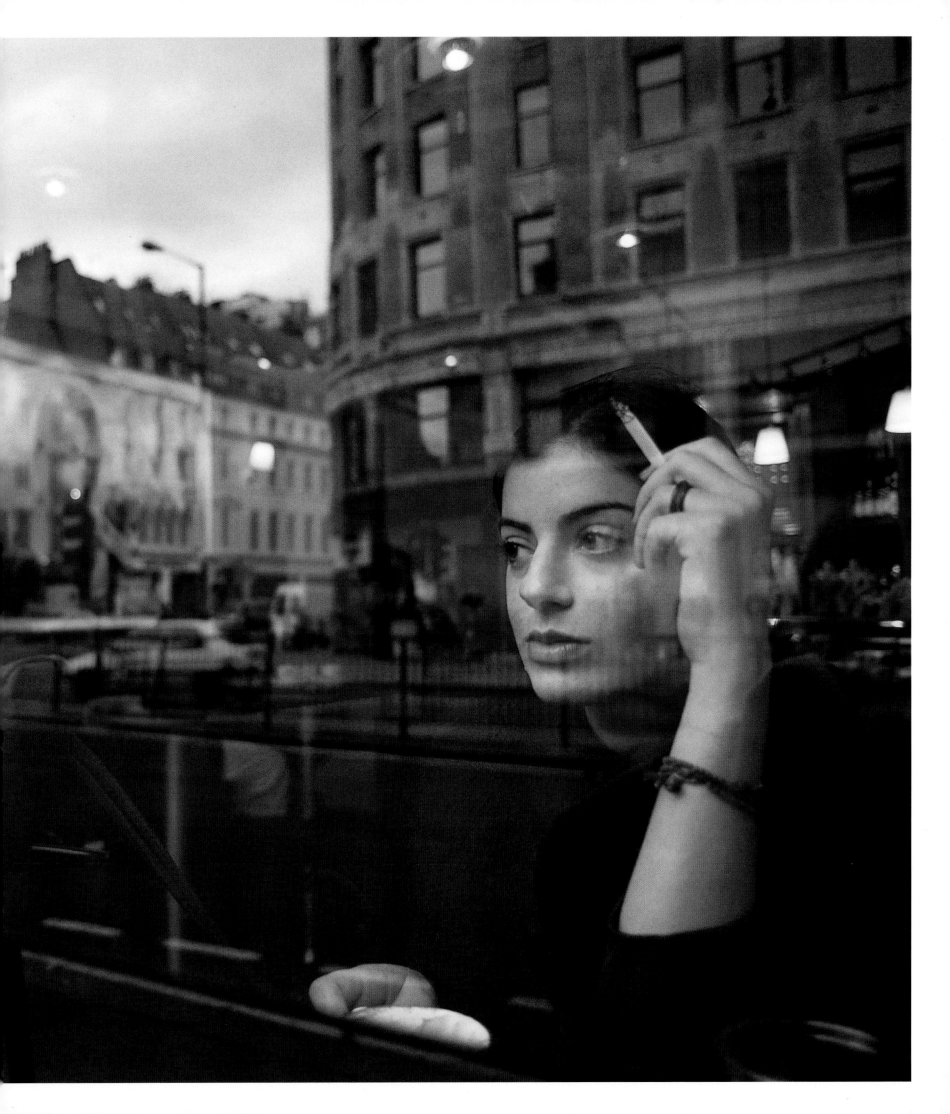

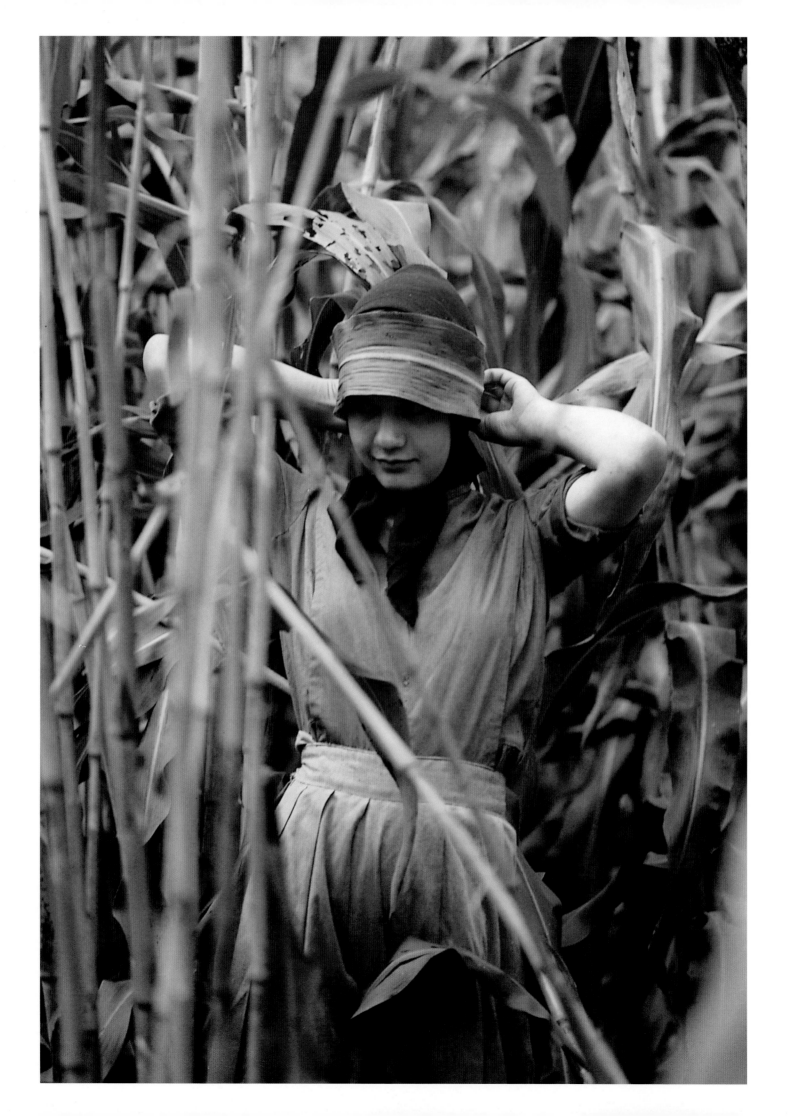

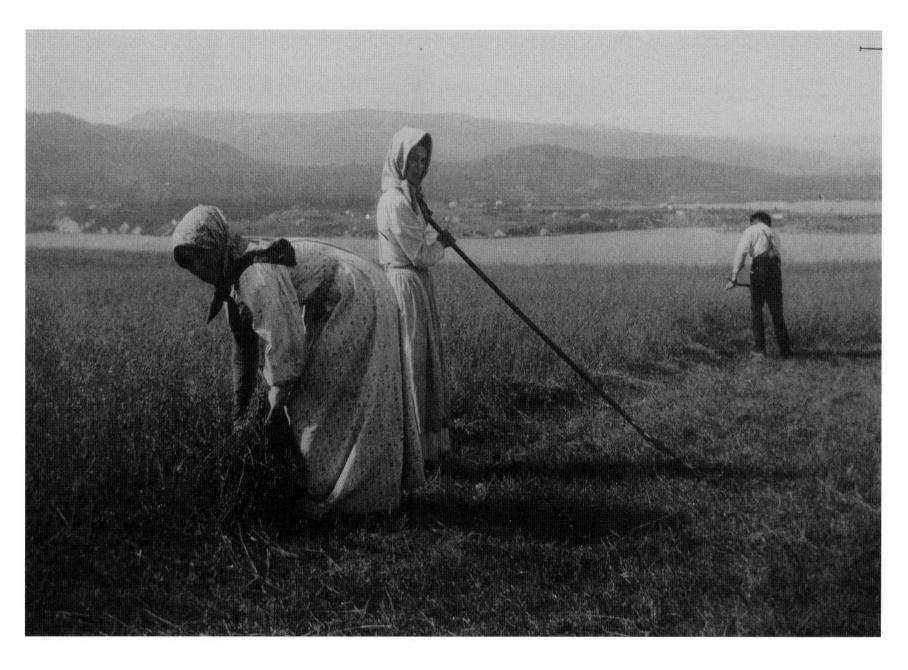

KAREN KASMAUSKI • KYOTO, JAPAN 1989

A study in grace, composure, and
modesty, a Japanese bride dresses in
the traditional white kimono.

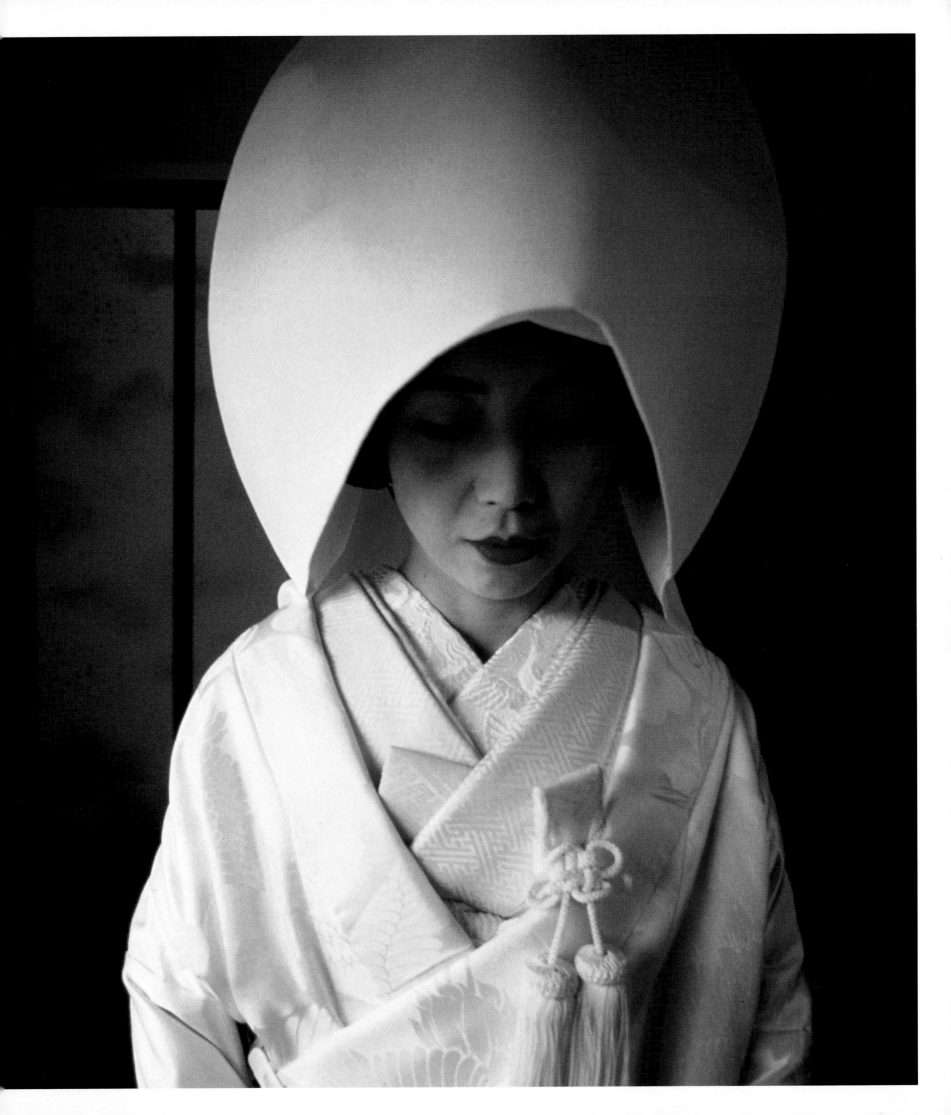

Jodi Cobb

WOMEN ON WOMEN

JODI COBB IS A MASTER of the telling detail—the clock on the wall above the aging actress; the solitary apple on the plate of an anorexic girl; the red tricycle at the foot of a red-carpeted set of steps that belongs to a toddler member of the Jordanian royal family. Such exquisiteness twists the heart and speaks to the mix of tears and laughter in life. "She has a homing device for the extraordinary situation," says Susan Welchman, an illustrations editor. "She has a more artful eye, a more cerebral eye; she's always dwelling in that part of the mind." She also has an appreciation for irony—an aspect of life difficult to show visually. Perhaps, suggests Tom Kennedy, a former director of photography, you could argue that women have better antennae for those complexities. "I love the element of surprise in a photograph," Cobb says. "I want to surprise the viewer. For that to happen, I need to be surprised, too. How to do that? I keep moving. I look at things in different angles, in different light." Some of Cobb's most powerful work has been of women. Her coverages of Saudi women and the geisha lift the curtain on otherwise inaccessible worlds. "The two cultures are different as can be," she observes, "but in their souls, women want the same things: dignity, respect, love, freedom." Cobb is one of seven photographers who hold coveted positions on the National Geographic staff and the only woman. Her strengths—artistry combined with intelligence, wit, and tenacity—enabled her to get images such as these from "The Enigma of Beauty" published in the magazine in January 2000.

HAWAII 1998 Hours before being crowned Miss Universe 1998, Wendy Fitzwilliam, a law student from Trinidad, puts the finishing touches on her national costume.

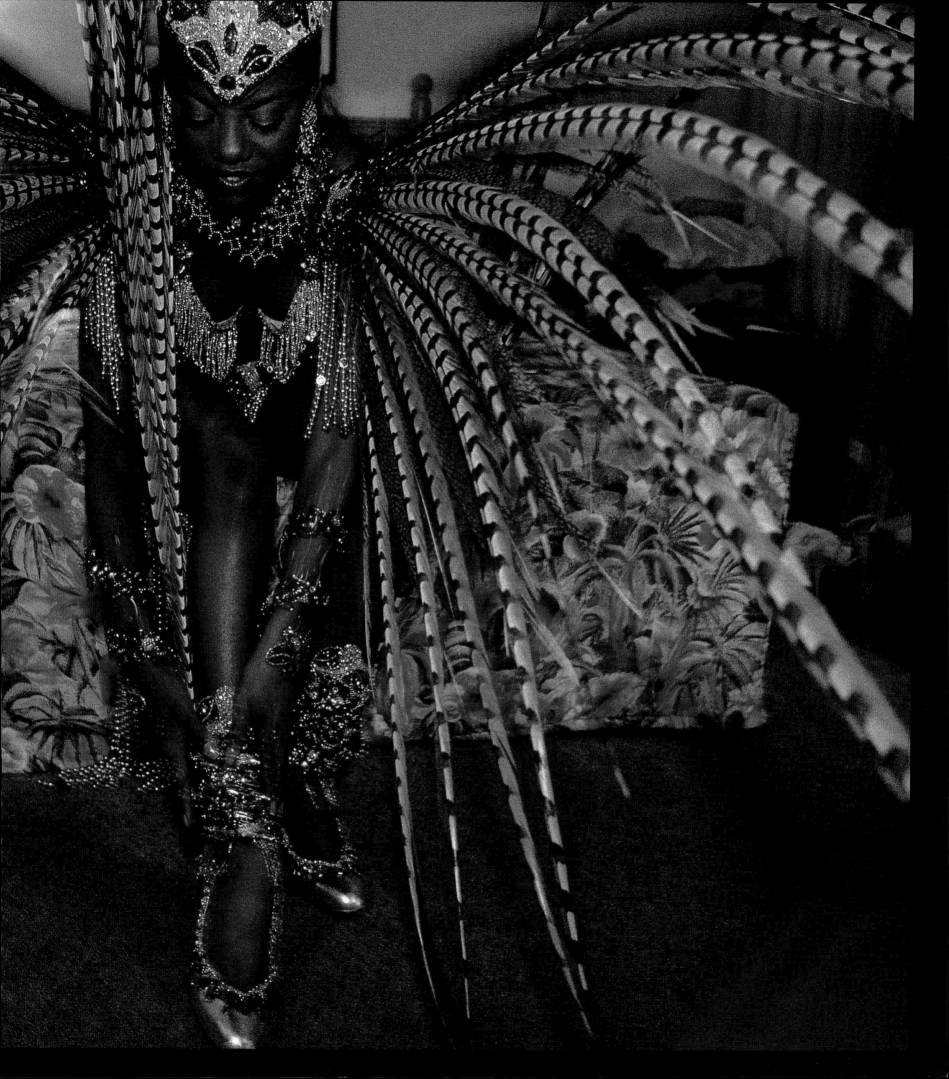

NEW YORK 1998

A model sits through the time-consuming tedium of having her hair done prior to a runway walk that will be over in minutes.

FOLLOWING PAGES

LONDON 1998

Graduates from London fashion colleges dress for a runway show featuring the evening wear of New York designer Carmen Marc Valvo.

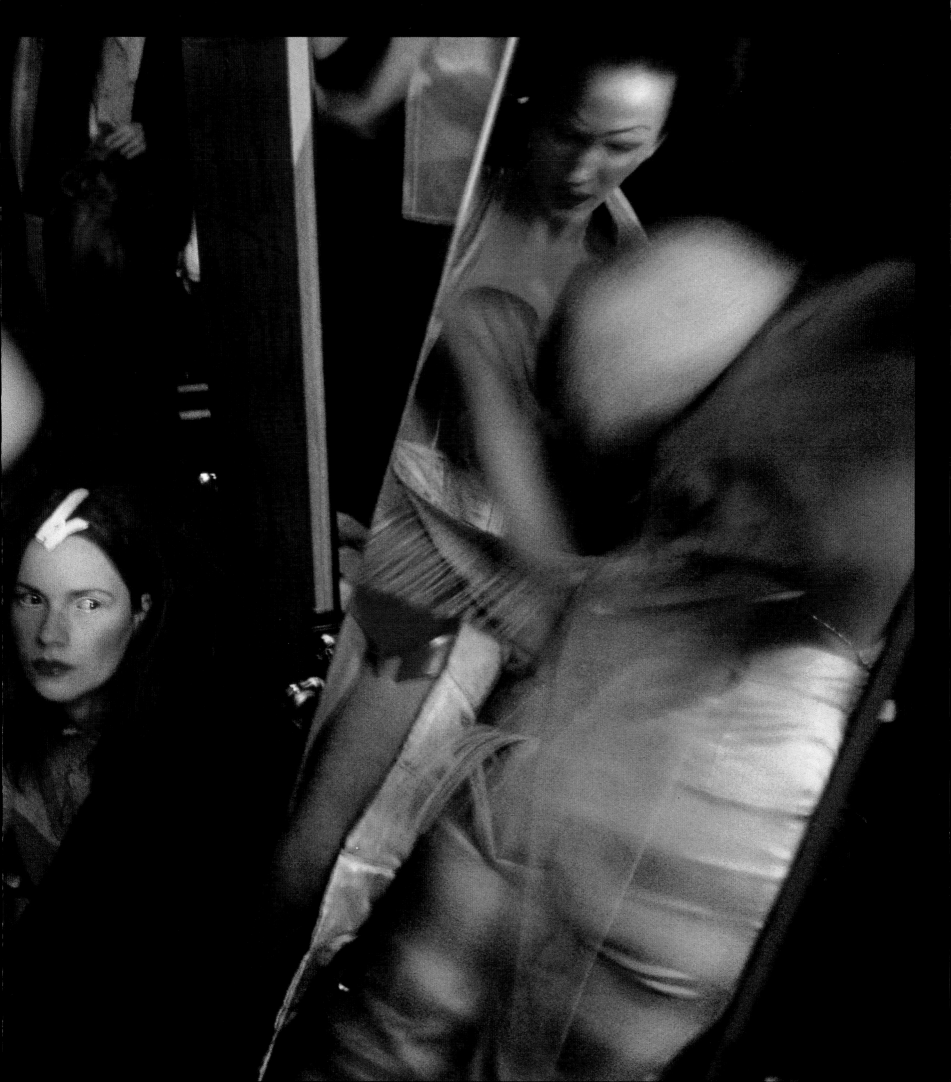

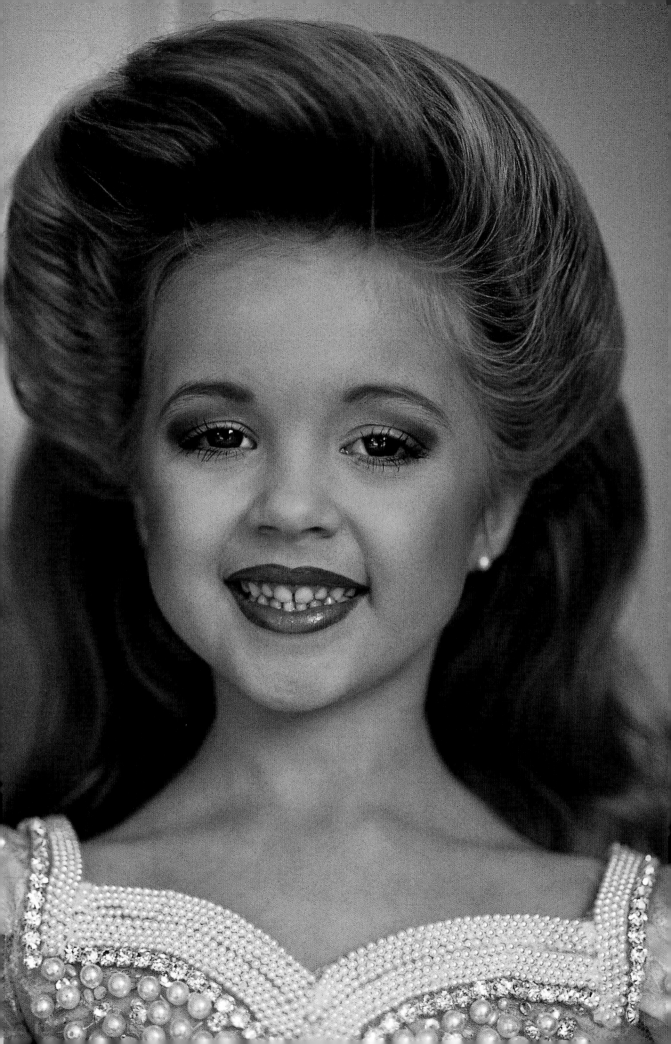

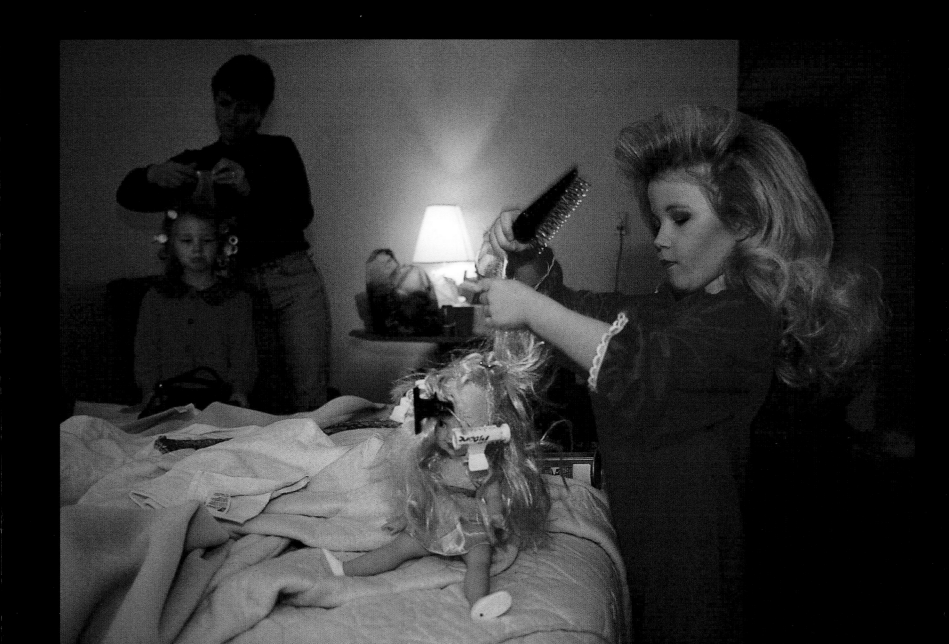

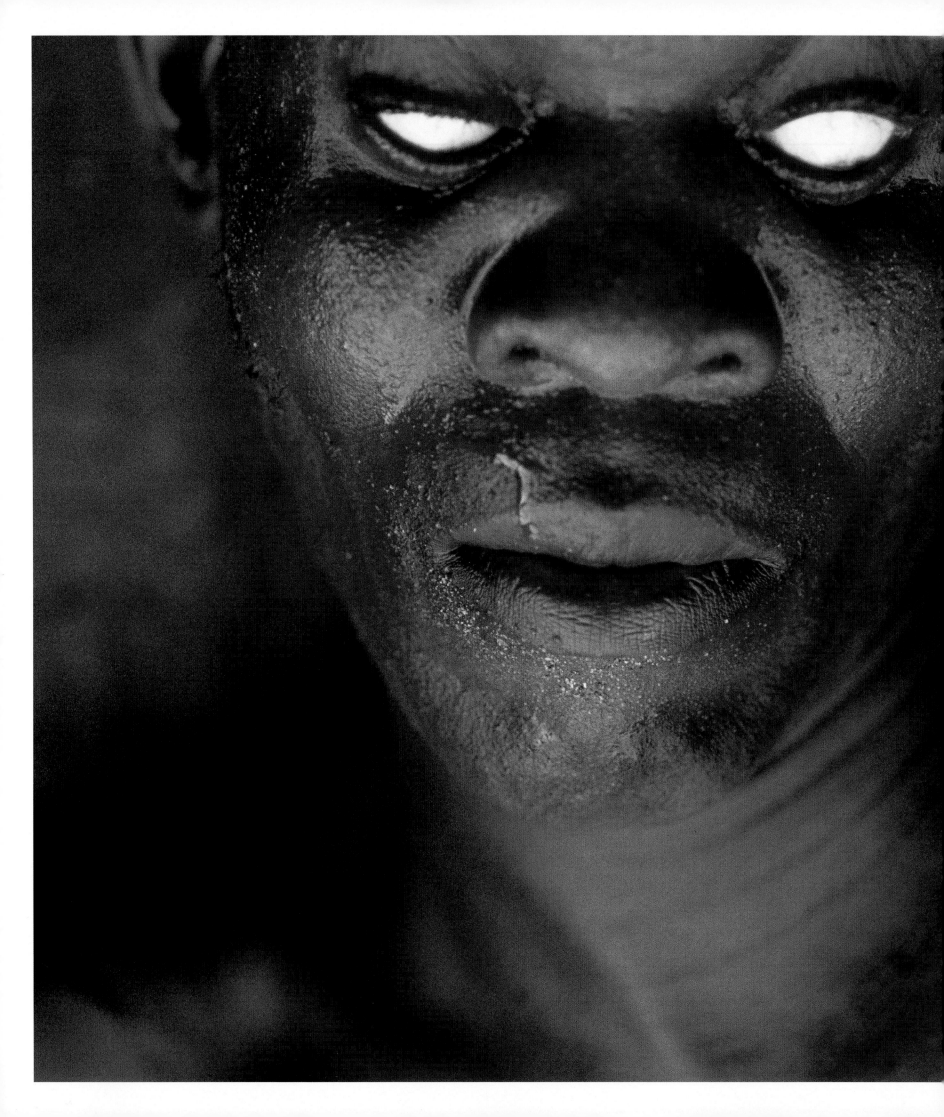

LURED BY THE HORIZON

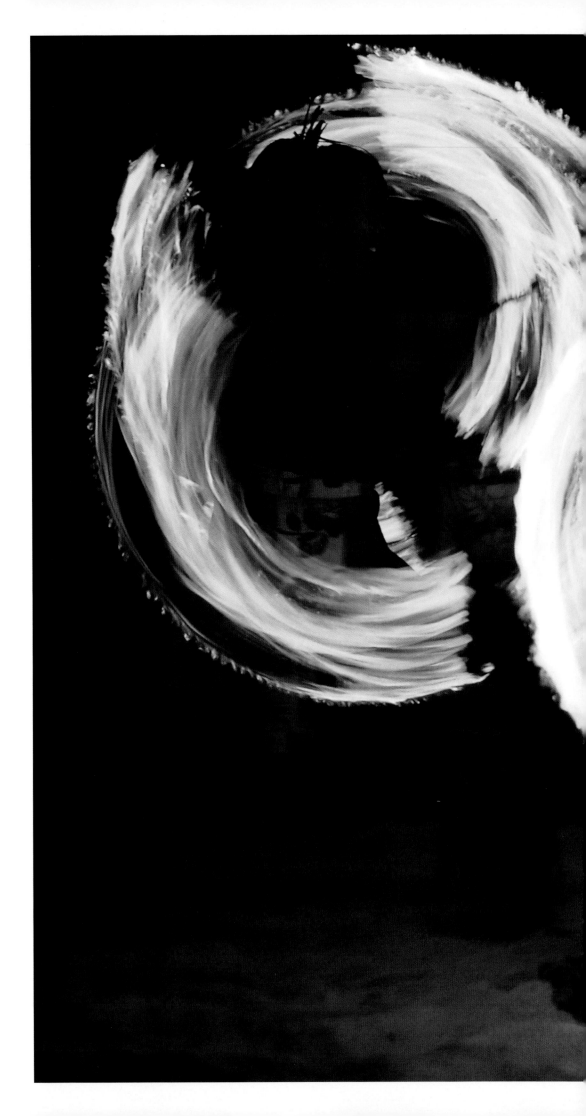

JODI COBB • FRENCH POLYNESIA 1997

The Polynesian passion for dance and
the tourism trade's appetite for entertain-
ment combine in an incendiary show
at a beachfront resort in Tahiti.

PREVIOUS PAGES

**CAROL BECKWITH AND ANGELA FISHER •
TOGO 1995**

In the grip of the voodoo gods, an
Ewe tribesman falls into a spirit possession.

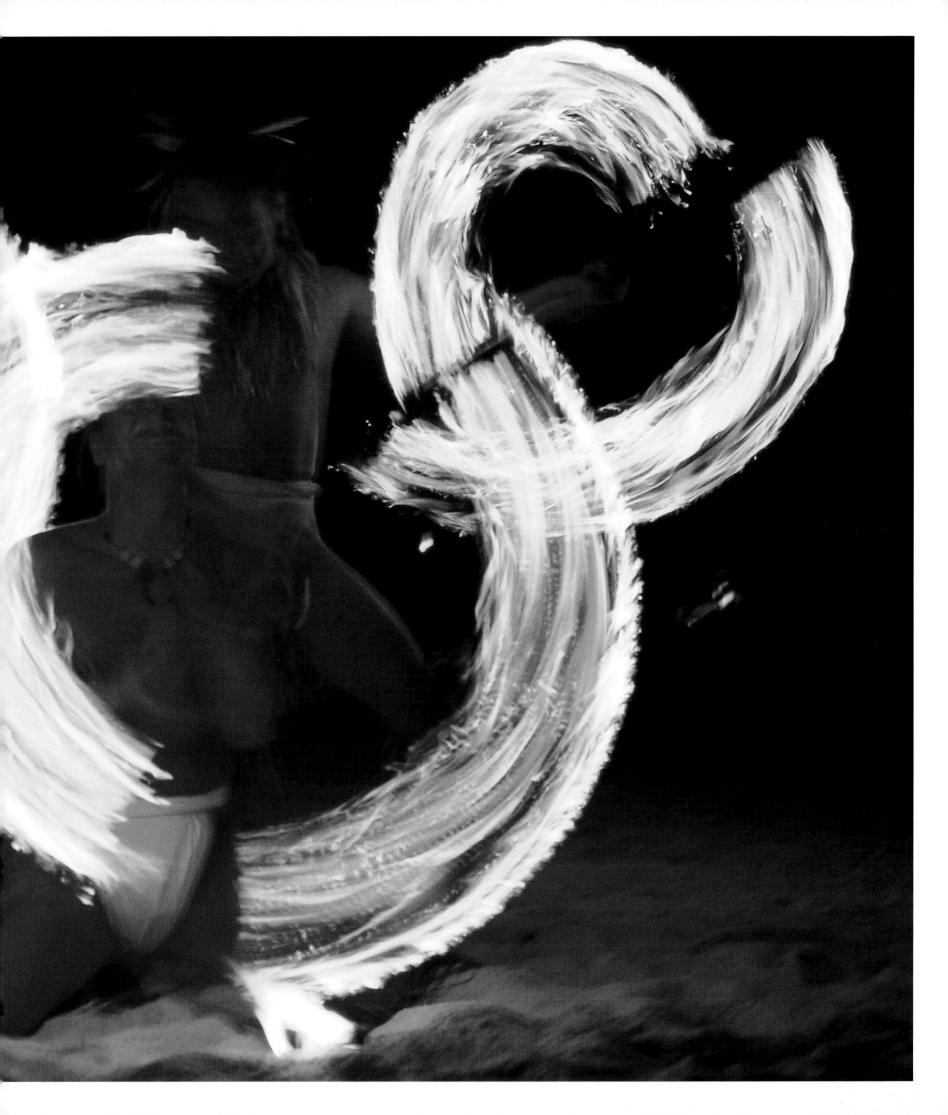

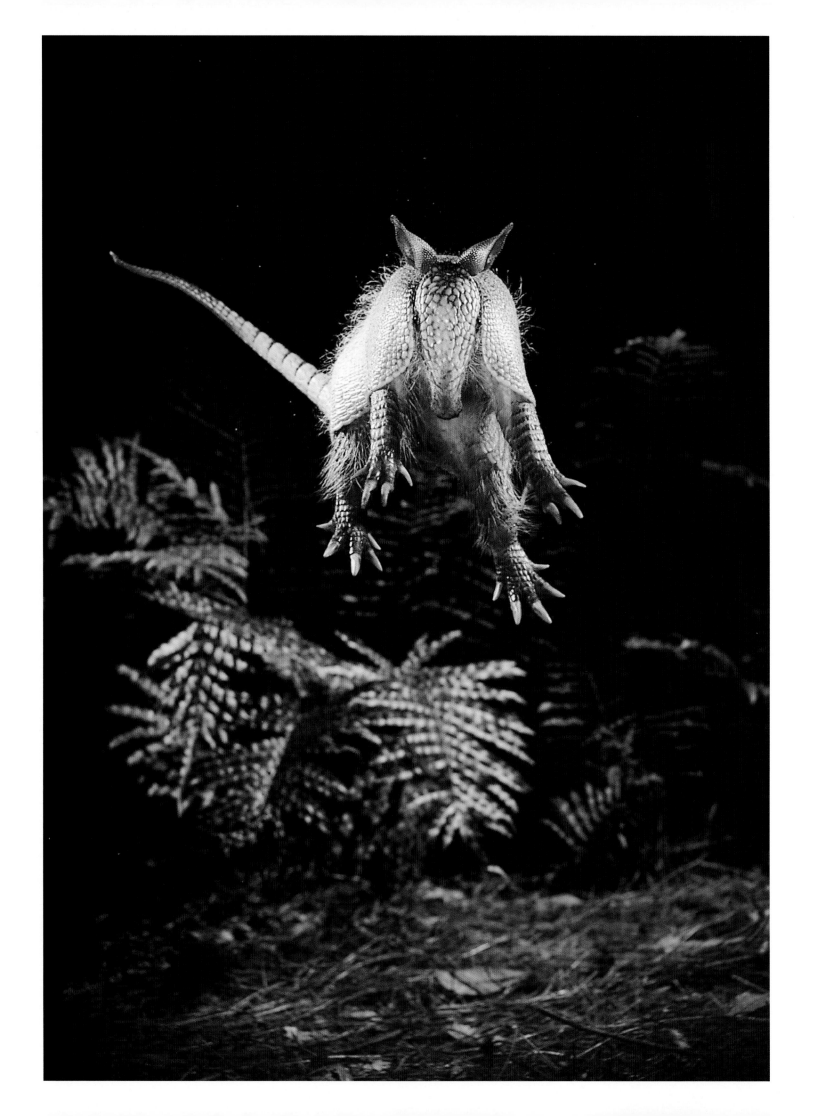

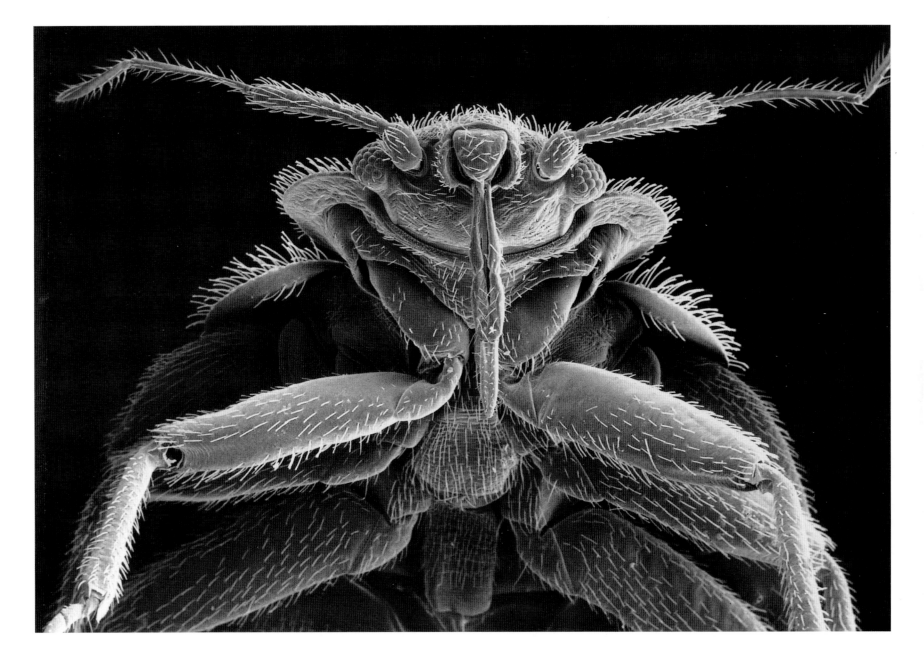

STEP INTO THE PHOTO ARCHIVES in the basement of Society headquarters and here you may find among the ten million prints stacked on ceiling-high shelves, something about the hidden history of women photographers at NATIONAL GEOGRAPHIC.

It is a random search. The work of these women is, at first sight, hardly visible. One does not type "women photographers" into a database and wait for the names to appear on the screen. Rather one shrugs off the 65-degree chill of the room and picks through folders one by one, hoping to stumble across a lead.

Here, for example, in a folder labeled *Mrs. J.N. Merrill,* is a notation scribbled in fading brown ink: "Received June 13, 1917, paid $60. For article on Persia and 30 photographs."

Among the aging black-and-white images in this folder are these two: a thin, wiry man in front of a balance scale surrounded by oblong, flat loaves of bread. "The baker is usually a busy man. The bread is quite palatable," reads the caption on back. Another shows a kneeling retinue of men attending a drowsy-looking man in a throne-like chair. "Massaging the Shah," reads the caption. "He is being served with tea at the same time."

There is no clue as to who Mrs. J.N. Merrill was, what she was doing in Persia in 1917, or how she ever managed to photograph the Shah being massaged and served tea at the same time. Only the notation "one picture published" tells us that the work of Mrs. J.N. Merrill, if only one image, appeared in the pages of the NATIONAL GEOGRAPHIC.

Here, too, are several particularly thick folders with photographs taken by and collected by Eliza Ruhamah Scidmore, who as author-photographer of "Young Japan," July 1914, was probably the first woman to have photographs published in the magazine.

Scidmore, the only woman on the Society's Board of Managers from 1896 to 1907, was a friend of the first editor of the magazine, Gilbert Hovey Grosvenor. Not surprisingly, their personal and professional relationship was lively and full of mutual respect and admiration. Dr. Grosvenor appreciated the contributions women could make. It didn't hurt that his wife, Elsie, was an active suffragist.

"As you know, I have felt for a long time that we should endeavor to develop more women writers for the magazine," Dr. Grosvenor wrote J.R. Hildebrand, one of his editors, years later. "Women often see things about the life and ways of people which a man would not notice.... Men are more forward in presenting and asking for assignments than women; perhaps that is one reason why the ladies of our staff have not received as many assignments as the men." He could have written the same about women photographers.

Although she spent the first 18 years of her life in the American Midwest, Scidmore spent her next 54 years traveling and writing about Alaska, Japan, Java, Thailand, India, Ceylon, and China for the NATIONAL GEOGRAPHIC and other publications. Her passion for travel took her everywhere; her magazine articles range from reports on the discovery of Glacier Bay, Alaska, to the King of Siam's annual elephant hunt. Her published images are few; she was by self-description an amateur. Nonetheless, her photographs have warmth, grace, and a gentle wit.

In the early years of the magazine, before the establishment of a photographic staff in the 1950s and '60s, pictures were often sent in as unsolicited material, or they were acquired by correspondents in the field. While on assignment, Scidmore worked hard at gathering illustrations and promptly let GHG know of the good work she was doing on the Society's behalf.

"They were a stunning lot of pictures, and I only feared to be too long-winded and space-consuming in what I had to say about them," she wrote GHG from the field. "I will keep my eye out for the NGS. I can get you some very stunning pictures of Chinese architecture this fall."

In addition to a keen eye, Scidmore had an instinct for the promotional value of using color in the otherwise monochromatic magazine then in its infancy. With a self-confidence devoid of arrogance, she gently prodded the like-minded GHG to publish more and more in color (at that time "color photographs" were actually hand-colored black-and-white plates. Autochrome, an early color process, would not be in regular use for another decade). Scidmore hand-tinted her own photographs and pronounced herself more than satisfied with the results. "Herewith 31 pictures of women and children, mostly children, as you see," she wrote Grosvenor. "I have had them made uniform in size and strongly colored, so that you can cover yourself all over with glory with another number in color."

"Why not try…color photography printing?" she had pressed Grosvenor earlier. "It's coming to stay and you might as well take a first flyer on some of those red and yellow temples among green trees, with snow on the ground."

More digging reveals the name of Scidmore's younger colleague, the remarkable Harriet Chalmers Adams. Adams, a president of the International Society of Woman Geographers, had some 21 stories published in the magazine from 1907 to 1935. Although listed as an author in the NATIONAL GEOGRAPHIC *Index,* an examination of her articles reveals that Adams took photographs as well. In her article, "In French Lorraine: That Part of France Where the First American Soldiers Have Fallen," published in November 1917, Adams, one of the first and few women correspondents of World War I, reports on her train trip from Paris to Nancy, a scant five miles from the front. The journey is a litany of sadness: "…no region on earth," she wrote, " has suffered more from fire and sword." Along the way, Adams would experience the fire firsthand: While on the outskirts of Nancy, the wail of a siren prompted her to bolt for the safety of a cellar where she sat out a bombardment by German shells.

"We two were the only women on the train," Adams wrote at the start of herself and a companion. "The soldiers dropped off at every station. We passed the River Marne, tree-bordered, grasses swaying in its tide, and skirted the famous battlefield…. I had seen the graves among the new-mown hay—white crosses with the tri-color, black crosses with the letter *A* for *Allemands*. And nearby a sign for the farmer to heed: 'In agriculture, respect the graves of the dead.'"

The photographs she took reveal more sadness and tragedy: Towns turned to rubble, women lined up for rationed coal, two soldiers in the forest warming their hands over a fire, and in a field, graves covered with flowers.

Remembered in a *Washington Post* obituary as a "confidant of savage head hunters," Adams never stopped wandering to remote corners of the world. Before her death in Nice, France, in 1937, this explorer-photographer had retraced the trail of Columbus, crossed Haiti on horseback, and, according to the *New York Times,* "reached twenty frontiers previously unknown to white women… [including] every linguistic branch of the Indian tribes from Alaska to Tierra del Fuego in her study of the history of the aboriginal Americans."

In "A Longitudinal Journey through Chile," September 1922, Adams wrote of her sweep down the 2,627-mile length of that string bean of a country ending with a winter crossing of the Andes: "Winter had set in," she recorded. "Avalanches in the mountains had blocked the road. After

many fruitless trips to Los Andes, at the foot of the Cordillera, we at last joined a party of restless pilgrims determined to cross the Andes that very month aboard a valiant mule. We lived to tell the tale."

There is a sense of astonishment at the rediscovery of such indomitable women. In an era when cultural and social norms muted their voices and actions, how did these women manage to speak so forcefully and venture forth with such self-assurance? We can only guess and piece together a biography of sorts from correspondence, newspaper clippings, unpublished manuscripts—and the folders of aging black-and-white images in the archives.

Consider Ella Maillart, a Swiss adventurer, photographer, writer—and in her earlier years, Olympic sailor and actress—whose book *Forbidden Journey: From China to India* brought her to the attention of Gilbert H. Grosvenor in 1937. GHG, always on the lookout for exciting material, directed his editors to query Maillart about submitting an article-length version of her journey with illustrations. Maillart responded with a manuscript and 271 photographs. "The pictures are excellent and numerous…," a senior editor reported. She was paid in full, but despite the initial enthusiasm, her manuscript and photographs remained unpublished and filed away for reasons unknown.

Whatever the fate of her story and photographs, let the record show that here was a woman passionate about distant lands. "I am determined to go East," Maillart wrote. "The nomad's life enthralls me. Its restlessness pursues me; it is as much part of me as of the sailor. All ports and none are home to him, and all arrivings only a new setting forth." Geography was her passion. "I feel the latitudes, each with its own color," she once said.

The photographs in the folder are those of a woman eager to experience the world. On the backs of images of the woman gathering cotton in Tashkent, the Kirghiz hunter with a gaze as hard and fierce as the eagle perched on his leather glove, and the wooden boat on the Amu Darya, are scribbled notes like these:

(Uzbekistan) Takhta Kooupir: The more I go North, fiercer is the cold (-30).

Afghanistan, Pushtu-speaking tribesmen stole one of our Leicas, but gave it back after we told them we trusted them as our hosts.

China, Peiping: Lice farm, the only place in the world where a vaccine is made out of lice to meet any epidemic in case of typhus. Every day beggars make a living feeding hundreds of lice on their legs which will be used for the preparation of the vaccine.

And on the back of a photograph of a fragile-looking rope-and-vine construction that spans a ravine, this: *In India there are even bridges….*

There is, as well, in one of the folders, a photograph of Maillart taken during a journey to Afghanistan. She stands on a rocky hill near Kabul, backdropped by the ruins of a Buddhist stupa. She wears a pith helmet, sunglasses, and—as if there were a luncheon somewhere to get to afterward—a cardigan sweater draped casually over a white dress with black polka dots. There is an air of the resourceful about her, not to mention an indisputably granite resolve. "Nobody can go? Then I shall go," she was once quoted as saying. Hardship was irrelevant. Comfort could be dismissed. Here was a woman who could ride a camel across the desert, walk 14 hours without food, gnaw a bone while observing the proprieties of nomad etiquette, and dress for a climb among the ruins with equal aplomb. For her most famous journey, a seven-month trek from Beijing to Kashmir in 1937, she set off with two pounds of marmalade, a rifle, a bottle of Worcestershire sauce, and a Leica camera.

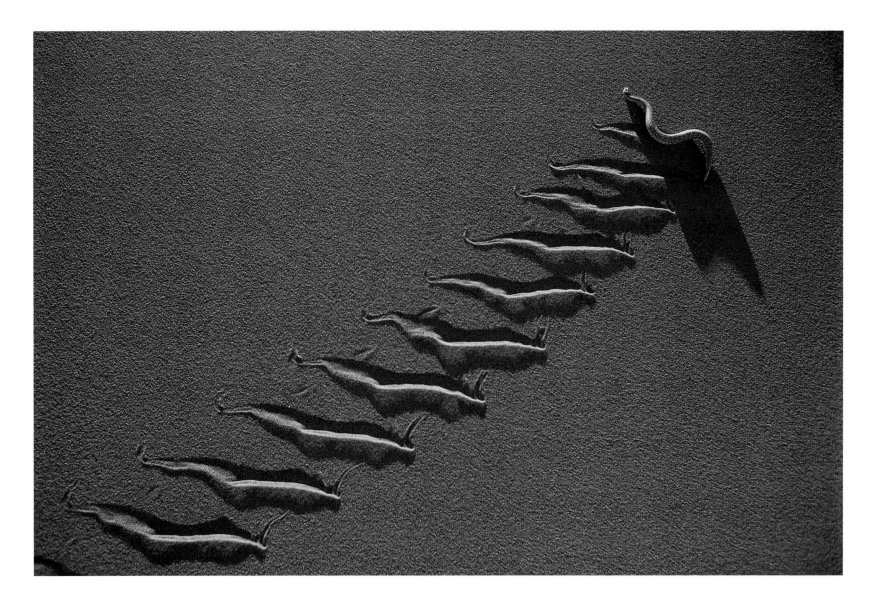

DAVID AND CAROL HUGHES • NAMIB DESERT 1983

A side-winding adder leaves its dinstinctive signature in the desert sand.

Only age could slow her pace. She made her last trip to Tibet at the age of 83 and died in her mountain chalet in Switzerland 11 years later at the age of 94. She had met life head-on, determined to observe "only one solitary rule—to go straight ahead."

In April 1937, a letter arrived at Society headquarters from a bright, spirited, 26-year-old named Dorothy Hosmer, who had, the summer before, quit her Wall Street job as a secretary, paid $89 for a third-class steamer ticket, and set off for a trip around the world.

"Gentlemen:" she wrote from Florence: "Tiring of secretarial work and commuting, I saved my pennies and left last June for an around-the-world trip by myself. To supplement my diary, I purchased a Rolleicord…, My as yet indefinite plan for this summer is to cycle through Poland and Romania along the Russian border…. Would the account of such a trip with illustrative photographs come under your requirement for subject matter?"

It did, in fact, and her "indefinite plan" was published under the breathless title: "An American Girl Cycles Across Romania: Two-wheel Pilgrim Pedals the Land of Castles and Gypsies,

Where Roman Empire Traces Mingle With Remnants of Oriental Migration." Three articles followed.

Her first story—the Romania trip—was published in November 1938, but not before John Oliver La Gorce, an associate editor and vice president of the Society expressed his misgivings to Gilbert Hovey Grosvenor, Editor of the magazine, in a memo.

"I should imagine," wrote La Gorce, a man not known for tolerance, "that a rather heavy percentage of our readers who are mothers with daughters would be terribly apprehensive and object to the last ditch to their daughters making such trips alone even while in their own hearts having the urge to be a 'free soul'.... Another percentage wouldn't want their daughters to read this story fearing that it might give them the idea that it was all right to travel the world on one's own if such an account appeared in the GEOGRAPHIC."

Grosvenor ignored the warnings, and the story ran, followed by another, seven months later. Both featured Hosmer's own photographs, including one of herself crossing the border of Poland and Romania. In the photograph, perhaps posed for readers who might well wonder what this intrepid young lady looked like, she stands by her bicycle, wearing a short-sleeve checked blouse and an ankle-length divided skirt, while a customs officer examines her passport and the contents of her rucksack.

Although Franklin Fisher, then chief of illustrations, suggested Hosmer be paid $500 each for two articles and accompanying photographs, La Gorce undercut his recommendation, saying: "I certainly wouldn't offer more than $300."

The $500 proposed by Fisher, more often noted for stinginess than largesse, was an uncharacteristically generous gesture. It was Fisher who authorized payment of five dollars a print to the renowned *Life* magazine photographer Margaret Bourke-White for several images now filed away in the Geographic archives. Recalls Kurt Wentzel, a staff photographer from 1937 to 1985, "GHG often took Fisher to task for being chintzy. Toppy Edwards (another editor in the illustrations department) used to relate how Fisher would go to New York to buy photographs from a noted photographer, then offer five or ten dollars in payment." The negotiation, says Wentzel, would end with the photographer saying in exasperation, "I'll just give them to you."

Hosmer spent four years, one month, and ten days, traveling the world, returning home only on news of her father's death. Today, at 89, Dorothy Hosmer Lee lives in Redlands, California, and can still recall the sense of wonder she felt as a child sprawled on the carpet as she read *The Book of Knowledge* and leafed through illustrations showing the grand spectacle of people and places around the world. It was a prelude to the things she would see for herself.

In 1953, NATIONAL GEOGRAPHIC hired its first woman staff photographer. The pioneer appointee was a quiet, self-effacing young woman who taught herself how to shoot pictures, loved the outdoors, and went camping every weekend while living in Denver where she worked as a medical technician. Her name was Kathleen Revis, and she happened to be the sister-in-law of the Editor of the magazine, Melville Bell Grosvenor.

"Melville Grosvenor wanted to bring women to NATIONAL GEOGRAPHIC," says Mary Smith, who picture-edited most of Revis's stories. "He wasn't a bit afraid of smart women; he liked and respected them and as far as he was concerned, the smarter the better.

"He was particularly gender unbiased, especially for a man of his generation. But then

don't forget that he was the youngest of five or six siblings, the rest of whom were female, and one of whom was a medical doctor."

Let others mutter about family favoritism. MBG, who, an editor once said, ran the magazine like it was a Lionel train set, breezily brushed any comment aside. If office conversation focused on the fact that he'd hired his sister-in-law to take photographs, well, so what? The point was that Kathleen Revis could take pictures, and he proceeded to encourage her to do just that with an enthusiasm as wide as the Potomac.

"It seems the boys thought it was some joke or I was nepotizing," he wrote Revis. "My only comment was, 'Well, boys, when you see a natural photographer, encourage him or her all you can!' Kathleen, you are a natural photographer. You not only have a feel for a picture but you love it, study it, and live with it. You could go places with that camera of yours. Keep on taking pictures. Try to tell a story in them."

She couldn't have had a better mentor. "Melville was always encouraging me," Revis recalls. "He would say, 'Take the pictures that appeal to you and tell you something, because the viewer will respond.' He said that professional photographers get too self-absorbed with doing something different for the sake of doing different. He understood the value of corny and that sometimes you can be too precious."

Her first payment from the magazine was $50 for two black-and-white photographs of the Colorado state capitol and the Denver city hall for "Colorado's Friendly Topland," published in 1951. She would go on to publish 12 stories in the magazine, mostly as a photographer, including "Soaring on Skis in the Swiss Alps," "Many-splendored Glacierland," and "Landmarks of Literary England."

If MBG was understandably protective—he once discouraged the photo editor from giving her an assignment on the Mississippi because it would mean she had to hitchhike up and down the river by herself—others sometimes veered over into what might be seen as patronizing.

"If you find the going too tough, why not run over to Paris for a week and get some new clothes…. I understand that is good for a woman's morale," Edwin Wisherd, chief of the photographic laboratory, suggested while she was in England on a story.

"Kathleen had good taste and she was earnest," recalls Mary Smith. "She was very careful with her assignments, she fit in, and she worked hard. She was a perfect pioneer woman photographer for the GEOGRAPHIC."

In 1960 Revis was assigned to photograph a story on New Hampshire's White Mountains with Chief Justice William O. Douglas as writer. While there, she met the man who would become her husband, Stanley Judge, manager of the Wildcat Ski Area.

"I had gone to Wildcat and was at the top building and wanted to go out on the platform to take pictures," Revis recalls. "But I was told I couldn't go there, and word went down to the front office that someone was telling the NATIONAL GEOGRAPHIC photographer that she couldn't take pictures. Stanley came up to see about that, and we met. I resigned the following May when I got engaged, and got married in June."

At 77 she still hikes the mountains of her New Hampshire home, and hasn't given up her love for riding horseback. "She had a tough streak back then," remembers Smith. She still does.

Photography is, for the most part, a solitary enterprise, but not always. Beginning in the

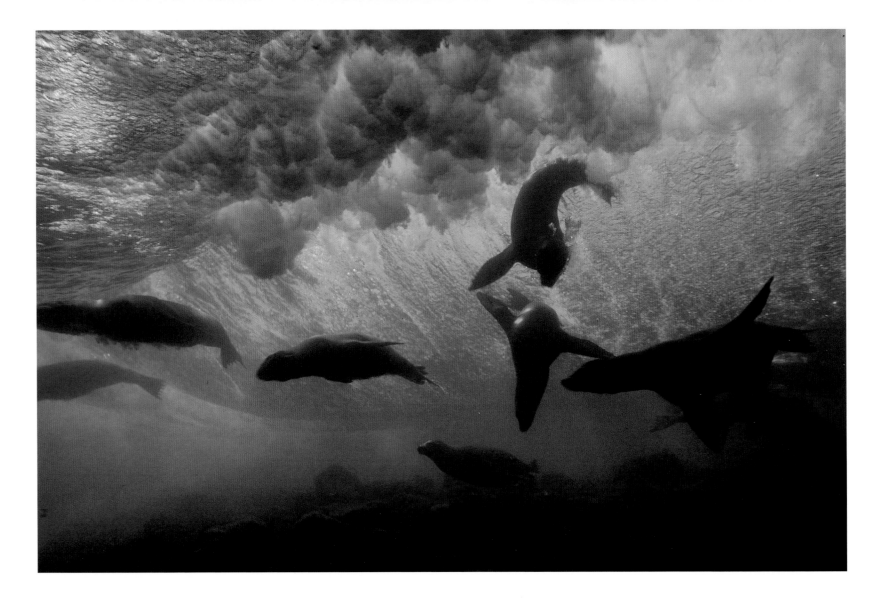

DIETER AND MARY PLAGE • GALÁPAGOS 1988

Sea lions play in the surf with the effortless grace of dancers.

1960s and into the next two decades, a group of women came to the GEOGRAPHIC as part of husband-and-wife teams. There is, in particular, a tradition of couples who specialize in wildlife photography, and among those who have worked for NATIONAL GEOGRAPHIC are Des and Jen Bartlett, Derek and Beverly Joubert, Dieter and Mary Plage, Alan and Joan Root, and Carol and David Hughes.

Because professional photographers back then were, more often than not, men, it was usually the husband who drew the spouse into the photographic life. "We were running a game lodge in South Africa," says Beverly Joubert, who has produced stories on elephants and lions with her husband Derek. "I was the executive caterer and housekeeper and Derek would take guests into the bush. I bought Derek a camera, and he, in turn, introduced me to the passion of wildlife photography. We went to Botswana, fell in love with it, and left everything behind."

Why does wildlife photography attract couples?

"Honestly, I don't think that a woman with children could do that kind of work alone," says Kathy Moran, an illustrations editor who specializes in natural history subjects. "It is one avenue of photography that is more closed for women. If you are in the bush, surrounded by the dangers and

beauties of nature, you cannot focus on the work and the kids. Natural history photography is not 9-to-5. You can't schedule appointments. The behavior of the beast determines every single thing the photographer does. You've got to stay in the field a long, long time and you've got to go a little wild yourself. Couples like the Bartletts who did this kind of work might spend up to two or three years in the field." Perhaps one of the best ways to ensure the continuity of a marriage, let alone family stability, if you do such photography, is to enlist your partner in the work.

What starts out as the joy of a common interest evolves into a shared passion and, ultimately, a shared life. "Our marriage, work, and lifestyle have long melded into a single entity," says Carol Hughes, who collaborated with her husband, David, to photograph stories on the Namib Desert and the Costa Rican rain forest for the magazine. "I can hardly imagine one without the others." Couples who do such work in tandem speak of the advantages of collaboration—often one spouse will do still photography and the other will do cinematography—and the joy of the shared experience.

But to share a passion does not exempt a couple from contention. "All is not sweetness and light," admits Carol Hughes. "Working in close proximity, in highly charged situations, there are inevitably tense moments. The decibel level can get quite high. Once David and I got into a shouting match so loud that the pride of lions we were shooting stopped their own fierce dispute over a kill to gaze up in interest at the noisy row coming from our Land Rover. But, like the lions, snarls said in the heat of the moment are best forgotten. Unlike the lions, David and I never come to blows."

Other women came to shoot photographs for NATIONAL GEOGRAPHIC in a wife-of capacity. There was Jean Shor, wife of associate editor Franc Shor, who collaborated on stories on Iraq, Argentina, Cyprus, and Afghanistan, among others; and Lynn Abercrombie, wife of staff photographer Thomas Abercrombie, who went on to establish her talent independently in such stories as "Oman," published in September 1981, and "The Frankincense Trail," published in October 1985.

For six years in the 1960s, Helen and Frank Schreider worked as a writer-photographer team on the foreign staff of the magazine. "They did monumental stuff," recalls Mary Smith. "'In the Footsteps of Alexander the Great' and 'East From Bali by Seagoing Jeep to Timor' for example." They specialized in the epic stories that helped make the GEOGRAPHIC's reputation.

The Schreiders were the kind of couple who would spend ten months trekking across Africa by Land Rover or float down India's Ganges River in an amphibious Jeep. Among their stories was "Journey into the Great Rift, part one," published in August 1965. "The magazine never did part two," points out Smith. "Things were happening in Eritrea and other events intervened and they couldn't go; I remember a big meeting in which I said, 'Let's just not worry about part two. No one will ever write and ask where it is.' No one ever did."

Crossing Indonesia's Lombok Straits during a typhoon in an amphibious Jeep or the Sudan Desert in a Land Rover didn't faze the Schreiders. The matter of credit lines did. "They'd get into a picture session and have a fight in the projection room over who took the picture," recalls Bob Gilka, a retired director of photography.

For precisely that reason, Yva Momatiuk and her husband, John Eastcott, who photographed six magazine stories and five books for the Society in the 1970s and '80s, insist on a double byline. "John and I have been taking joint credit for 24 years," Momatiuk says. "We are both photographers and it was very apparent to us that the idea of 'I will follow around and hold your

socks,' wasn't going to work for either of us, since neither of us likes to play second violin to anybody.

"There are times when I do the majority of photography," Momatiuk explains, "and sometimes it's John. We've never had a single squabble about it. Once in Poland, John saw a farmer sowing his field. The man had big muddy boots on and a big canvas sack slung over his shoulder. John spotted the picture, called me over, and said—'here's the picture, but we have to lose the horizon.' It needed to be taken from an elevated perspective. The problem was that the terrain was absolutely flat—not a tree around. So I got on John's shoulders and took the photograph. He saw it, arranged it, and I pressed the shutter. So who took the picture? We've been doing it this way for 24 years."

From Eliza Scidmore to Carol Beckwith and beyond is not so broad a span of time, after all. What connects these women photographers then and now is the open embrace of experience. The passion to travel to far places to capture the light is a calling. Some are born to it and some discover it in the course of time.

"I was an outsider as a child," says Beckwith. "I was sick for three years and didn't adjust. Because I had been in bed for three years, I was terrified of anyone my age; I imagined that they were worldly and I was not. My teachers would tell my dad, 'When the bell rings and everyone goes to the playground, instead of going to play with anyone, Carol stands and gazes out beyond the playground. We don't know where she is.'"

Beckwith pauses as if retrieving the scene. There is no trace of the sickly child now. She is a robust woman with dark eyes and a mass of hair that flies off in thick curls as if it had a life of its own. "I was always gazing at the horizon, wondering what was there," Beckwith says. "I was fascinated by that line of horizon—the most distant point that I could see from the playground."

Years later she would travel to that distant point and beyond to record the vanishing cultures of Africa. Her most recent story for the NATIONAL GEOGRAPHIC, along with her collaborator Angela Fisher, was on African marriage rituals in November 1999.

"In 1974 I got an invitation from a friend in Kenya who was teaching," Beckwith continues. "I bought a 45-day ticket, and stayed eight months. That was the beginning. That was when I really knew where I wanted to be. I saw people making art to ensure survival, not to display in museums or galleries. It was the art of everyday living. It was a much more powerful way of creating. I watched how strongly people believed in their art, whether it was making a mask to evoke an ancestor, or placing a clay pot on a roof to make sure no drought or famine came to their fields. I realized art was about survival. I wanted to document this. I wanted to tell a story through photography—a story of people and their survival."

For women like Beckwith and other explorer-photographers before her—Eliza Scidmore, Harriet Chalmers Adams, Ella Maillart—the camera becomes a passport. For those with an adventurous heart, the farther one travels, the better.

"I like difficult places. I like untrod territory—places other people haven't done," says Sarah Leen. "I need to be out of my element so my vision isn't contaminated by what others have done. Those places are difficult in creature comforts, but there's a freshness to them."

Leen's first assignment as a young intern for NATIONAL GEOGRAPHIC was in Uganda, on the heels of Idi Amin's dictatorship in 1979. The country had been turned upside-down; all was chaos.

Leen arrived at night to the sound of gunfire. It was the beginning of a lifetime of adventure and fulfilling, creative work.

"I love living in wild places," explains Carol Hughes, the wildlife photographer. "Living close to nature keeps me close to the big mysteries of existence. It's important for me to be aware that I'm an animal, too, subject to the same rules. Here today; gone the same day."

Such a life does more than excite; it enriches. To see a pack of lions hunt down a gazelle; to climb the Andean peak of Llullaillaco; to attend a Berber bridal fair—all teach us to revel in being astonished. To have a door opened by a stranger in Mali and be welcomed into the home is a privilege of the highest order. We learn about graciousness. We learn to suspend judgment. Most of all, we learn to be humble. "The shortest road to oneself goes around the world," said the French poet Henri Michaux. The more we live and see, the more generous our embrace of the world becomes. The soul expands into the space provided.

"The more I travel, the bigger I think the world is," agrees Maria Stenzel. A tall, athletic woman, she happily goes off to difficult, remote places to work—Antarctica, the Bolivian *Altiplano,* the Madagascar rain forest. There she captures the long blue horizon of icy sea, the dry brown stretch of dusty plain, the hot green tangle of Borneo rain forest. "People say, 'The world is homogenous; the world is small.' Not where I am going. It's still big; it's still timeless. To hike out in Antarctica and have a scientist say to you, 'It hasn't rained in this valley in 17 million years.' That's timelessness."

Seven months after starting from Sinkiang in northern China, Ella Maillart reached Srinagar, Kashmir. She had seen marvelous things in the course of that 3,500-mile journey in 1937, and she had a marvelous story to tell in words and images. "I had a keen interest to see that part of the world without delay, before it would be altered by the spreading influence of Europe," Maillart wrote.

And so she did. "I had seen Mongol princes, great-grandsons of Genghis Khan, the flower of the Khalkha tribes…. Japanese women wrapped in their high-waisted satin belts, wearing wooden sandals in the snow…. Motor-buses plying between the villages of Jehol. In the cold morning, the motor of my lorry had to be heated from underneath by charcoal braziers half an hour before starting. Everywhere, day or night, I was able to rest for a while in cheap opium pubs; there lying down on a wooden platform I could drink tea…."

The photographs in the archives of National Geographic bear witness to her journey. The work is easily passed over, unpolished and unpublished as it is. Still, even a fragment of hidden history has something to say. Maillart plunged into a life of adventure and recorded it on film so that others might share. To show this world to others is exhilarating work. It is, as well, an exhilarating life.

"There in the distance is Samarkand awaiting me," Maillart wrote. "The fabled ruins of Tamerlane crumble day by day, and I must hasten…. My desire is to cross the desert to the slow gait of camels, and, in this age of aeroplanes, enter into the thoughts and feelings of the padding caravans."

The women who capture these images—a padding caravan, the long horizon of the Antarctic sea, a lion about to pounce on its prey—are explorers as much as photographers. It is a distinctive sorority. In the images made by Ella Maillart, Eliza Scidmore, Harriet Chalmers Adams, and others, you can feel a sense of wonder at the astonishing breadth of the world—the same sense of wonder that infuses the life and work of women photographers at NATIONAL GEOGRAPHIC to this day. ■

BEVERLY JOUBERT • BOTSWANA 1994

Under the cover of an African night, a lioness sinks her teeth into a terrified young elephant.

FOLLOWING PAGES

JOANNA PINNEO • SPAIN 1995

A daredevil sprint, the "running of the bulls," takes place during the weeklong Festival of San Fermín in the Basque town of Pamplona.

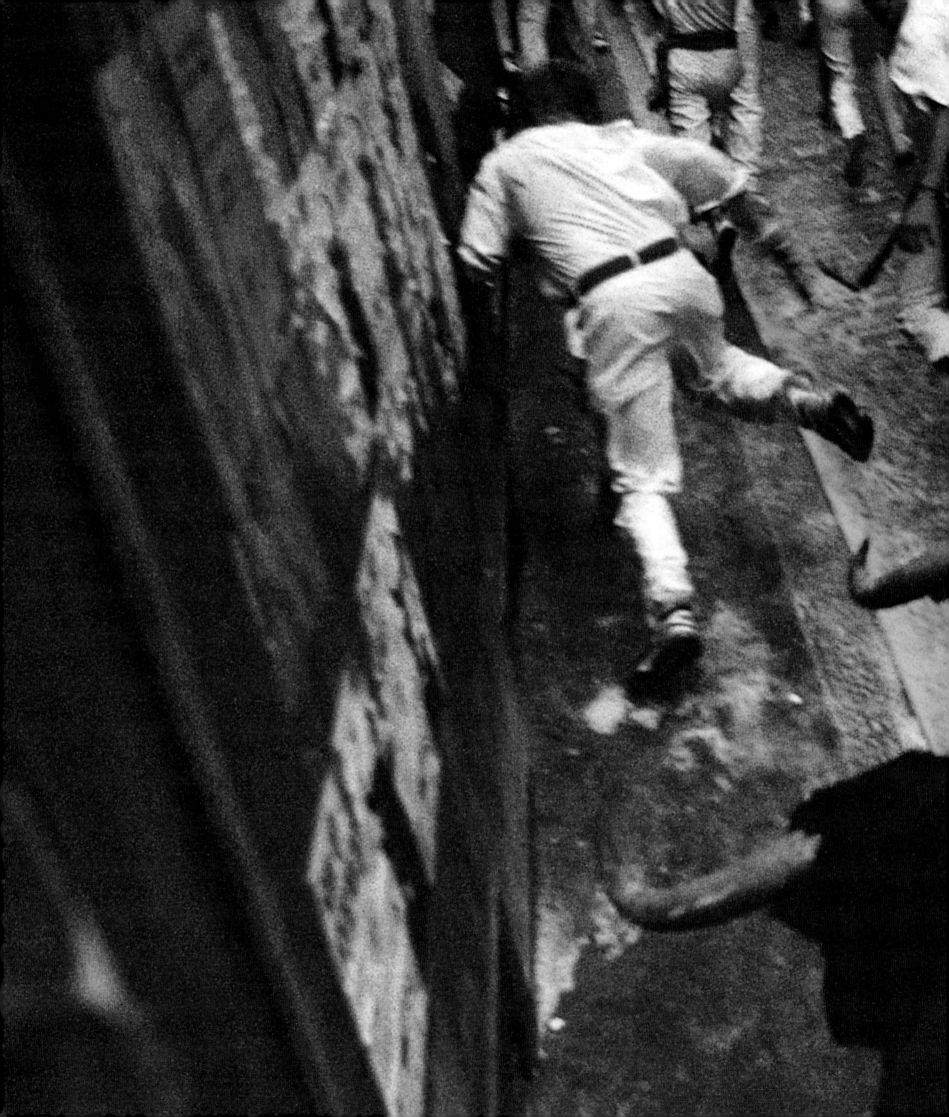

MARIA STENZEL ◆ ADIRONDACKS 1998

Kevin Burns, an Adirondack guide,
leans into the 50-mile-an-hour winds
on the summit of Algonquin, the second
highest peak in the chain.

FOLLOWING PAGES

LAURA GILPIN ◆ COLORADO 1932
Gilpin, a noted photographer of the
Southwest landscape, captured the
tracks of a lone walker in the desert
of Great Sand Dunes monument.

JINX RODGER ◆ ALGERIA 1958
George Rodger is credited as author
of the story with this photograph; but
this image of him groping through a
sandstorm is clearly the work of Jinx.

ALICE SCHALEK • INDIA 1928

Schalek, an Austrian correspondent, traveled widely through Asia, Africa, South America, and the Pacific. She submitted hundreds of photographs to the magazine, including this one of the main street in Udaipur, India.

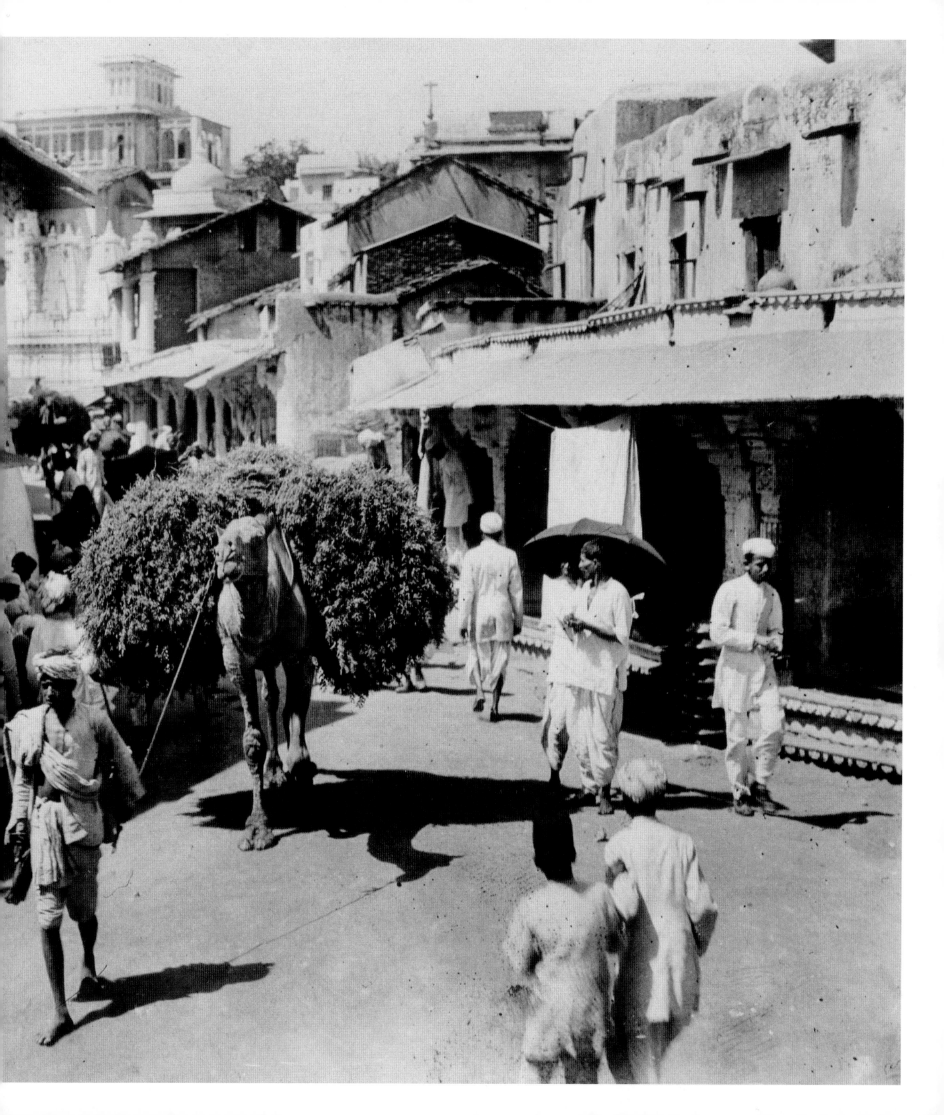

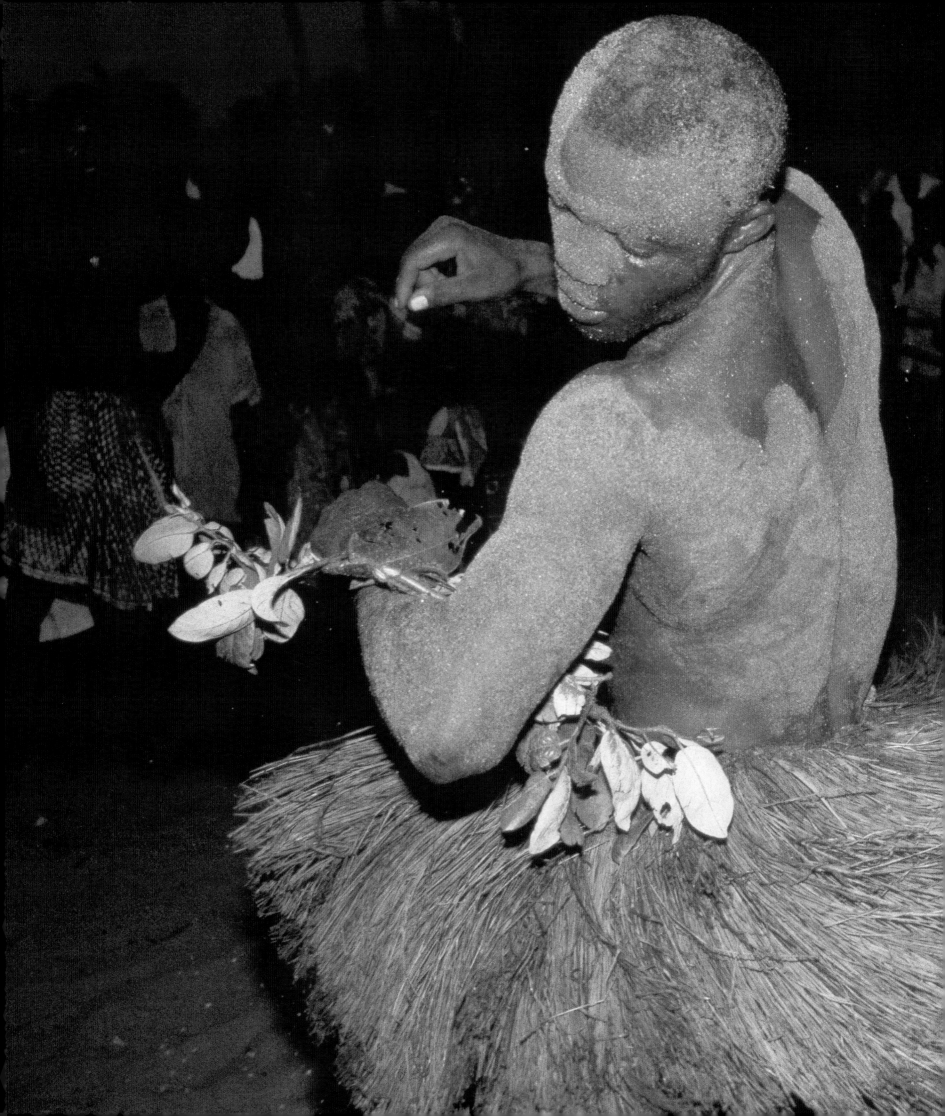

MELISSA FARLOW •
OKEFENOKEE SWAMP 1992

An alligator lies motionless in swamp
water stained the color of tea by
dying vegetation.

PREVIOUS PAGES

CAROL BECKWITH AND ANGELA FISHER •
GHANA 1995

A dancer caked in sweat-soaked sand
spins into a trance at a celebration for
the deity Flimani Koku near a village
on the coast of Ghana.

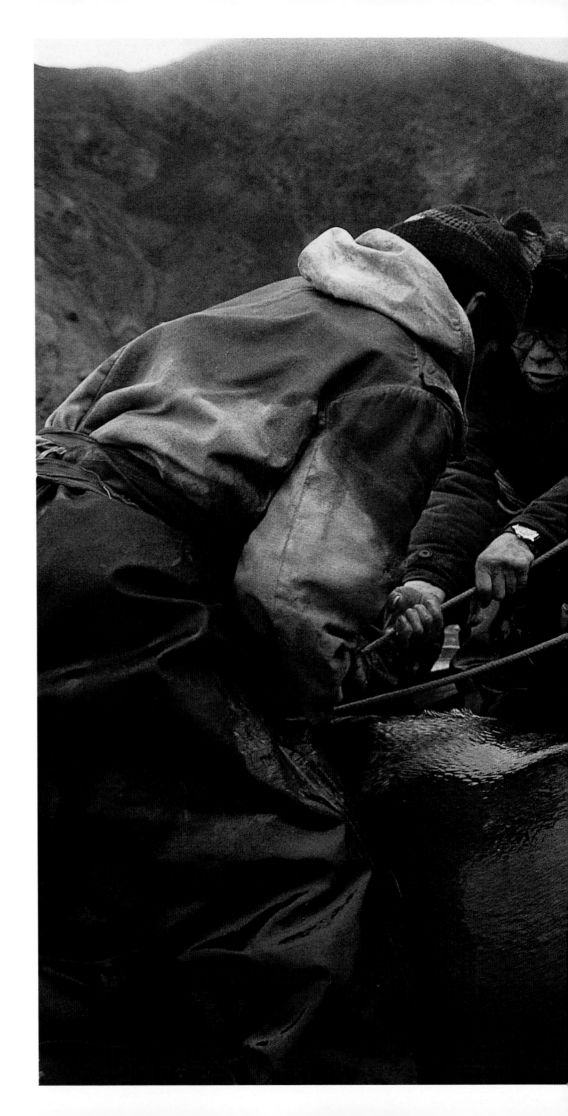

SARAH LEEN • KAMCHATKA 1994

Hunters haul in 600 pounds of bearded
seal off Rekinniki, a village on Kamchatka,
Russia's eastern peninsular outpost.

FOLLOWING PAGES

DICKEY CHAPELLE • SOUTH VIETNAM 1966

"Night fighting is sudden, vicious, deadly,"
wrote Chapelle, who shot this firestorm
set by South Vietnamese to flush Viet
Cong into the open. In 1965 the war took
her life; this image was published later.

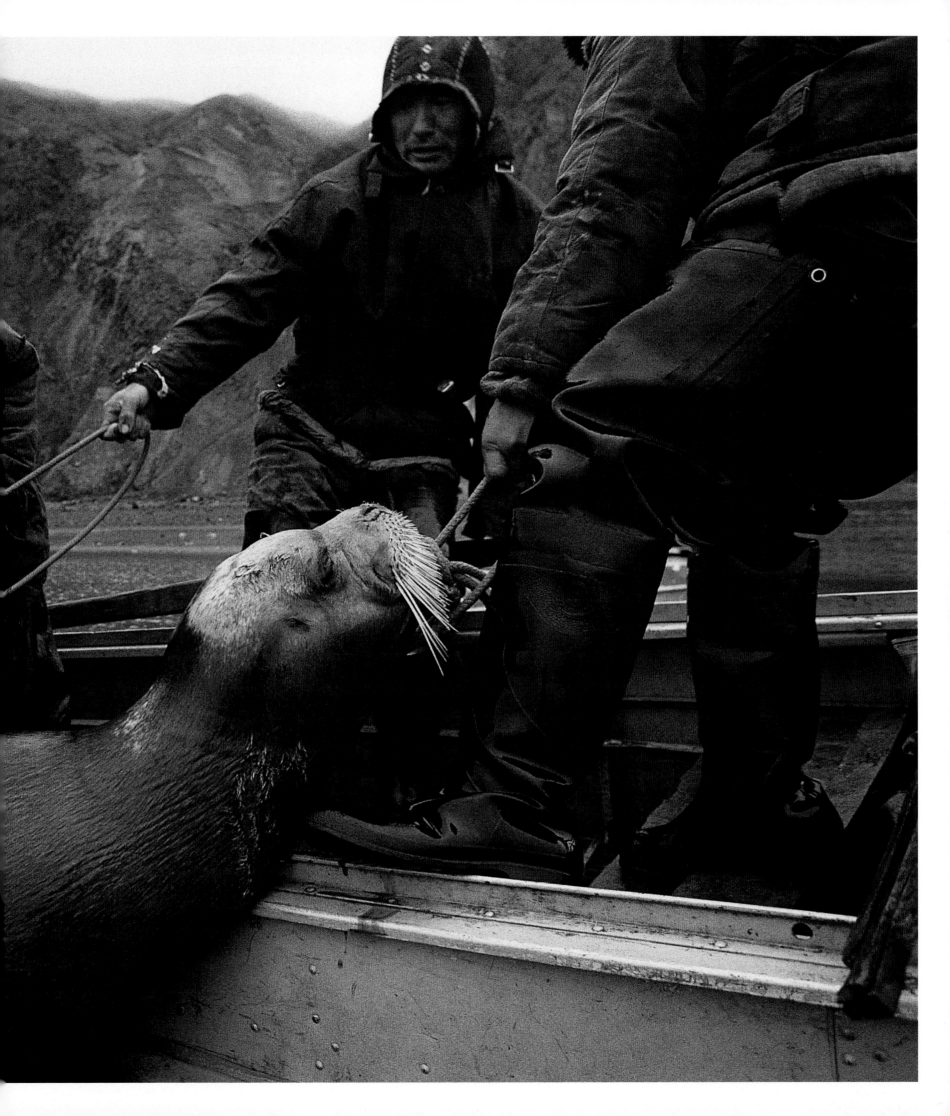

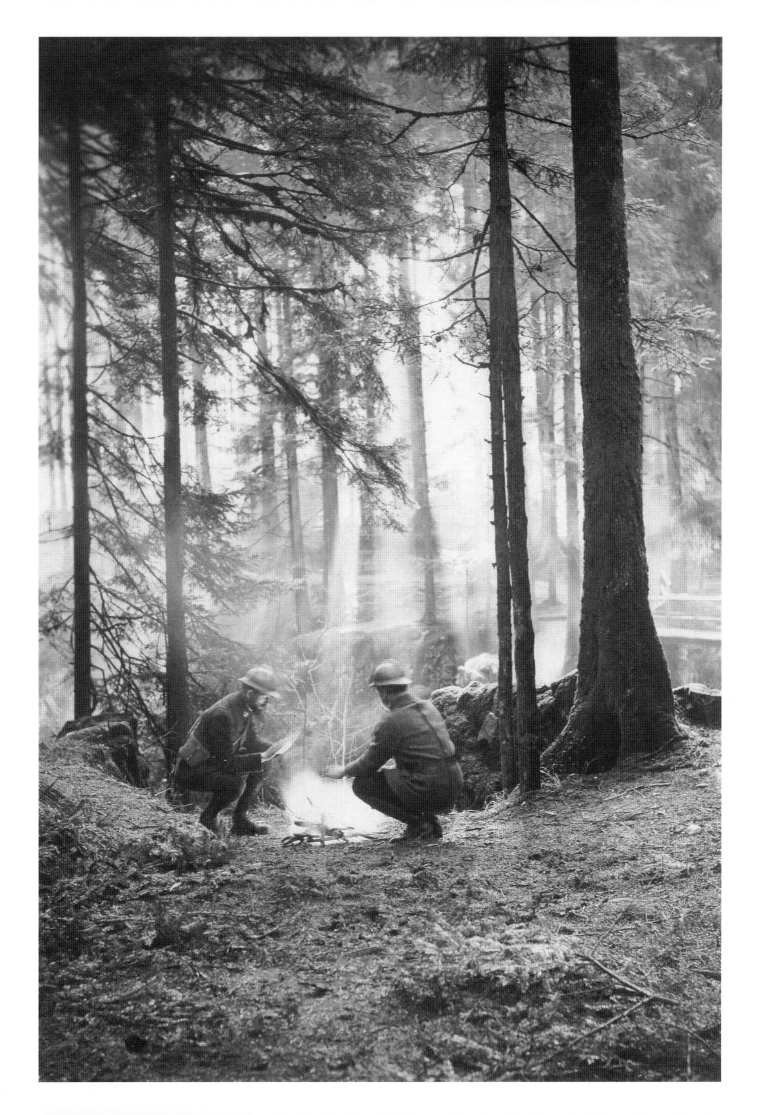

FRANC AND JEAN SHOR • PAKISTAN 1952

Passengers jam the third class car of the *Karachi Mail*, filling every cubic inch of space in the compartment.

PREVIOUS PAGES

DICKEY CHAPELLE • SOUTH VIETNAM 1962

Children in a village near Binh Hung hold their ears against the roar of mortar fire.

HARRIET CHALMERS ADAMS • FRANCE 1917

Chalmers Adams, one of a few women correspondents in WWI, photographed soldiers warming themselves at a fire behind the lines in French Lorraine. "Here there was pain," she wrote.

LYNN JOHNSON • CHICAGO 1989

Maintaining a delicate balance, Charlie
Lomas fixes an antenna cable atop the
1,127-foot-high John Hancock building.

JODI COBB • NEW YORK 1990

Night softens the hard edges of Times
Square, turning it into a dream of light
and smoke.

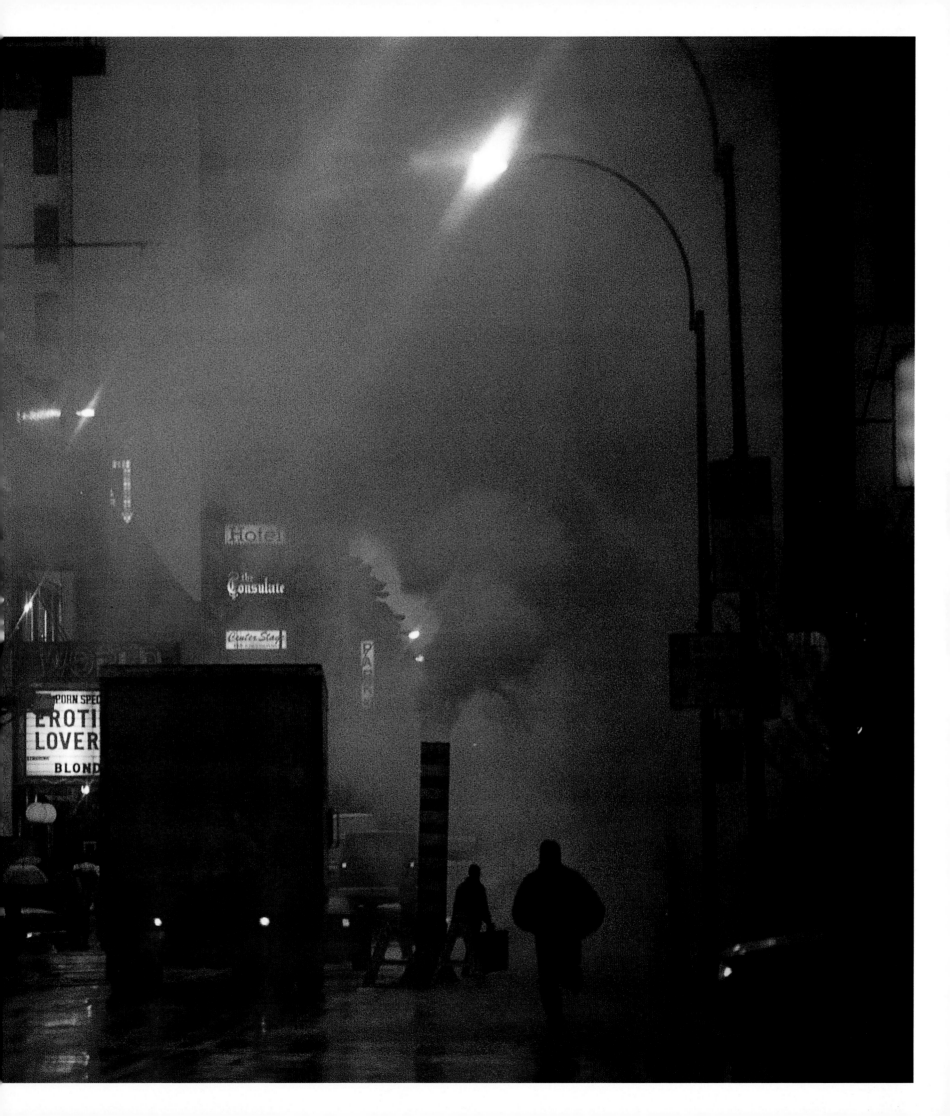

Maria Stenzel

ADVENTURE

"I LIKE THE IDEA of distance," Maria Stenzel says. "I like being alone on an icebreaker in a sea of ice the size of Europe or in the Adirondacks or driving across the Arctic tundra on a sled pulled by reindeer." As a photographer specializing in adventure, she has been there and done it all. Stenzel went to work for NATIONAL GEOGRAPHIC in 1980 after graduating from the University of Virginia. Her first job was in Film Review, sticking labels on film cans. By 1989, she was head of the department. "I had worked for the college newspaper, but didn't want to be a photographer," she says. "Coming here changed my mind; I realized there was a wide world out there." With the guidance of staff photographers Sam Abell and Jim Amos, she started shooting for local publications. Her break came in 1990, ironically, with downsizing and the loss of her job. Stenzel, who didn't enjoy managing people anyway, met the news philosophically. Sensing her talent, Susan Smith, assistant director of photography, gave her small, inhouse jobs, such as retirement parties. In 1991 she got her first assignment: "The Catskills." She never looked back. "Migratory Beekeepers" followed, then physically tough stories like "David Thompson," the "Dry Valleys of Antarctica," and "Sea Ice," shown here. Although colleagues teased her about the assignment, which entailed 50 days on an Antarctic icebreaker ("You'll have time to write Christmas cards," said one); she found it exhilarating. Where others see hardship and discomfort, Stenzel sees tranquil beauty. "I've always preferred a tent to a hotel room," she says. "I find solace in landscape."

ANTARCTICA 1996 Stopped by sea ice 1,300 miles from the South Pole, the *Nathaniel B. Palmer* grinds to a halt. From here scientists embarked on their studies.

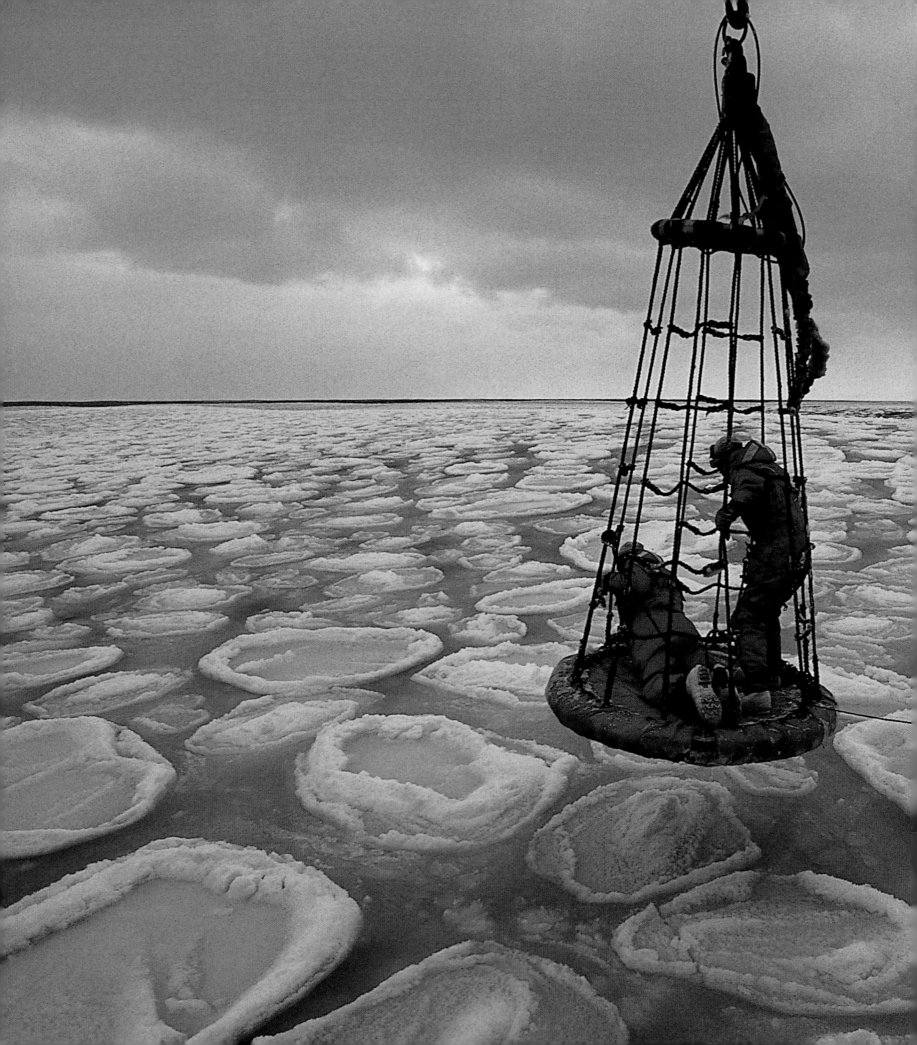

ANTARCTICA 1996

Scientists fish for secrets locked inside
the winter sea, here frozen into pancake
ice—the early stage of solidification.

FOLLOWING PAGES

ANTARCTICA 1996

Struck by the beauty of a solitary iceberg
held fast by sea ice, Stenzel convinced the
ship's lead scientist to stop so she could
get the shot. "He gave me three minutes,"
she says, "then the ship moved on."

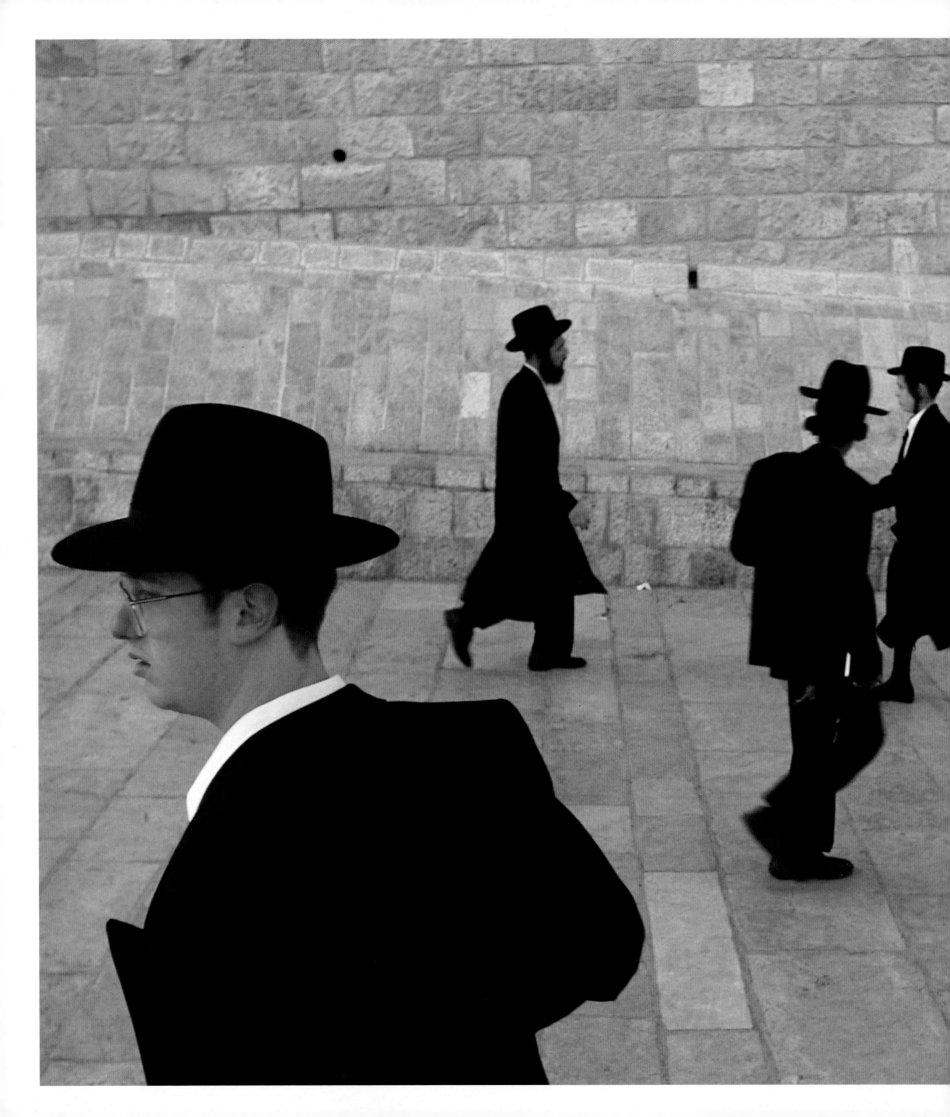

WOMEN'S WORK

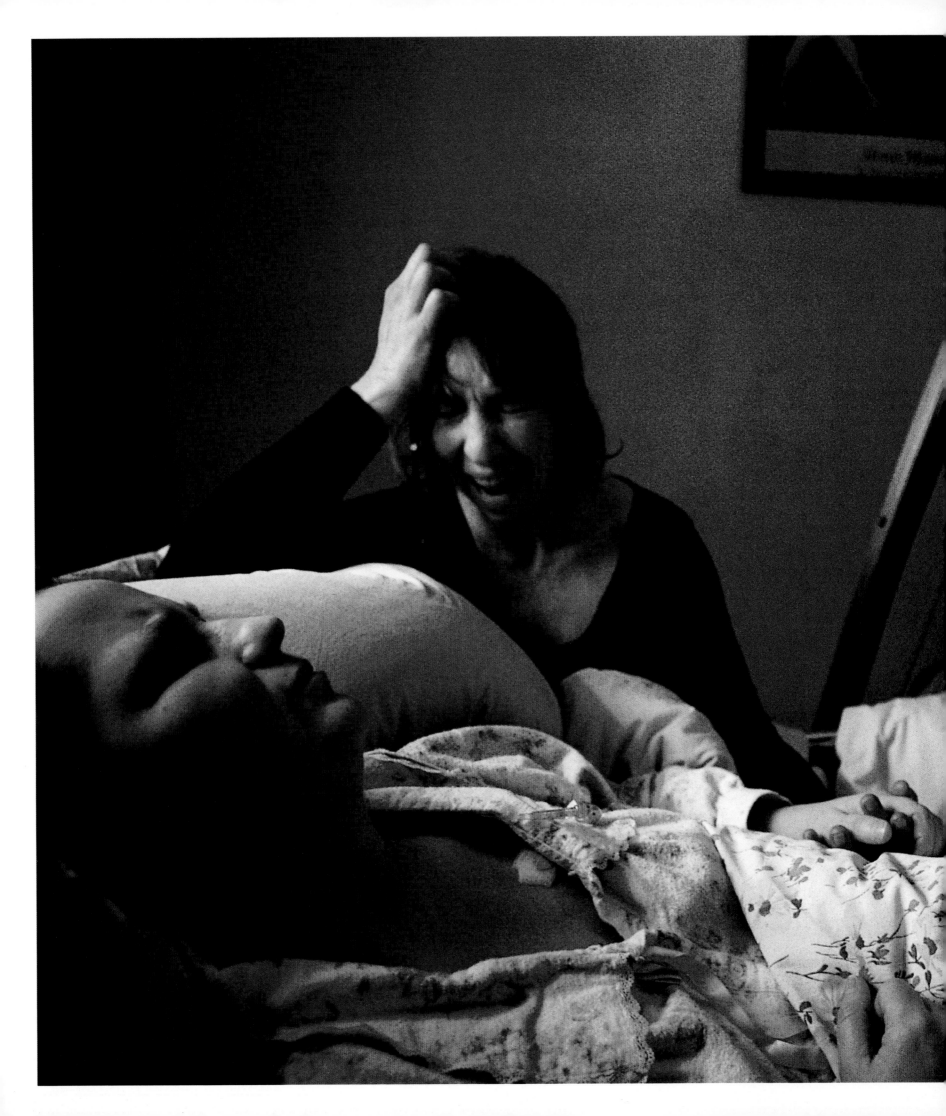

LYNN JOHNSON ◆ MONTANA 1993

A woman sobs in anguish for her
dying friend, stricken by a brain tumor.
A harpist from a group of women in
Missoula dedicated to easing the passage
into death, plays in the background.

PREVIOUS PAGES

ANNIE GRIFFITHS BELT ◆ JERUSALEM 1996

Orthodox Jews pass by the revered
Western Wall, one of many holy shrines
in a city where the faithful of three
religions live, worship, and often clash.

131

DOROTHY HOSMER LEE • ROMANIA 1938

In 1936, Hosmer, a young secretary, quit
her job to cycle in Eastern Europe. These
begging gypsies appeared outside her lodging.

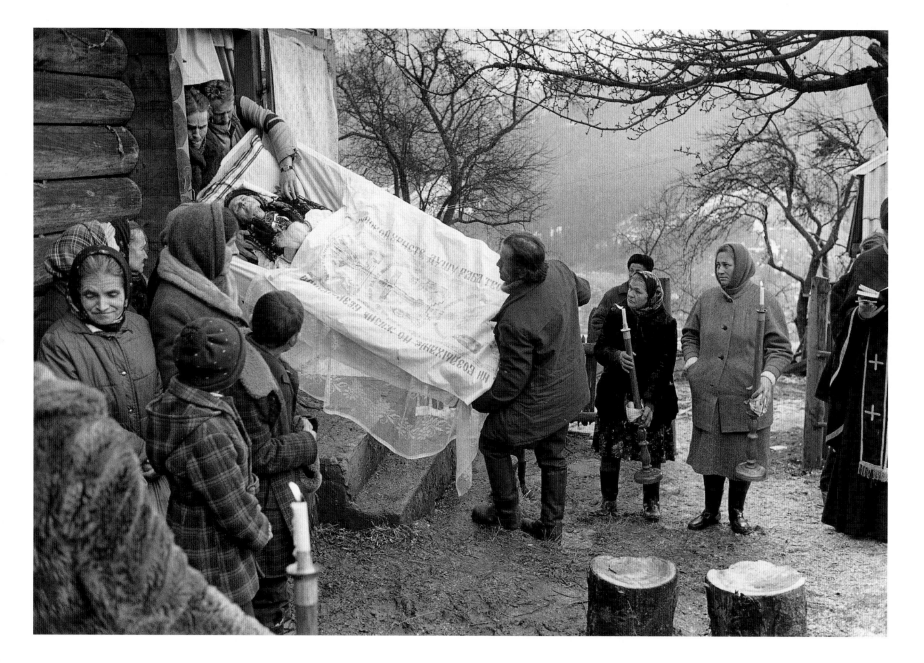

LIDA SUCHÝ• UKRAINE 1997

Hutsul mourners ease a woman's coffin
out her door. Bread loaves tied to candle-
sticks with handkerchiefs honor her soul.

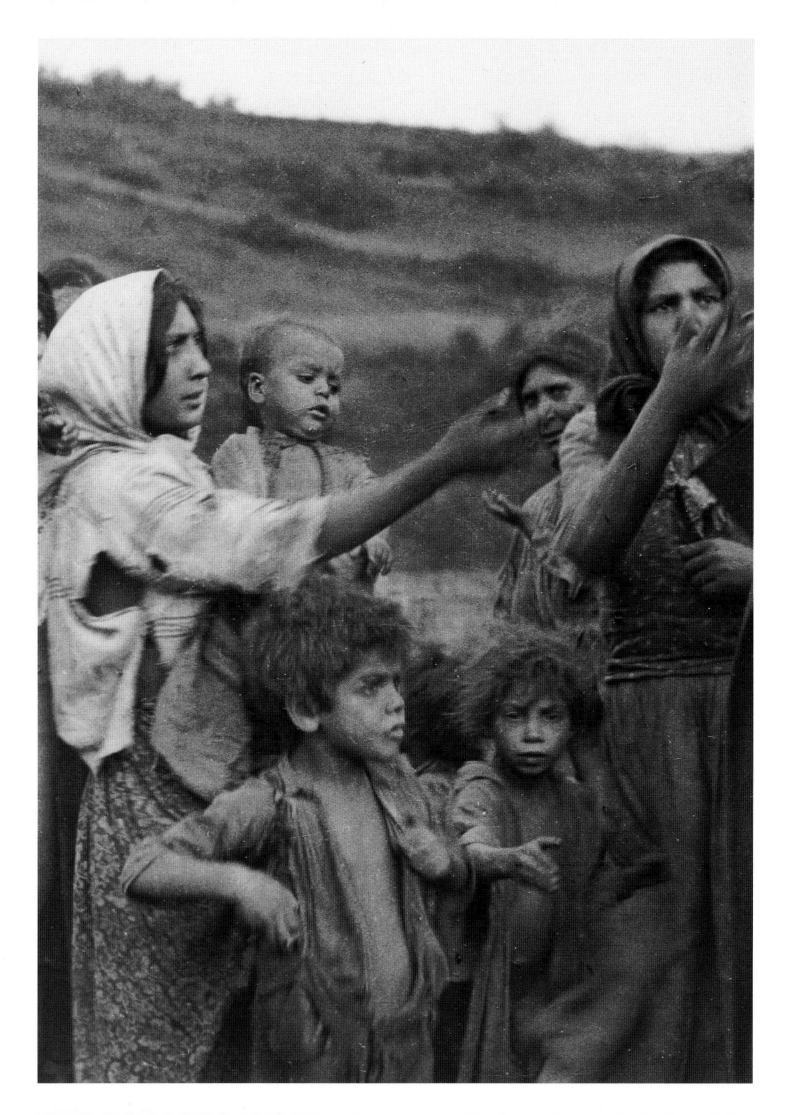

THE FIRST RULE OF PHOTOGRAPHY is to get close to the subject. How simple that sounds. How complex it can be. You enter as a stranger, unknown and unknowing. What follows is subject to the whims of the Gods of Photography.

"It's sink or swim," explains Jodi Cobb. "'Here's a ticket,' the editor will say. 'Go find your story.'"

So you do, not knowing even if there is a story. You read everything you can. You grope around, trying to figure out what the assignment is supposed to be about. You collect names and phone numbers. You make hundreds of calls. You begin to make contact—with the story and the people who will ultimately become the story. Everything is set, you go, and the Gods have their biggest laugh of all. For Cobb, the nightmare moment came when she went to Saudi Arabia to do a story on Saudi women. "I got there," she recalls, "and found out that not only does every single Saudi think that it's illegal to photograph women, they think it's illegal to photograph anything." She got the story anyway.

There is another thing, rarely thought about beforehand, often thought about afterward. Whatever unfolds between the photographer and the subjects of the coverage who bring the story to life, this much is true: Sooner or later the photographer will leave. In the best of all possible worlds, what is taken and what is left behind does no harm and leaves both sides richer for the experience. A photograph is a record of a relationship. "Only connect," wrote the English novelist E.M. Forster.

"It's a little like falling in love," says Sarah Leen. "You fall in love with a person, then you fall in love with a place. You know about that heartbreak at the end. You're going to leave. There is an end."

Before that end there is work to be done. Some things are not to be rushed. Making contact—whether with a bluegrass fiddler in Elk Creek, Virginia, an Ariaal teenage bride in Kenya, or a Chipaya family in the Bolivian highlands—is one. "You sit down and start talking and maybe you end up not taking pictures at all," says Maggie Steber. "Maybe they're not ready. Maybe you're not ready. So you talk some more."

You sit and talk and after a while everyone relaxes. Stiffness melts into ease. Conversation loosens and then flows. There may even be laughter. The time comes to pull out the camera.

Djénné, in Mali, a city of mud-wall houses, is a tourist attraction. "But I'm not a tourist," says Sarah Leen. "I'm a journalist trying to present myself in a different light." Her assignment to photograph Djénné was not going well. "I couldn't break through," she recalls her initial frustration.

One afternoon Leen was on top of a roof shooting pictures of the distinctive architecture, when she noticed a woman on an opposite roof smoking fish. The woman shook her finger in mock reproach at Leen; Leen responded in kind. The woman held out her hand in a mock demand for payment. Leen mirrored the gesture. The two played like that, returning gesture for gesture. Finally, the young woman smiled and beckoned Leen over to her rooftop. The two women started to talk.

The young woman's name was Ina, and through her Leen found her way into the story. "I bought her a pair of high-heel shoes and she had me take her picture in them," says Leen. "The family gathered around in great excitement. I was humbled by how such a simple act can have such an impact. It changed the whole mood for me. How do you explain this to someone after the assignment

is over and you are home? It's not cocktail party chatter.

"It's important for me to feel invited in," Leen continues. "I do my best work when I feel welcomed. I am most comfortable when I've spent enough time with people to have earned their trust. It then becomes my job in their family to document. So they'll say, 'Be sure you're here when....'"

Be sure you're here for the birth; be sure you're here for the graduation; come to the engagement party, the wedding, the anniversary, and, sometimes—be sure you are here for the funeral.

Be sure you're here for the Easter hat party, the ladies of the black Baptist church in the area of Miami known as Coconut Grove told Maggie Steber.

"You don't just walk into a situation," explains Steber, who on assignment to photograph a story on Miami wanted to portray that city's black community in a meaningful way.

"First I called the minister and explained that I wanted to take pictures of Easter Sunday. Could I come address the congregation and explain this? One Sunday I attended the service and sat, and then I got up and introduced myself. I talked about 'this wonderful church which is the oldest black church in Miami.' Afterwards Bobbie Mickens, a member of the congregation, came up to me and said, 'We're going to have an Easter hat party. Would you like to come?'

"So I went and set up my lights and then we just sat and drank punch and ate pigs-in-blankets, and by the time they were ready to try on hats we were friends." The photograph she took shows just that—a group of friends playing dress-up, having a grand old time trying on hats of every imaginable color and shape.

"If you want the picture, you have to pay the price—and it's usually yourself," Steber continues. "Otherwise you hang the pictures on your wall, and they'll be empty and you'll be empty."

Sometimes the price is heartbreak. There are people you carry around in your heart for the rest of your life, and some of their stories are sad beyond tears. "I met Fanny soon after I was assigned the viruses story," recalls Karen Kasmauski.

Fanny had AIDS, the consequence of her marriage to a bisexual drug addict. At the time they met, Kasmauski was seven months pregnant. "I knew I couldn't get AIDS from Fanny," Kasmauski says. "But I was worried about all the opportunistic diseases that plague people with AIDS. Fanny made it easy for me. She sensed my uncertainty. She quickly let me know how concerned she was about being an infectious person."

Fanny opened her soul to Kasmauski and spoke about the betrayal she felt when she found out her husband had infected her. She recounted the devastation she felt when her youngest, Jason, was born positive. She told about her joy 18 months later when he was declared disease-free. She explained how careful she had to be in order to protect her own children from herself.

She spoke of her frustrated search for good parents to take care of her children after her death. The search had been full of anguish. One couple agreed to step in after her death, then reneged. A second family did the same. Because Fanny was estranged from her wealthy parents in New York, relatives were not an option.

"She looked at me with such pleading eyes that I knew she was asking me," Kasmauski relates. "I had just had Katie, my second child. I came to the same conclusion I'm sure the others did. After the double trauma of losing both parents to AIDS, these kids would require tremendous care and emotional support. So I said something, like, 'Gosh Fanny, I would take them if my life wasn't so

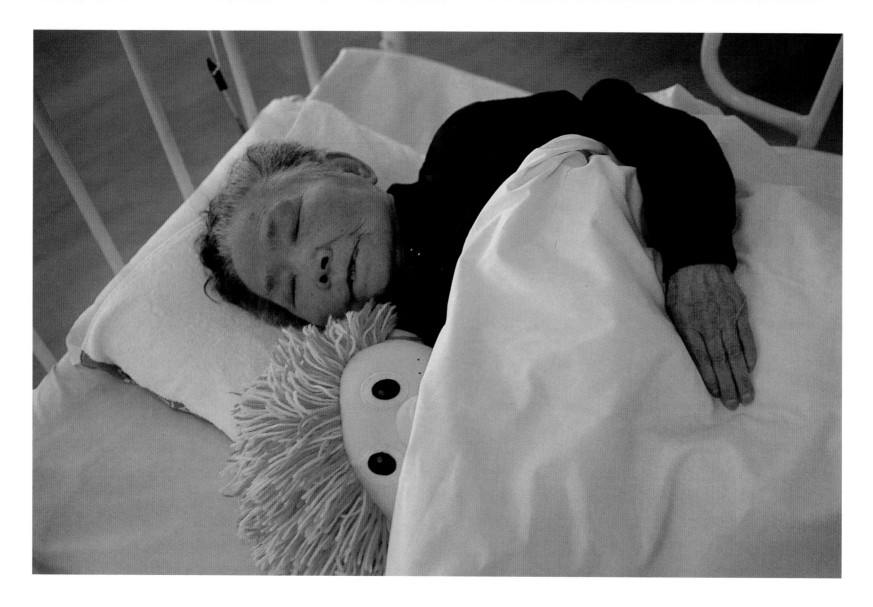

Yoshi Seki settles into the embrace of sleep in an adult day care center in Yamato, Japan. She comes to the center three days a week, allowing her family time to tend to other duties.

completely crazy. I could never give them the attention they would need.' I was letting her down like everyone else. But she forgave me without saying so and made it easy."

During Kasmauski's last visit, Fanny was clearly overwhelmed by the fatigue of her illness. She was losing the war. "She walked me to my car, and gave me a last hug good-bye," Kasmauski says. "She looked at me with sad eyes. 'Do you think anyone will help me through these last days?' she asked. 'I have given so much to people, will I get anything in return?' I was heavy with sadness. I could not promise that I would be there for her."

Several months after the story ran in the NATIONAL GEOGRAPHIC, Fanny's nurse called Kasmauski to say that Fanny was near death. Kasmauski was torn. Should she fly down and see her? Would she even be alert enough to know if Kasmauski were there?

"I called her," Kasmauski says. "Her nurse answered and said Fanny could not talk. She had left the conscious world. 'If she ever regains consciousness, please tell her that I love her and am praying for her,' I told the nurse. I felt hollow. I had let Fanny down. One of the biggest regrets of my

life was not flying down to be with her when she died; I am certain she would have done that for me."

Fanny's brave gift—allowing Karen into her life as it neared its close—was repaid. Karen's photographs allowed Fanny to share her story with millions. In the end, no one is immune to life's consequences. "We're all responsible for our actions," Fanny said.

In the field, a photographer is enmeshed in the intensity of the moment. The life left behind fades. The experience can be life-changing, liberating, and dangerous. Passion can erupt— for a person, a thing, a place. It is the wild-card factor in every assignment.

"I covered Brazil for six months," recalls Stephanie Maze, who photographed that country for a magazine story in 1987. "I was determined not to miss a thing. I was waking up at four in the morning with howling monkeys in the Amazon. I remember the sensual whirl of Carnival in Rio de Janeiro and of being in the Serra Pelada gold mine with 60,000 miners, all men. I became infatuated with the country. When I returned to Washington, I put my apartment on the market and moved to Rio. I learned the language by watching soap operas. I lived two blocks from Ipanema beach, with a jazz club on the corner. I stayed for two years."

Along with exhilaration, there is risk. The perils of photography come seen and unseen. It is the given of the work. The guiding principle is to avoid carelessness, over which there is some control, and to hope to avoid bad luck, over which there is none.

"The stupidest thing I ever did was when I was photographing a big radio telescope in Chester for the book on Great Britain," remembers Annie Griffiths Belt. The telescope is like a giant dish facing the sky. "I climbed to the rim by ladder, and perched myself on a large bolt so I could shoot down at the dish. Chester was 30 stories below me. A gust of wind hit me, knocking me off balance, and so I grabbed at a rope and glanced back. I wasn't wearing a safety belt, and then I realized that if the wind had been a tiny bit stronger I would have been a grease spot in Chester. I couldn't get down fast enough." Before she did, she got the picture.

The carelessness of others can be just as hazardous. "I'm above Cape Cod," Belt says, talking about her coverage for a TRAVELER magazine piece. "We're ten minutes in the air and the pilot informs me we are out of gas. 'Out of gas!' I said and glanced out to see where we were. 'There's a beach, land on it!' I told him."

The pilot replied he had never landed on a beach.

"Have you got another suggestion?" she snapped.

He didn't. They landed on the beach.

Not unexpectedly, working with wild animals, particularly large animals like elephants, carries great risk. "We have had a few close calls," says Beverly Joubert, who has photographed elephants and lions in collaboration with her husband, Derek, for several NATIONAL GEOGRAPHIC magazine stories and books. "Most of them have been with elephants, although we've been charged by lions while on foot. Once we'd finished filming lions around one in the morning and thought we'd park in an open area and sleep. We'd been dozing 15 minutes when we heard a scuffing sound. It was an elephant cow at the side of the car, her ears flattened. She was hitting us from all sides of the vehicle, then lifted the car up on one side. The car had no top, and next she managed to get her tusks under

the windshield and rip it off. The cry of a calf made us realize she had given birth ten minutes before we had disturbed her; at last we managed to shine a light in her eyes to scare her off."

Another time, the Jouberts were walking toward a bull elephant that picked up their scent, turned, and suddenly charged. The couple stopped in their tracks. "I remember staring at his feet and thinking how huge they were," Beverly Joubert says of the heart-stopping experience. "If you stand your ground it makes them feel awkward and they move off." Which the elephant finally did. Ironically, the real danger, says Joubert, is the tiny bugs you can't see. "I've been ill for 12 years; only recently have I discovered that I have parasites."

Sometimes the danger is invisible even to a microscope. While doing a story on radiation, Karen Kasmauski unknowingly met her subject face to face. A junk dealer in Brazil had broken open an obsolete x-ray machine, pulled out a highly radioactive cesium 137 isotope and stuck it in a jar. Four people died before the source of contamination was discovered. Several city blocks were razed as a result. Karen escaped with no internal contamination.

On a later assignment in Sweden she ingested radioactive reindeer meat, and when she returned home went to NIH for assessment. Luckily, although she was contaminated, she had suffered no harm.

Even the most innocuous situation can turn menacing. Sisse Brimberg recalls sitting in the town square of a Mexican village waiting for the light to improve when an argument erupted between a dignified older man and an inebriated younger one. The old man ran off and returned, angrily waving a pistol; his young antagonist ducked behind Brimberg. Brimberg froze until bystanders persuaded the old man to put down his gun.

For Darlyne Murawski, a biologist who specializes in photographing small worlds like fungi and diatoms, the work can be not so much dangerous as what some people might consider downright unpleasant. Take her search for a tiny mushroom called pilobolus, also known as shotgun fungus, so-called because a mushroom of less than an inch can shoot a spore packet six feet. The mushrooms germinate in dung, so Murawski went to a horse farm in Maine and asked permission to examine the dung pile. "They're beautiful," she says admiringly of her subjects. "They have little beads of water that reflect what's around them." Another story, on parasites, meant calling clinics that specialized in the treatment of sexually transmitted diseases to find crab lice to photograph. For a portrait of head lice, Murawski tracked down a professional nitpicker in Boston who helped provide suitable subjects for her camera.

First bug, then backdrop: Murawski's grown son volunteered his arm for a shot of a medical leech at work. But when it came to photographing body lice, there were no volunteers, so she ended up putting a body louse on her own arm and shooting it.

A photographer who is close enough to shoot riot or rebellion is used to being swept up in chaos. There is no immunity from the panic of a crowd—even outside a zone of conflict. "In Romania I was pushed off a ramp by 70 people desperate to get on a boat—the first in three days," says Alexandra Avakian, who covered that country for a magazine story. "I fell and my leg got caught in a loop of steel cable. I hung upside down, dangling above a metal float. The cable crushed my knee, but saved my life. It knocked me out of work for seven months."

It wasn't her first close call. While working in war-torn Sudan years before, Avakian was

a passenger on a plane that hit a hole during takeoff and crashed. She hitched a ride to another village and ended up stranded in the desert for two weeks. "I didn't tell my mother for years. I didn't want to upset her," she says.

There is something intoxicating and terrifying about the life-and-death drama of revolution and war, and the living-on-the-edge rush of adrenaline it provokes. "If the picture is worth it, it's not scary," avers Alexandra Boulat, a young French photojournalist whose most recent work has been in Kosovo. Photographers tell of being so focused on the task at hand that everything else seems to fall away. There is an illusion that the camera will save you from harm. The sense of security is false—and dangerous.

"I was in a Catholic church in Port-au-Prince one Sunday in 1988, when 40 men stormed in wielding machetes and machine guns," says Maggie Steber. It was another attempt on the life of Jean-Bertrand Aristide, who would later become president. "I started taking pictures, then realized how really stupid that was and that I ought to get out. But I couldn't. The doors were blocked. I ran down the aisle and right into the arms of a man with a machete. He grabbed me by the shoulders and lifted the machete, which had blood on it. I looked into his eyes and there was nothing—not a shred of humanity. It was like looking into a deep black hole. I came to my senses and turned to flee; he grabbed my dress which tore and that must have startled him. I ran to the only unblocked exit, which went to the sacristy, and pushed against all the people and we all fell through the opening into a courtyard. It was still several hours before we were rescued and I was sure we were going to die. I don't want to ever have that feeling again. I was okay until about a week later when I shook uncontrollably for three days.

"Recording life and death teaches you to think about your own life and death," she adds. "There's something about seeing people fighting for something. You become intoxicated by their courage, and sometimes their cause becomes yours. You catch fire yourself."

There are self-inflicted perils like the black shroud of depression—the Arctic chill in your stomach, the mouth dry as the Sahara, not to mention the sea of self-doubt that churns in your psyche. On the other hand, a little anxiety isn't a bad thing; it keeps you fresh and on your toes. There is the temporary bout of ineptitude—shooting with the wrong camera, the wrong lens, in the wrong light, the wrong film—and sometimes, even, with no film. (Says Carol Beckwith, who forgot to load her camera while shooting a tribal ceremony in Africa, "I sulked, and the chief offered to do it again.")

Most and worst of all there is fear. Fear of failure.

"I've felt that sense of panic every time," Sarah Leen admits. " I need to hold on to the thought that it's not as bad as I think it is. That it is going to work out somehow."

Invariably it does and even if it doesn't, there are compensations.

"If I miss something, " says Maggie Steber, "I imprint it on my memory and it's there just for me. Sometimes I like that better. The pitfall of photography is that you can end up looking at everything through a camera, instead of seeing it for itself. The viewfinder isolates you. When you look through one, you're cutting everything else out of your vision. The camera can open many doors, but sometimes you need to put it down and live."

It is easier said than done. Having the camera in hand can become so reflexive that it becomes difficult to imagine seeing in any way other than through a viewfinder. "I used to go to

KAREN KASMAUSKI • JAPAN 1989

When words fail to describe the horror and pain of Hiroshima, survivor Busuke Shimoe takes out the charred remains of the jacket he was wearing on August 6, 1945, when the atom bomb exploded less than a mile away.

parties and I would hardly talk to anybody," says Joanna Pinneo. "I would just watch. I'd go to some event strictly for pleasure—a ballgame, say—and I would be annoyed because I wasn't up front. I was watching from the bleachers like everyone else. The camera can be a barrier. The camera can isolate."

The line between photographer and subject wavers. It will not stay still. "The older I get, the more I see that there is a permeable boundary between me and the subject," says Lynn Johnson. For Johnson, the classic ideal of distance and the dispassionate observer has been transmuted into a softer, more gentle and malleable approach. "Compassion is nothing without the touch," she says. "If you can't embrace the person on the other side of the camera, there is no exchange. I am a better person for understanding this."

It is an ever-delicate balance: When to pick the camera up. When to put the camera down. "I would love to work with an invisible camera," says Carol Beckwith. "The camera is always in the way to giving full attention to friendship; it also protects you from things you could never see objectively if you didn't have it. There are things difficult to shoot: Voodoo rituals, for example,

in which men and women cut themselves with sharp glass. People go into wild states. At some point you have to engage in order to let them know the bond of trust is still there. When you take 36 pictures of one woman without stopping to interact, it can arouse suspicion and hostility. No one understands why you don't click the camera once and leave."

Getting the picture is what the job is about, but it's also about reaching out to affirm the vulnerability that makes us all part of the human race. If the photographer sees and captures the human spirit on film, does she not show to us something of her own spirit as well?

There was a one-room schoolhouse in McLeod, North Dakota, Annie Griffiths Belt remembers. The story she was shooting highlighted the rural, sparsely populated nature of that state. "The class was down to three students," she says, "and one of the families was about to move away, leaving only two. Of course they were going to close the school. The teacher, Janice Herbranson, was a real trouper. I was there on the last day of school. She was so upbeat with the kids. But when the day had ended and the kids ran out the door, she walked over to the window, watched them running home, and started to sob; as she did, a great sob went through me.

"First I had to take a few pictures. Then I could go over and hug her."

The privilege of photography is its access to the human soul. It is a gift and it is humbling. Perhaps the finest thing a photographer can do is repay the debt in kind. The great American photographer Marion Post Wolcott, who knew the human spirit when she saw it and who photographed women farm workers in the 1930s and '40s for the Farm Security Administration, once addressed a conference entitled Women in Photography: Making Connections. "Speak with your images from your heart and soul," she implored her audience. "Give of yourselves."

If the first rule of photography is to get close to the subject, the second is to keep on shooting. "I get seasick," says Sisse Brimberg, who got tossed around in a small motorboat during a thunderstorm in the San Bernardino Straits between the South China Sea and the Pacific while shooting a story on the Manila galleons. "How do I put this delicately? I can vomit, then turn around and take the picture."

While driving around on assignment to photograph a story on New Zealand, Annie Griffiths Belt was struck from behind by an inattentive motorist in a four-wheel drive. Her own car was demolished. Belt ended up in the hospital with a compression fracture of the spine. Three days later she was in a helicopter shooting a snowfall. "I knew I would pay for it, but that's what I was there for," she shrugs.

What about the photographer whose viewfinder frames the worst that humans can do to one another? How do you keep the camera steady when the tragedy of war fills the lens?

"I always saw it as being like a surgeon," answers Alexandra Avakian, a veteran of shooting uprisings in Eastern Europe, the Middle East, and the Caribbean. "If your hands shake, you shouldn't be there. You want to make a beautiful picture and you want the composition to be perfect. You want the person looking at the picture to stay there transfixed. "

Often in the grim matrix of tragedy and pain, a kind of professional numbness sets in— an instinctual mental self-preservation that enables the photographer to keep shooting. Once someone asked Margaret Bourke-White how she could photograph the horrors of World War II and its ghastly

aftermath at Buchenwald. "Sometimes I have to work with a veil over my mind," she replied.

Alexandra Boulat is showing her photographs of the war in Kosovo, part of her coverage for a story on the Albanians—her first assignment for NATIONAL GEOGRAPHIC. They are difficult pictures to look at. There are images of a woman overwhelmed by grief for her dead husband, scenes of villages burned to the ground, and most painful of all, a photograph of a dead child.

"It's difficult to know why I am taking pictures at such moments," Boulat says. "You cannot say: 'It's going to change the world.' In fact, it could make it worse. My motivation is not to bear witness. It is because I am interested."

It sounds perverse, the interviewer suggests.

Her face darkens. "It is perverse. It's painful, miserable, and crazy. Maybe I have some pain inside myself," she says. "Maybe it's masochistic. A war photographer is not necessarily pure. Inside us there are some very dark, unpleasant things."

Among the photographers who deal in the very dark, one of the darkest was Dickey Chapelle, who had four stories published in the magazine, two of them on the Vietnam War.

"She was hypermanic; she laughed too loud, too long, and too often," recalls Bill Garrett, a former editor of the magazine. "She was so loud she made people uncomfortable. She was a chain smoker. She had this gravelly voice that got on your nerves. Dickey was very feminine, but she worked real hard at covering it up when she was with the military. I think she looked on them as her family. Most of her assignments were with them. She ran every day to stay in shape. She wanted to be sure she didn't hold up the unit she went on patrol with."

Chapelle, who had attended MIT engineering school, was a registered pilot and parachuted out of airplanes. She fell in love with a Navy photographer, who introduced her to the camera. She seemed magnetically attracted to the danger of combat; she raced for the front row seat in Laos and Vietnam. The pictures she sent back—a Vietnamese field muffled in smoke from a phosphorous shell, a gunboat in the Mekong Delta, a Buddhist funeral parade—spoke of the life-and-death drama of war.

Once, while in the Calcutta airport with Garrett, she ducked into the ladies room. She was wearing her floppy fatigues, her trademark Australian bush hat with Marine Corps insignia, and she had her hair up. She reappeared seconds later. "I just got thrown out of the goddamn ladies room," she told Garrett with a hoarse laugh.

That was one of the last times Garrett was in the field with her.

On November 4, 1965, while on patrol with Marines near Chu Lai, Vietnam, Georgette Dickey Chapelle fell victim to a booby trap. A piece of shrapnel tore open her carotid artery. She bled to death. Her final words were, "I guess it was bound to happen."

"She died because of her insistence that she be up front," says Garrett. "When you think about it, it wasn't very smart. She'd have been better off if she had stayed in back. She would have gotten better pictures. She was the moth that circled the candle and finally got too close.

"We published her article on the Vietnam War posthumously."

The work is lonely. To be a spectator is to be isolated. To examine life is different from living it. An assignment is an insatiable blaze that devours everything in its path. Everything else, including family and friends, fades. Only the work lies ahead and the business of getting the next

photograph. There is, by turns, joy and terror, boredom and excitement, in the search for the ephemeral truth that film records.

In 1981, Sarah Leen spent four months in the barren expanse of Siberia to photograph a story on Lake Baikal. To cover a story in Russia is to work in a place where nothing works and where everything, even the simple act of buying a loaf of bread, is a logistical swamp. There is the isolation imposed by geography, language, and poor or non-existent communications systems. During the course of coverage Leen was able to call home once. As an antidote, she kept a journal, an extended letter home that, because of the remoteness of the place, could never be sent. To read her words from that chronicle is to understand something of the emotional roller-coaster that is the photographer's life:

March 10, 1991 Irkutsk: There were no stairs for the plane so we had to sit for 30 minutes until they brought them. I had been wondering why I was the only one who got right up, got my coat, and gathered my luggage. Everyone was just sitting there staring ahead, prepared for their expectations not to be met. I stood alone for awhile and finally sat back down. I have to shed my American impatience.

March 13 Listvyanka: overcast: Lystvyanka looks like someone dumped an ashtray on it. I think I am eating the same boiled beef and cold peas I had for three straight meals. I did my laundry in the bathroom sink using a plastic bag to stop it up.

March 14 Listvyanka: snowy: The day's depression deepens. Not leaving today. Truck's not ready. Need supplies. Tears in my voice. I can't sit here another day. They find me a guy with a car who will drive me around for $5 an hour. I think "helluva deal." They think, "highway robbery." Culture gap.

April 9 Nizhneangarsk: cold windy dry: We have crossed the ice. This morning I watched the sun rise and listened to the sharp explosions of the ice cracking, the birth pains of a lake trying to be born. 'Baikal draws you,' the seal hunters say. I feel that pull now.

April 10 Nizhneangarsk: dry dusty not so cold: The ice is deteriorating every day. I am afraid of the thin ice. I hear many stories of people going through. I have bad dreams about it.

April 22 Seal camp: bitter wind cold: There are six hunters and Sasha [the guide] and I. We sleep like sardines on a platform one and one half feet above the ice. There is a wood stove and the ice floor is covered with wooden planks. I walk out far onto the ice until the tent is a speck to go to the bathroom. There are no bushes out here. Yesterday was my birthday. Sasha said I am most certainly the first woman to have her birthday in a seal hunter's camp.

April 25 Ol'Khon Island: cold blue sky: I was interrupted in mid-sentence by the arrival of the helicopter. As suddenly as it had dropped us on the ice, it plucked us from the tent and hurled us into the cold blue sky. The abrupt departure left me feeling unfinished, the job incomplete, relationships that had begun to gel torn apart. Quick good-byes, a few Polaroids, shouted thank-yous. A look back, a wave, and the men quickly became small shadows on a vast plain of ice.

April 29 Listvyanka: very windy, sunny

Transformation!!! The ice had been breaking up the last few days; a windstorm has blown it all away. There is a whole other life when Baikal becomes a lake. But I am leaving and will have to wait till I return to explore its liquid soul.

It is time to go home. ■

LYNN JOHNSON • NIGERIA 2000

A woman presses the leaf of a "headache
plant" against her forehead to ease pain.

144

Pollen's blessing showers on Cora Knight during a coming-of-age rite celebrated by the White Mountain Apache.

CAROLE DEVILLERS • FRENCH GUIANA 1983

In a reverie of joy, a Wayana boy luxuriates in the cascading Itany River. His people, who speak Carib, number fewer than a thousand.

BELINDA WRIGHT • AUSTRALIA 1988

Keepers of the Dreamtime, the Gagudju
and neighboring Aboriginal peoples join
in a ceremonial dance in the Northern
Territory of Australia.

FOLLOWING PAGES

KAREN KASMAUSKI • TOKYO 1991

The energy and movement of humanity
in a hurry give a Japanese citizen much
to ponder in modern-day Tokyo.

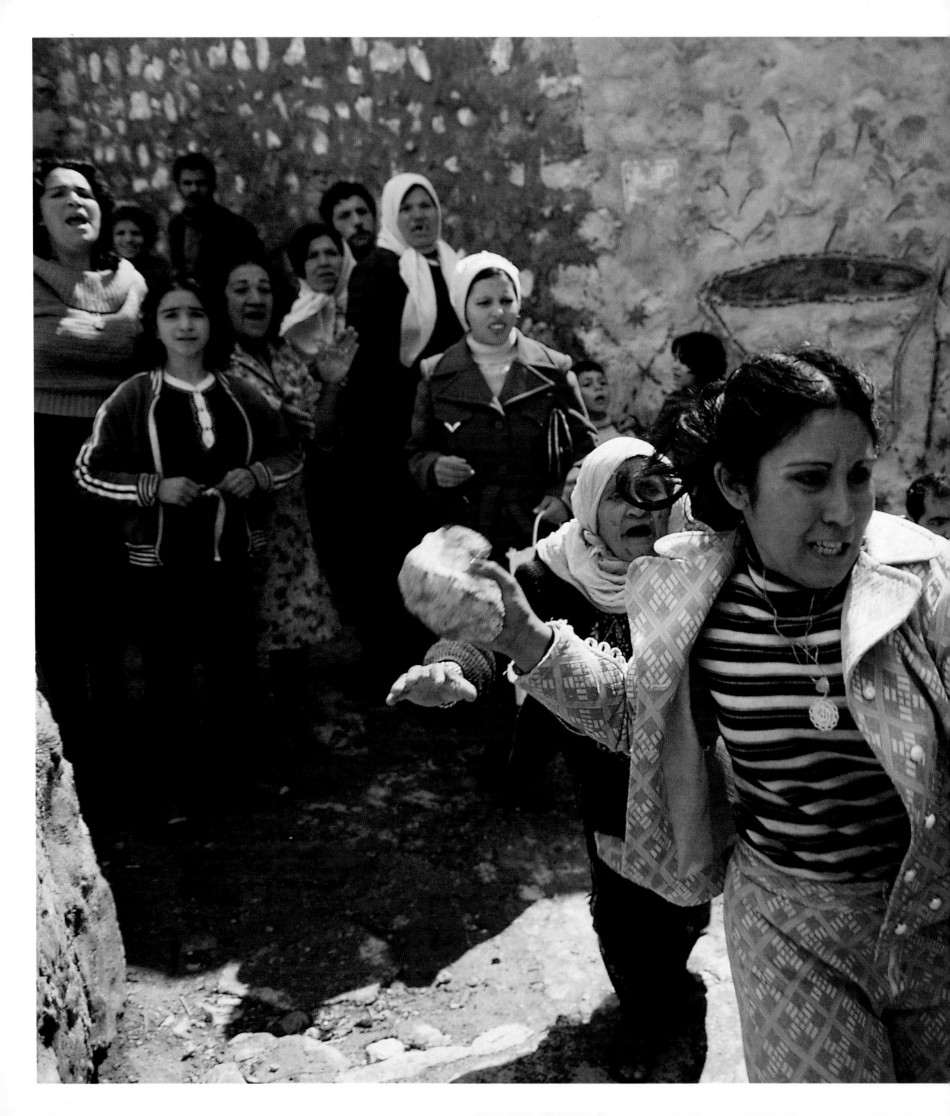

JODI COBB • JERUSALEM 1983

A woman vents her rage at Israeli police in East Jerusalem during a strike held by shopkeepers.

153

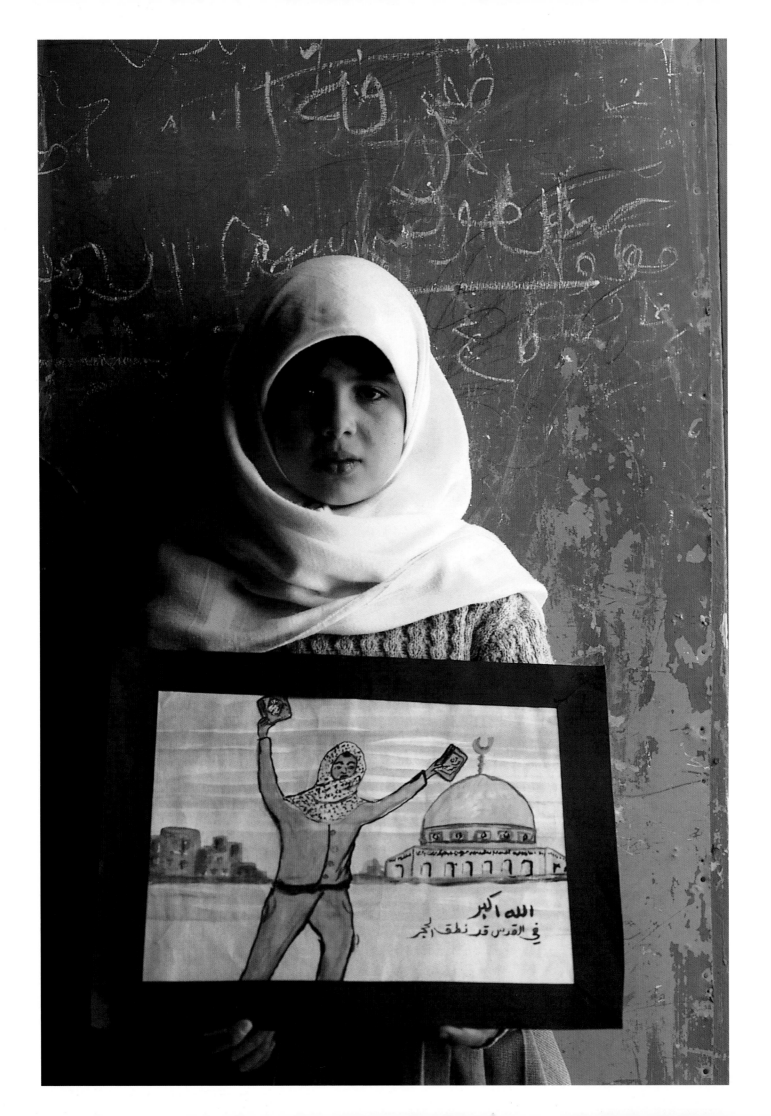

Paper dreams: a ten-year-old Palestinian holds a drawing of Jerusalem, which she has never seen; but she hopes to live there.

JOANNA PINNEO • WEST BANK 1992

Waving guns and the outlawed Palestinian flag, Black Panther militants demonstrate for national recognition in the West Bank.

ALEXANDRA BOULAT • KOSOVO 2000

Their lives and homes in ruins, ethnic
Albanians survey the wreckage of their
once thriving town destroyed by Serb
forces several days after NATO air
strikes began.

ALEXANDRA BOULAT • KOSOVO 2000

In a grim funeral parade, mourners shoulder
coffins holding the bodies of Kosovar
Albanians killed by Serbian forces.

ALEXANDRA BOULAT •
KOSOVO-MACEDONIA BORDER 2000

A woman collapses in a field as her
family appeals to border guards for help.
They were given refuge in Macedonia.

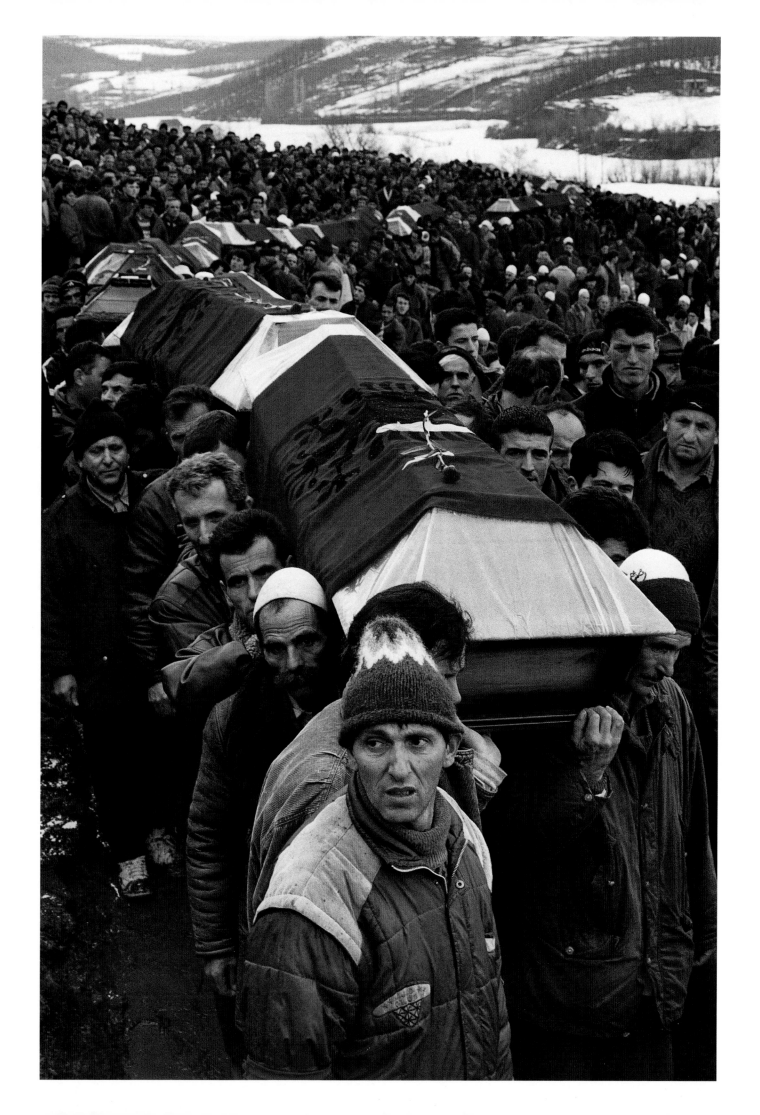

JOANNA PINNEO • SERBIA 1993

A life of sorrow marks the face of
Dragica Kostadinovíc, who fled to Serbia
when her Bosnian village was shelled.
In World War II, her entire family died
in a Croatian work camp.

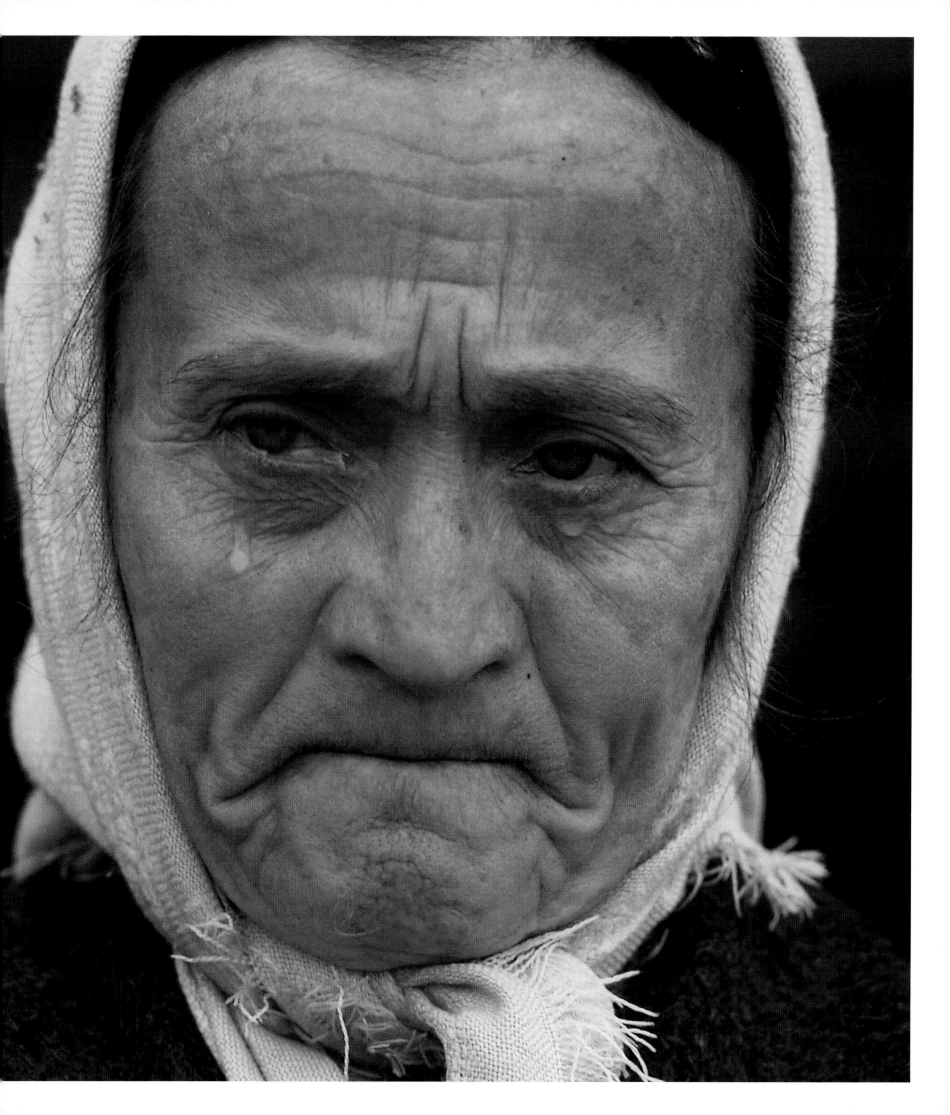

JOANNA PINNEO • GERMANY 1993

His face to the wall, a Nigerian who
illegally slipped into Germany from
Poland is arrested by police in the
town of Guben.

FOLLOWING PAGES

LYNN JOHNSON • NIGERIA 1991

In the arms of her mother, a young
girl suffering from malnutrition receives
syringefuls of soy milk at the Kersey
Home for Children in Ogbomosho.

SARAH LEEN ♦ MACEDONIA 1996

Amid money and comforting hands,
a young boy is circumcised in a Muslim
sunset ceremony.

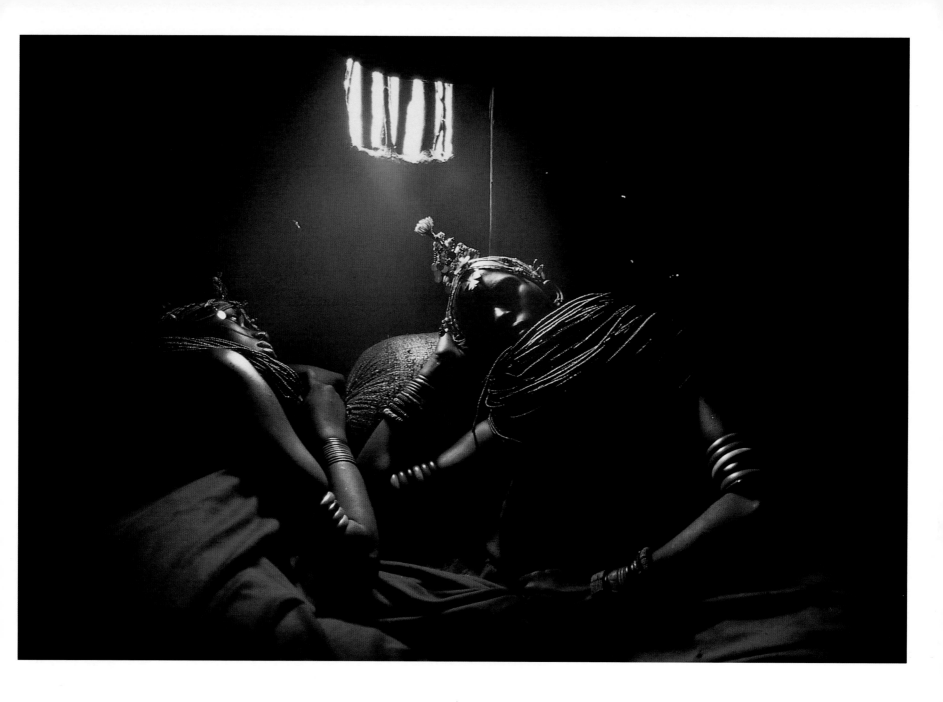

MARIA STENZEL • KENYA 1999

A newly circumcised Ariaal bride, at left,
lies in her mother's hut, accompanied by
her best friend.

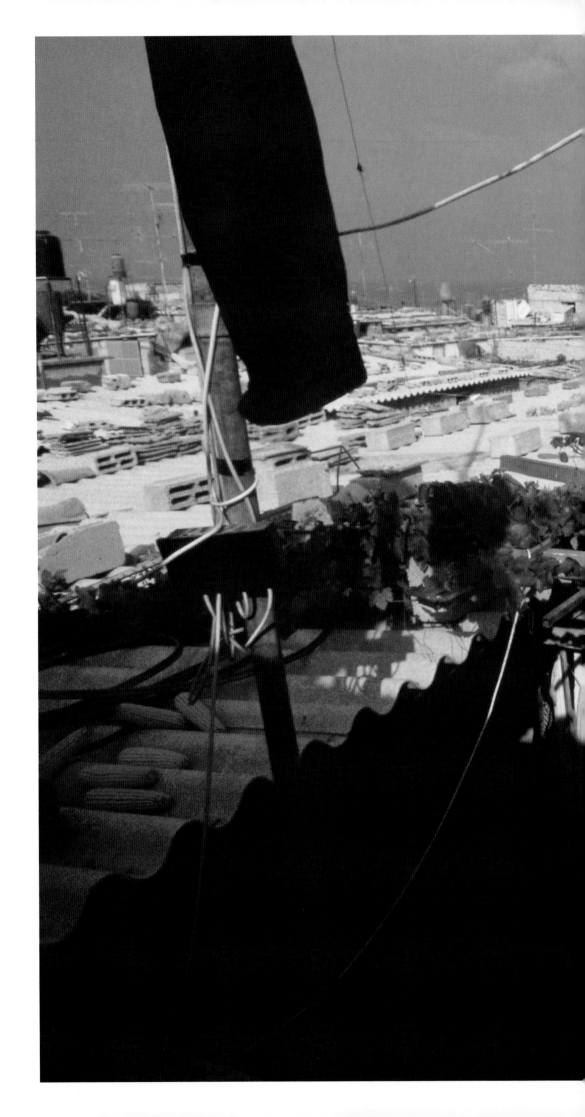

ALEXANDRA AVAKIAN • GAZA STRIP 1996

Fatima al-Abed holds one of her birds,
a symbol of peace and hope in a narrow
sliver of land that has endured military
occupation, terrorism, and despair.

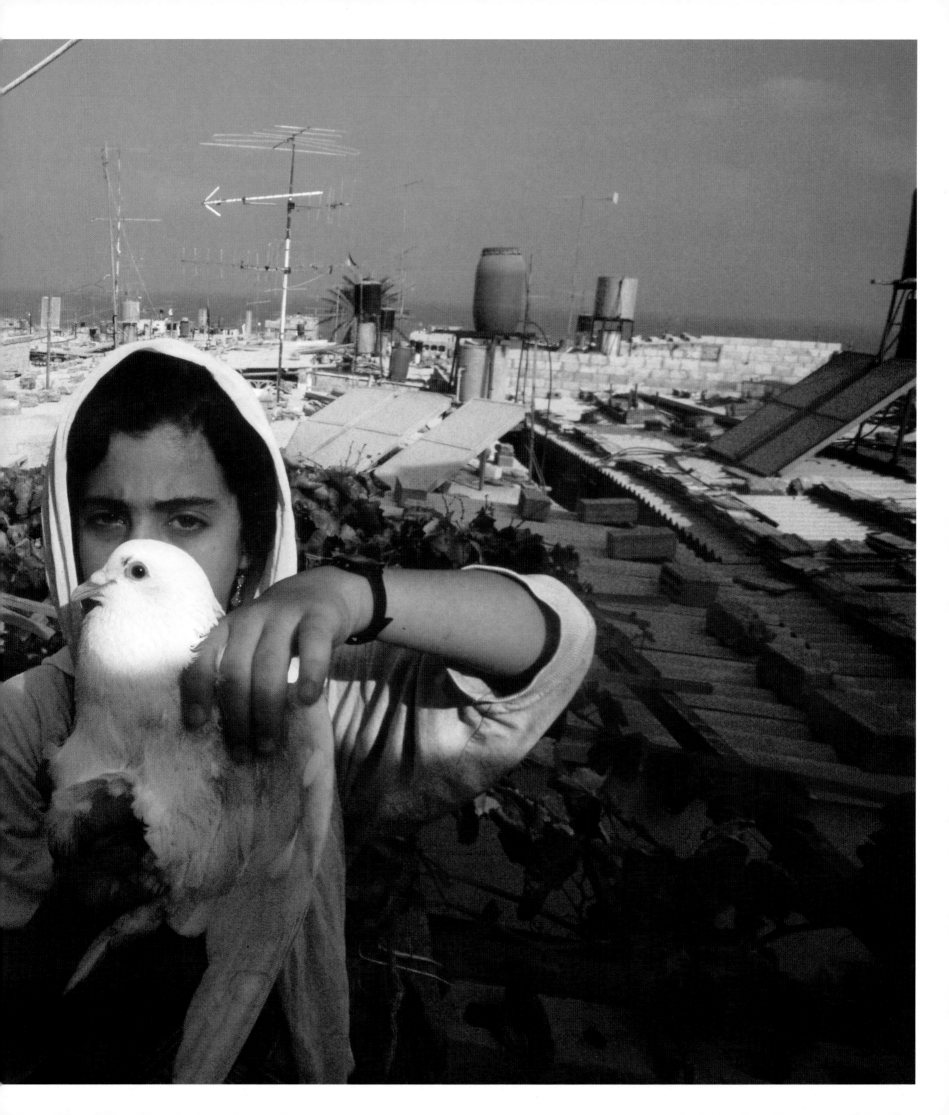

Karen Kasmauski

HUMAN CONDITION

KASMAUSKI'S BEAT is the big-picture, broad-sweep story like "Viruses," "Aging," and the "Human Genome." Because subjects like these disregard geographical boundaries and are so huge in scope, focus is everything. For her story on human migration she visited nine countries in four months. "I didn't set out to be a photographer," Kasmauski says. "I wanted to be a marine biologist, although I ended up with a degree in anthropology and religion. Those disciplines turned out to be marvelous tools in exploring my real fascination—how science allows us to understand ourselves and how that shapes our destiny." When Kasmauski shoots a story, she looks at science in relation to the human condition. She brings to the task an ability to pick apart a complex subject and put it back together in a visually compelling and comprehensible way. "Karen thinks through her pictures," says her husband, Bill Douthitt, a senior editor. "My interest is the people, not the process of technology," says Kasmauski. "Instead of saying, 'Here is the machine our understanding has created,' I say, 'Here is the person affected by our understanding.'" Kasmauski was six months pregnant when she was assigned a story on viruses, shown here. "I didn't want to do anything that would expose the baby to harm," she says. So she began the domestic part of her coverage and deferred the risky parts until after the birth of her daughter Katie. "I weaned Katie, and three days later I was in Puerto Rico shooting heroin addicts," she recalls. "I didn't think you could pull it off," her picture editor told her later. Of course she could. And did.

PENNSYLVANIA 1999 Jaundice tinges a girl's eyes, sign of a genetic disease linked to toxic levels of bilirubin, a blood product the liver cannot break down.

PUERTO RICO 1994

Addicts get a fix. "I needed to get close
to show this," says Kasmauski. "I had to trust
that they wouldn't accidentally stick me."

CALIFORNIA 1989

Immobilized by a brace and mask,
a woman with a spinal cord tumor
is treated with heavy-ion radiation.

Overwhelmed by AIDS, the exhaustion of caring for her two children, and the aftermath of an argument with her estranged husband, Scott, Fanny Tremble collapses on her bed as Scott, also HIV positive, retreats into his own world of frustration and anger.

BALANCING ACT

JOANNA PINNEO • SPAIN 1995

The bond between father and son
shines from the faces of five-year-old
Andoni Legorburu and his father Ixidro,
a shepherd in the Basque highlands.

PREVIOUS PAGES

SUSIE POST • ARGENTINA 1999

Lost in a world of music and movement,
a couple in a Buenos Aires nightspot
aptly named Club Alegro, dance to the
beat of a tango.

VERA WATKINS • AFRICA 1954

Massive earrings and beadwork proclaim
a Masai woman's marital status. The
jewelry of an unmarried girl is sparser.

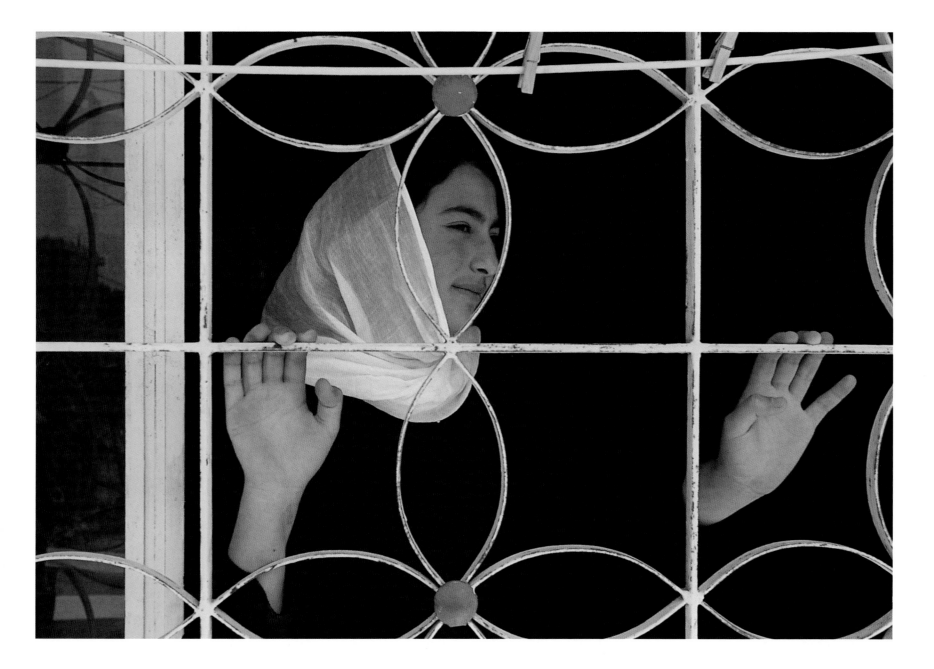

ANNIE GRIFFITHS BELT •
SYRIA-ISRAELI BORDER 1995

A young Druze woman gazes out
from her house at a demonstration.

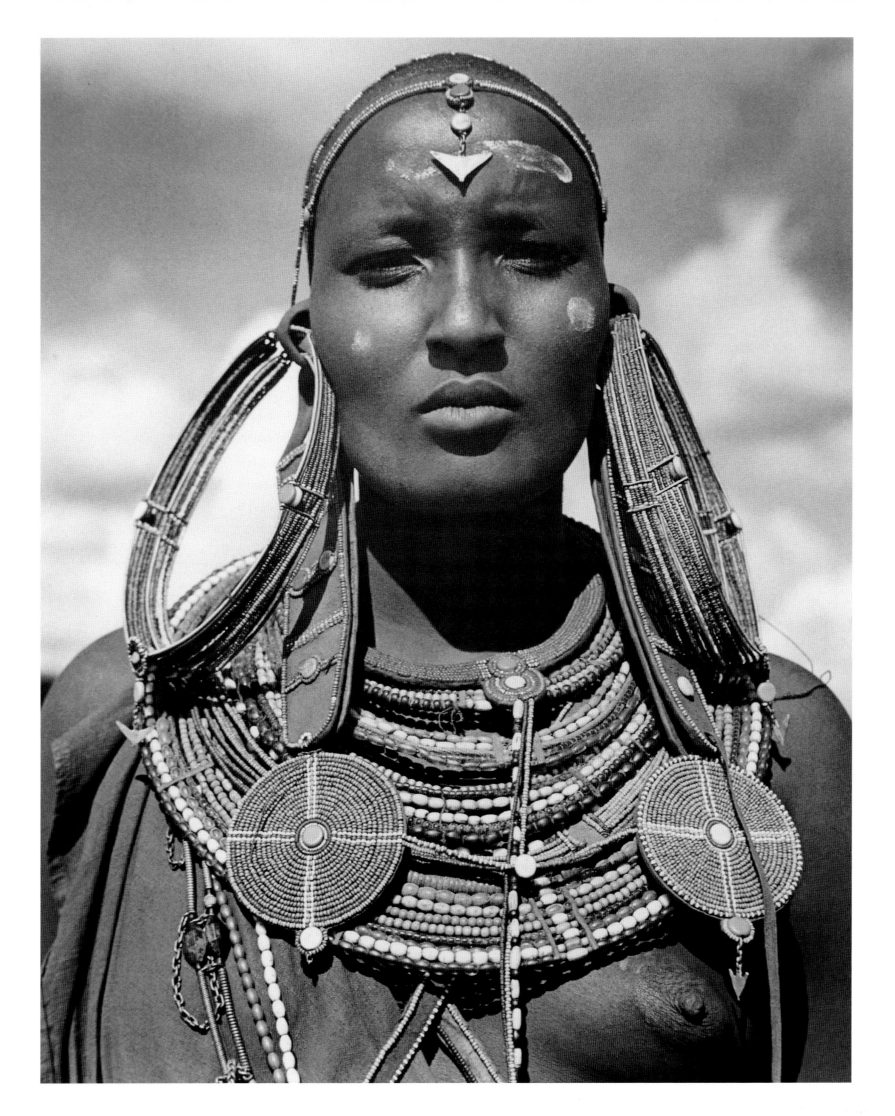

"WE ALL DO THE SAME WORK," says Michael Nichols, a staff photographer who specializes in wildlife photography for NATIONAL GEOGRAPHIC. "What's different is what women have to do to get there and stay there. It's not politically correct to talk about this, but there's this biological clock that kicks in. It shortens careers. Lately, I've had to realize there is more to life than photography; I think women are forced to face that earlier."

Married with two kids, Nichols is 47 years old on the day he makes those observations. What's more, he is about to step on a plane to Africa for a year-long expedition across the Congo. The imminent separation from home has triggered some introspection of his own struggle with the conflicting demands of career and family.

"How come I seem to get away with it?" he asks rhetorically. "It's easier for me to be totally obsessed with this work than it is for a woman. If she focuses 100 percent on the career, she leaves something else behind." A glimmer of self-revelation lights his face. "I've been allowed to have my cake and eat it, too."

There is always a price to pay for what you take in life—an emotional balance sheet that can never conform to standard accounting practices. This, then, is the price of choosing to be both a photographer in the field and a spouse, mother, sister, friend at home: Marriages that will not hold. Friendships that decay. Children who grow up without you. School plays missed. Soccer games missed. Weddings missed. Anniversaries missed.

"The plane moves faster than the heart," is the way one woman puts it. She means that guilt is part of the baggage she carries to the airport every time she leaves.

"I live separate lives," says Sisse Brimberg. "My first priority is my children. But in the field, I'm immersed in the story; the family fades." First there is that abrupt transition between being at home and being in the field, and it can be sheer hell. Take the time Brimberg got on a plane headed for France to shoot an assignment on early humans. The family—her husband Cotton, son Calder, and daughter Saskia—came to see her off. "I boarded the plane," Brimberg recalls. "I found my seat, settled into it, heaved a sigh of relief, and as I did, I heard Saskia crying and screaming, even through the shut doors. It was torture. You just had to hope that the plane would take off real soon. It did. If it hadn't, I would have stood up and walked out."

For some, being single seems to be the solution. Margaret Bourke-White was married—and divorced—twice. "It was not that I was against marriage," she wrote years later in her autobiography. "But I had picked a life that dealt with excitement, tragedy, mass calamities, human triumphs, and human suffering. I needed an inner serenity as a kind of balance…something I could not have if I was torn apart for fear of hurting someone every time an assignment of this kind came up."

In the field, life is lived totally in the present. Other aspects get pushed into the background. Says Jodi Cobb, "You can have a life in the field, or you can have a life at home. But it's hard to have both. When you're on location for a long time, you know everyone in town from the king to the hotel housekeeper. You come home. You don't have a mission. You have housework and unpaid bills—and it can seem like you're starting over with your friends and relationships."

The stay-at-home partner easily puts on the hair shirt of martyr. "You're in Paris, Hong Kong, Tangiers and I'm not," the litany goes. Stress cracks appear. Resentment seeps in. Absence makes the heart grow cold.

Joanna Pinneo reflects on the end of a 16-year relationship, eight in marriage. "He was my high school sweetheart. I always told him I wanted to travel; he didn't really believe me," she says. "He wanted to settle down, and I didn't. We parted when I was 31.

"When I was first divorced, I didn't want to get involved. I didn't want to hurt anyone again or involve anyone else in my decision to be gone. I also thought a relationship would be a distraction. I remember thinking, 'I'm single now. Now is the time to push the envelope.'"

So she pushed. She worked on tough, challenging stories on the Basques, the Palestinians, and climate until there was scarcely room for anything else.

"I had wonderful assignments," Pinneo says. "I didn't want to come home, and when I did, I felt very disconnected. I was absorbed in the Palestinian assignment for a year. Afterwards, I went to Richmond to visit a girlfriend who'd had a baby while I was away. She held up her baby; it was her first. I held up a copy of the magazine with my story as if to say: 'This is what I've been doing for my nine months.' We both giggled at the irony. Afterwards, to continue the analogy, I went into a postpartum depression. I tried to have a relationship with a correspondent who lived in India. It seemed romantic and glamorous. Of course it didn't work. What was I thinking? Then I did a story on European immigration and I got as much into that as I had into the Palestinians story. I flew from country to country and soon got the feeling I could get on any plane anytime and go anywhere. I could just keep going and going. It was an odd feeling. I liked it and yet it frightened me. I seemed to be losing touch with who I was and where I came from."

Many jobs require travel. Not so many require travel for months at a time to such remote and exotic locales as NATIONAL GEOGRAPHIC photographic assignments demand. Even fewer have the power to take over the heart and soul the way such an assignment can. The center of the universe shifts. "I'd been away so long my dog growled at me when I got back," a photographer once said. It was a joke, but a serious one. A growling dog is the least of it.

"Things corrode in your absence," says Sarah Leen, speaking of the struggle to keep a marriage intact. "It's a challenge to know how to balance your life. In this respect, shorter assignments are better. The days of going on the road for ten weeks at a time are over. When you're younger you don't know any better. I like to immerse myself in where I am. But I can't act like I'm not married. This job is not a normal one. Most marriages don't have to put up with this."

For the editors in charge, there is a dilemma. There is the need to get the assignment done balanced against concern for the well-being of those who do it. "I think women are forced to make more difficult choices, particularly as they age," says Tom Kennedy, a former director of photography who hired many of the current generation of women who shoot for NATIONAL GEOGRAPHIC. "It's not that it wouldn't be hard for a man, but I think that most men have a greater ability to compartmentalize the family/job decision in favor of their careers."

Some do it better than others. Kennedy mentions a male photographer, blessed by a brilliant career, cursed by a personal life in shambles. "He may well have regrets about the way he's lived his life," Kennedy comments. "When the demons come out—and I have seen them come out— they're incredibly intense. I was always aware that family/career was a problem that could be helped or hurt by the way we dealt with it," Kennedy continues. "Not that we could be responsible for how someone chooses to live their life, of course. But it made me sad and uncomfortable to envision a

photographer coming to the end of life and being full of regret and rage at what he or she did or didn't do."

Women photographers at National Geographic who combine family and work are so few that there is no path cleared for those who would follow. It is improvisation every step of the way.

"I teach at workshops," says staff photographer David Alan Harvey, "and when my female students say, 'Okay, let's get real. How hard is it going to be to do this and have a life?' I say, 'It's going to be harder for you.' But I point to photographers like Annie Griffiths Belt and Sisse Brimberg as proof it can be done."

"Role models?" muses Annie Griffiths Belt. "There aren't that many. When I was pregnant, Sisse Brimberg was the first person I talked to. When she had Calder, I asked: 'Is it difficult traveling with Calder?'

"'Oh, it's so difficult,' Sisse responded. 'The most difficult thing I've ever done. Except, it's almost as difficult as traveling without him.'

"Then, when she was pregnant with Saskia, her second, I said: 'Oh, Sisse, how wonderful. Was it hard to decide whether you could keep up the job with two?'

"'Well,' replied Sisse, 'I decided I could have maybe three or four extra stories in the NATIONAL GEOGRAPHIC magazine. Or I could have a son and a daughter.'"

Belt, who is ferociously organized and who credits her efficiency to her early years as a waitress, tried to do both—get the extra three stories in the magazine and have a son and daughter. After Lily and Charlie came along, she and her husband, Don, worked out a shared system of responsibility. The basic rule in the family was that if she had an assignment that would take her away for more than two weeks, the kids would travel with her. Otherwise they'd stay home with Don. The choreography was intricate, to say the least. As it was, many of her trips ended up being a lot longer than two weeks. She'd scope out the assignment, figure out where she could set up a temporary base in the country she'd be working in, line up an apartment or rental house, and hire an au pair to help care for the children. It worked well for a time, although some colleagues had their doubts.

"When Lily was about three," Belt says, "the classic line was, 'Well that might be all right now...*but....*' And what they were really saying was, 'What you are doing with the kids is really not okay.' It was like being in Catholic school with a nun wagging a finger at you.

"I remember one depressing lunch, where the consensus of all the photographers was: 'either you're going to screw up your kids or you're going to screw up your career.' I left that lunch so discouraged, thinking, 'You guys, my work's okay, my kid's are fine. Why are you doing this?'"

Nonetheless, Belt had a plan. She kept shooting assignments while also carving out time to teach workshops and edit pictures as preparation for the day when she might have to stop being a field photographer. Finally, last year, after 20 years as a photographer, she decided it was time for a shift and accepted a position as a senior illustrations editor in the Geographic Book Division.

A few days before she left for Australia and New Zealand to photograph what may end up being her last work for the magazine, Belt reflected on her full career as a NATIONAL GEOGRAPHIC photographer.

"There will be days when I'll feel very left out," she says. "I'm going to miss the life experience. I'm going to miss being part of that group of people. I'll have to remember that I got to do that

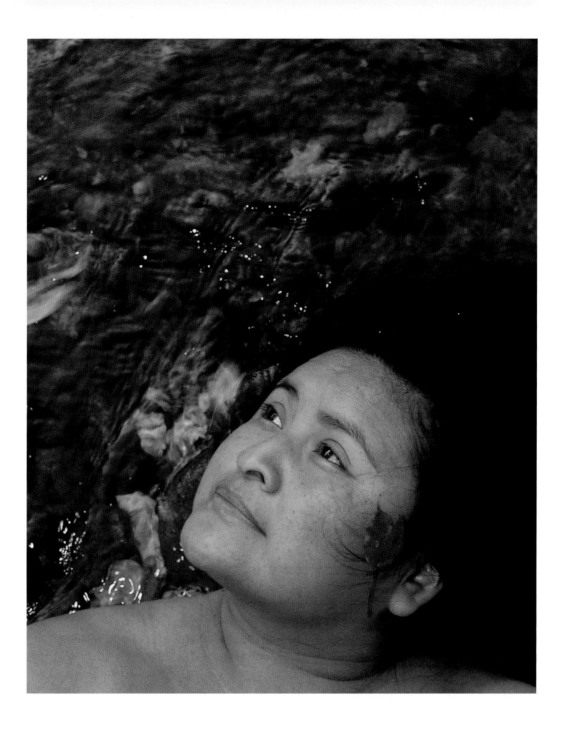

MAGGIE STEBER • NORTH CAROLINA 1995

"Her tranquility and vibrancy reminded me of water," says Steber of Laura Hill, a teacher and member of the Cherokee people. So she photographed her subject with the Oconaluftee River as background.

for 20 years. Now I've got another 20 years to give to something else. It's nice to go out when things are going well. There will be a lot less pressure and it's better for my family. But I know there will be days when I will feel like an old horse put out to pasture. There's a part of me that says: 'Oh, I hope I don't stop shooting.' But you know, I probably will.

"I've always known that 25 years from now, nobody will remember what I did. The people who will remember are my kids, parents, husband, and best friends. So how can I feel sorry for myself when I got to live this crazy life for 20 years? I've got these kids for ten more years. They've got to come first."

There is another party to the decision and it is her husband, Don, an editor for NATIONAL GEOGRAPHIC.

"It did work and it still could work," he says of the juggling act they participated in for years, "but it would be more and more difficult." The stay-at-home job happened to coincide with the increased difficulty of traveling with the children as they reached school age, he explains.

Any misgivings? he is asked. As a writer he too understands the electric thrill of being in the field and what his wife is giving up.

He considers the question and carefully frames his reply.

"We've never lived a normal life before," he says. "Everything was always up in the air. We could never get into any routine. Now we're making plans and we're finally able to stabilize. But, how do I put this? We've always had the space of travel between us—the idea of being away for several weeks, refreshing oneself, and then coming back to the marriage. Now, we'll have to create our own excitement to substitute for the travel. What happens now that we're in the box? This is unexplored territory."

There is a cautionary tale that is told around the offices of National Geographic, and it resonates in the heart of every photographer—male and female—who struggles to balance the professional and personal. On the day he retired, staff photographer B. Anthony Stewart pulled his younger colleague Bruce Dale aside. "Bruce," he said, "it's been an absolutely marvelous 42 years...but if I had it to do again, I wouldn't.... I have a son that I not only do not know—I never even met him."

So how to make it work? Susie Post is sitting and thinking about this and wondering how she might, as Michael Nichols says, have her cake and eat it, too. Post is going from strength to strength as a photographer. She has just had a story published in the magazine on the New River in West Virginia; she is now working on another assignment in Central America and has been published in a book on the Pan American Highway. The career has clicked into place and now she is 37.

"I was born knowing I wanted a family," says Post. "I came from a family of five brothers and sisters. They are all married with kids. I might have gotten married when I was 22 and had six kids by now and been very happy.

"Some time ago my sister paid a professional to interview the family about its history. I'm listening to this tape, in which the interviewer is asking my Dad about his marriage and the family and she asks him, 'Is there anything that would make you particularly happy?' And my father answers, 'If Susie would get married and have kids.'"

Her face darkens at telling this. "What's the answer?" she asks.

There is no answer, she is told. Certainly there is no good answer. There is only a sort-of-answer and everyone wings it as they go along. Much in life is negotiable. Biology is not. Only women bear children. Sooner or later women confront the choice: To have or have not. Who knows how circumstance and character conspire to write the narrative we come to recognize as our life?

Of course, one part of the answer is that we bear responsibility for our own narrative. How we handle the structure and plot of our lives is, in the end, up to us.

"I'm exceptionally close to my family so being away is hard on me," says Alexandra Avakian. "Because of my work, I have missed six Christmases and most Easters."

Now, she says, things have changed. "Before 1996, when I broke my leg while working on the story in Romania, I would work, pause for two weeks in a place like Paris, and go on to the next job." The "next job" might be in Haiti, the Sudan, or Iraq. During that period of her life, she was out of the country and away from home nine months out of the year.

"Finally," Avakian explains, "I felt, 'that's enough.' I had covered revolutions and some civil wars and had been lucky and was alive and well. I didn't want to go to another funeral. And there were other things I could do. Now, I do my job and come home. I've opened myself to a whole other way."

Opening herself to a whole other way included marriage. Of course she'll continue to shoot; that is clearly her calling. But marriage can have a way of rearranging one's priorities.

Perhaps, suggests Kent Kobersteen, current director of photography, the relationships that have the best chance of succeeding are those in which both partners do similar work. They understand. They know.

Bill Douthitt, now senior assistant editor in charge of projects, is married to Karen Kasmauski, a photographer for the magazine. "When we got married, I had been working in layout," Douthitt says. "I wasn't too happy in that department and wanted a change. The associate editor told me, 'You can be a contract photographer or a picture editor.' Karen and I were planning to have children and I was watching my colleagues having trouble with their marriages. I could see that two photographers in the family just wouldn't work. Anyway, I was an okay photographer, but Karen had more insight, nuance, and far more ability."

So the two came to an agreement. If there was room for only one photographer in the family, it should be Karen. If someone had to stay at home, that someone should be Bill. Which meant that Douthitt signed on for the jobs as picture editor and stay-at-home parent. Kasmauski became the photographer and traveling parent.

"When Karen travels, we go through a lot of rituals," Douthitt explains. "We all go to the airport. We see Mom get on the plane, so the kids understand it's not just a trip to the grocery. And we all go to pick her up. We spend a fortune on phone calls. I put up a big map with pins in it: 'Here's where Mom is.' These kinds of things are important for them to understand that Mom's job may not be like others.

"With Karen on the road, it's a tight schedule. The kids get fed in the morning and dropped at school, then I go to work. I leave at five and pick them up and make dinner. I become the single parent."

Yva Momatiuk and her husband and co-photographer John Eastcott took the opposite approach. Their daughter, Tara, now 19 and a senior at Mount Holyoke College, traveled everywhere with them on assignment.

"She went on her first GEOGRAPHIC assignment when she was 13 days old—to New Hampshire," Momatiuk says. "At seven months, she went to Poland. We carried 4,000 diapers. She flew on the Concorde and on a helicopter before she even got into a sandbox. In the field, we'd just put her in a backpack and go to work. I nursed her for two years, which I feel can be very beneficial. It worked for all of us because she did not get sick in spite of changes in diet and water.

"The travel made her enterprising and curious, and it gave her life skills. She began to read when she was four. She went to college when she was 16. She saw her mother as focused and competent. She never saw her mother sitting and waiting for a man to come up with solutions."

But there was another side, too, Momatiuk says, adding that the lifestyle worked fine until their daughter began to attend school. It became increasingly apparent she would just as soon stay at home.

"She would make friends during our trips—which she does easily—and in three days, I would say: 'We have to go now.' She would never protest, but she would hang her head and I could tell she was sad."

A taste for the unconventional comes with age and experience. The last thing a child wants is to be perceived as different—no matter how exciting or exotic the difference. It would take another decade or so for Tara to understand the gift of her nomadic upbringing and appreciate the self-reliance and worldly perspective it gave. At the time, there was none of that. Only a discomfiting sense of being set apart from others.

"We would pitch a tent in the backyard and spend the night in sleeping bags to show her you can camp in the middle of the winter," recalls Momatiuk. "When we came back to the house, she would mumble under her breath, 'I am not going to mention this to anyone.' She was afraid the other kids would laugh.

"Once she came to me and said, 'Could you please work at IBM?'

"We lived near Kingston, New York, and most of her friends' parents worked for IBM. She was saying she wanted to stay at home and not go away and not feel different. In Kingston, mothers took daughters to the mall. Tara didn't have that. She was around for a while, and then she was gone, off to wherever the next assignment took us."

It is every parent's angst. What to do about the children. The collision between the welfare of the child and the well-being of the parent. It is worse than a tug at the heart. It is a tearing of the heart and there is nothing new about it.

Gertrude Käsebier, the 19th-century American photographer who specialized in portraiture, waited until her children were nearly grown and then enrolled at the Pratt Institute in New York to study painting. It was a long-deferred yearning, and finally she could realize it. "My children and their children have been my closest thought," wrote Käsebier, "but from the first days of dawning individuality, I have longed unceasingly to make pictures…."

In the 1930s, Dorothea Lange, famous for her social documentation and portraits, left her children with friends and relatives while going on the road to shoot her memorable photographs of migrant workers for the Farm Security Administration. The FSA project, under the aegis of Franklin Delano Roosevelt's New Deal, documented the work and life of farmers impacted by drought and the Depression. There were nine photographers in the project. Two were women: Lange and Marion Post Wolcott. "The women's role is immeasurably more complicated," Lange said, and she spoke from experience. "They produce in other ways. Where they do both there is conflict."

In the 1980s Yva Momatiuk dealt with the conflict, bringing her young daughter along while she and her husband worked on assignments. "I would probably perish if I just had to stay

MARY ELLEN MARK • SYDNEY 1988

Playing to her father and grandfather, Irene Sifniotis presents an informal encore following a recital of dances at an afternoon
school for the study of Greek language and history.

home and take care of her," Momatiuk says in retrospect. "I was probably a much better mother
taking care of her in the field and going crazy."

There are many ways to cope, but there is no escape from conflict. There is only angst and
the hope of doing the right thing, whatever that may be. "You come to the office and insist you want to
be treated as a photographer, not as a woman," says Annie Griffiths Belt, "and then you go home and
you *are* a woman and a mother and have to do all those things that go with it." To be a woman photog-
rapher is to realize somewhere along the way that you are both a woman *and* a photographer.

Thoughts on the road not taken. Lynn Abercrombie, whose husband Tom worked
as a NATIONAL GEOGRAPHIC staff photographer and writer for more than 38 years and who is a
photographer herself, is looking back on her life and late-blooming career. "Tom always wanted me to
travel with him, but I didn't want to leave the kids. I didn't have the courage that Annie Griffiths Belt

had to take the kids with her. I still don't know how they do it," she says with admiration of the generation that followed her.

"At that point I was just a housewife. But I was traveling with Tom and helping him. He would encourage me to pick up the camera, and the picture editor on the story would make it clear that the GEOGRAPHIC would pay for whatever they published of mine.

"My first published pictures appeared in Tom's 1977 story on Egypt. But my big break was the Oman story in 1979. I had access to the women, which Tom didn't have. Then Tom proposed a story on the Frankincense Trail, and Bob Gilka [former director of photography] called me in and said, "I want you to be the photographer on this assignment.""

Any regrets? she is asked. It must have been clear that she could have had a career had she pushed in that direction.

"Maybe I could have had a career," she responds. "But I was from the old school. I didn't wake up until it was too late. If I had to do it over, I would have done more with the career. I still feel the mother has to be close to the kids, and the places we went to were not necessarily the places you bring children. I was just getting started," Abercrombie says, not so much with regret, as wistfulness. "I always wondered what was around the corner."

There is wisdom in knowing no one ever gets it all. The question comes down to what is important. There is love for one's family and friends and children and there is love for the feel of the camera in hand and of turning toward the light, and the two do not always coincide. "Can you be a wife and a correspondent?" the war photographer Dickey Chapelle was once asked. "Not at the same time," she replied.

For three short years in the late 1930s, Marion Post Wolcott traveled the dusty roads of America for the Farm Security Administration and documented the Depression in a series of luminous and touching photographs. Then, she quit. She married and had four children.

In his biography of Wolcott, Paul Hendrickson asks why she abandoned her gift. Was it cowardice? A loss of confidence in her ability to see a photograph through the lens? An inability to demand what she needed? Was it the selfishness of a dominating husband who couldn't bear sharing her with anyone else, let alone the world?

It was all of that, but something else, as well. Wolcott, Hendrickson concludes, put down the camera in an act of generosity and wisdom. Raising good children, he realizes, can be a supremely creative act, too. Marion Post Wolcott took great photographs, then gave that up to raise a family. The things we do for love are many and varied.

Maggie Steber is on the verge of tears, but there's no time for that, just yet. She has a projection session to get through. It's the ritual of showing the editors a work in progress, and so Steber is deeply engaged in going over the slides she shot on assignment in Nepal and in organizing her notes in preparation for the show.

There is a theatrical, almost eccentric flair to Steber. She has broad mobile features, is all jump-start energy, and speaks with a Texas drawl soft as a lullaby. Most of all she wears her great, big heart bravely on her sleeve. On this particular day, she confides, she is dealing with the death of a beloved cat, Spike. It had been a well-loved and loyal friend through dark times, and she had to go

back to New York on the weekend to bury it, then turn right around and return to Washington for the projection session. Grieving would have to wait.

"On the train, I found myself asking myself. 'Why do we do this job?'" Steber says. The past year had been a litany of loss for her: A 20-year-long relationship with a boyfriend had ended; her mother ("the bravest, smartest person I know") had been diagnosed with Alzheimer's; and now, she was dealing with the death of her pet. The balancing act never ends. It simply gets more complicated.

Why, Steber wonders, do we do this job when people we love fall away from us unable to tolerate the uncertainty, the long separations, the divided loyalty? Why do this job when we are not there for the important times? "I never thought I would have this life," Steber reflects. "I thought I'd marry an insurance salesman and teach French in Texas, and it was not until I found photography that I ever thought there could be something beyond that. As a child I had a vivid imagination and wanted to be an actress and a spy. If I had, I would not have had this full and rich life. Anyway, as a photographer I got to be an actress and a spy in a different way; I got to be a French teacher as well."

It was a privilege, this life. She could add up the richness of it. There was, to begin with, the access one had to people's spirit, the experiences in the field, the relationships, the voice one could give to people who would not otherwise have had one. It went far beyond what a little girl growing up in Electra, Texas, could ever dream.

Yet there was a bittersweet acknowledgement that every choice has its consequences—broken relationships, broken hearts, and not being there for the important times. "There are days when my greatest fear is that I'm going to be a woman alone," Steber said. "And there are days when I see myself standing atop a mesa and I'm soaring like an eagle and I can only do that alone. Ultimately we're alone anyway. Some days I see it as an excruciatingly beautiful flight and other days I feel like, 'Oh, I'm going to end up an old maid.' You go from one to the other back and forth, back and forth."

Why do we do this job?

On her way back to Washington after burying her cat, Maggie Steber thought about that question yet again. There were times, she had to admit, when photography felt frivolous. Photography could be intrusive. The repeated exposure to tragedy and pain could numb the soul. It could put people's lives—and your own—in danger.

Why do we do this job?

Steber considered the question carefully and wrote down her answer en route to the projection session at the magazine. Anyone who wonders about the compulsion to shoot pictures should pay attention to her words:

"If each photograph represents an experience, a document, a memory, then you can look back at a life of memories, all strung together, trailing off behind you like the tail of a kite. If you represent the kite, the memories are what keep you from floundering, from falling off track. Sometimes I want to put my arms around all the people I've photographed and scoop them up with my heart, the way a woman gathers up flowers or berries in her skirt, and carry them with me always. These people, then, are my family, forever connected by the click of a shutter and a moment frozen in time."

Later she added, "I can't think of many other ways I would rather have spent my life." ∎

KAREN KASMAUSKI • TENNESSEE 1986

In east Tennessee, superstition holds
that women bring bad luck to the zinc
mines. Carolyn Wood turned that one
on its head when she showed up for
work and "just decided to stay."

FOLLOWING PAGES

ALEXANDRA AVAKIAN • IRAN 1999

Under the watchful eye of a chaperon,
a betrothed couple relaxes on a bridge
above Isfahan's central river.

SARAH LEEN • RUSSIA 1992

Tradition mandates a wedding portrait
with Russia's Lake Baikal in the back-
ground. Natasha Shirobokova and Igor
Karpov comply even in dead winter.

FOLLOWING PAGES

HARRIET CHALMERS ADAMS • SPAIN 1929

A letter writer's booth advertises
"The Truth"—*La Verdad*—above the
door. Other services include posting
and filling out official documents.

ANNIE GRIFFITHS BELT • JERUSALEM 1996

The secular—an off-duty soldier—and
the ultrareligious—an Orthodox Jew—
stand side by side at a phone booth.

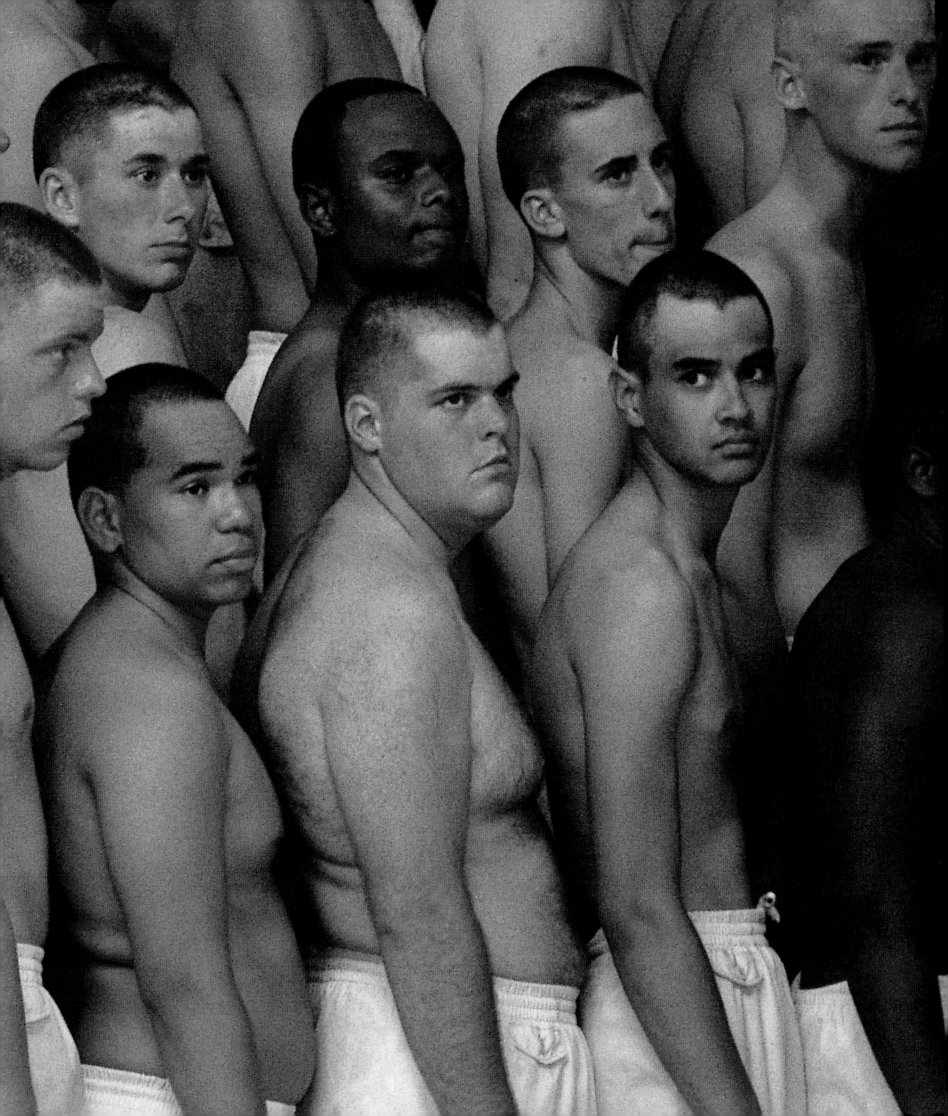

SARAH LEEN • KAMCHATKA 1994

In the shadow of two active volcanoes, Petropavlovsk lives under the constant threat of an eruption. But shoddy housing causes residents to fear earthquakes even more.

PREVIOUS PAGES

KAREN KASMAUSKI • SAN DIEGO 1989

Slouching at attention, a crew of young recruits line up for their first swim at the San Diego Naval Training Center.

LYNN JOHNSON • BELGIUM 1997

Former coal miner Giovanni Russo fingers
the portrait of his wife, who prayed to St.
Anthony to bring him home safely each day.

KAREN KASMAUSKI • BALTIMORE 1999

Surrounded by the love and support of her three daughters, Ina Savage, an Alzheimer's patient, sits on the porch of her Baltimore home.

PREVIOUS PAGES

MARIA STENZEL • CATSKILLS 1992

The cold, clean Neversink River draws swimmers on a summer's day. Eventually this water ends up in a reservoir that supplies most of New York City's drinking water.

MELISSA FARLOW • NEW YORK 1996

A little girl leans close to the comforting
presence of her mother on a private estate
above the Hudson River.

YVA MOMATIUK • POLAND 1981

The journey to a married life begins
with a ride in a horse-drawn wagon
for Staszka Pradziad and her groom.

213

JODI COBB • SUWANNEE RIVER 1977

At times as many as ten people crowd
the tiny cottage of John L. Colson,
a fisherman on the Suwannee. Finding a
space of one's own can be a challenge.

Annie Griffiths Belt

INTIMACY

ONE OF THE MOST SIGNIFICANT photographs
Annie Griffiths Belt ever took was of a seemingly insignificant
subject: a golf course being watered by a sprinkler system. "I shot
the picture for my first photo class at the University of Minnesota,"
Belt explains. "I was 21 years old. I was so lost in capturing the
morning light filtering through the spray of water, I didn't realize
I was lying on top of another sprinkler. It went off, soaking me.
But I got my picture." She got her picture and fell in love with
photography. Belt, who has published 17 stories in NATIONAL
GEOGRAPHIC, has been capturing the light ever since. The privilege
of photography is the privilege of access: to people's lives, their
hearts, their souls. It's the privilege to make intimate photographs,
such as the ones that follow, selected from stories Belt has covered
in the Mideast. "Covering a major league game or riding in *Air
Force One* is a thrill," she says. "But in the long run they don't
satisfy. The greatest satisfaction is to arrive on the doorstep of
a stranger and say, 'May I come in?' and be allowed in." How to
get the door to open when language is a barrier? For Belt, a gesture
is worth a thousand words. "I rarely work with an interpreter. I can
get closer without one. I make myself understood through charades.
It forces you to use touch, eye contact, and laughter." She uses that
and more. She becomes part of the family—bathing the kids,
changing diapers—camera always in hand, capturing the intimate
moment as it unfolds.

GALILEE 1995 Marking a year of mourning, the women of the Zuabi family visit the grave
of their brother Hisham, killed in an car accident.

GALILEE 1995

The family of Asher Attia collapse in grief
at his funeral. He died when a car bomb
exploded beside the bus he was driving.

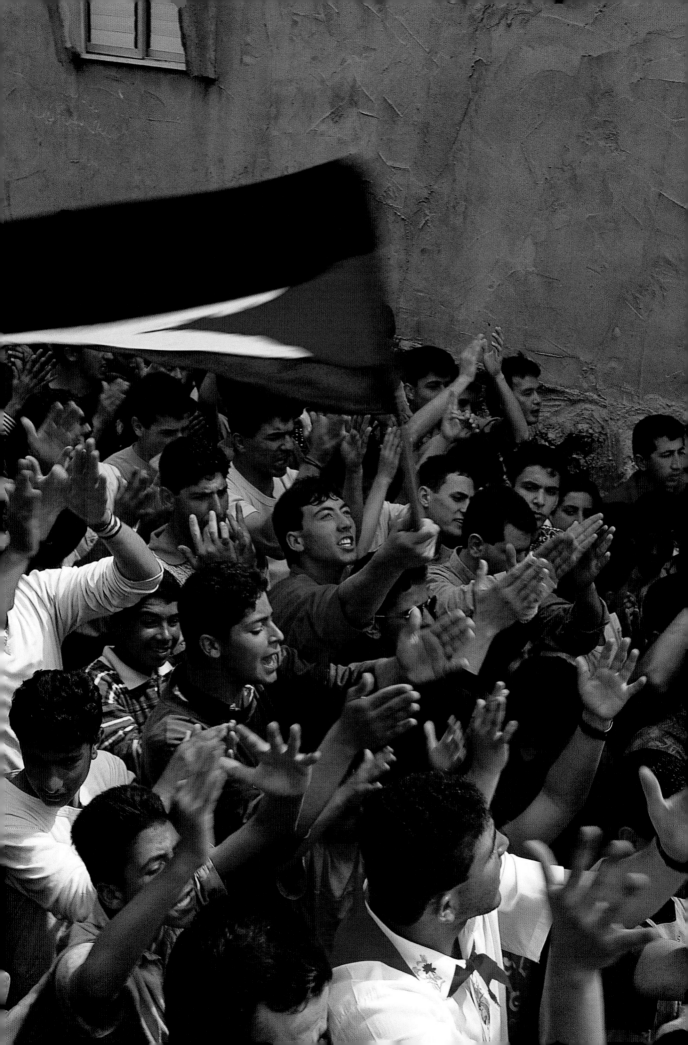

JERUSALEM 1996

A stolen kiss between an off-duty Israeli soldier and his girlfriend goes unnoticed in West Jerusalem's Zion Square, where young people socialize on stone benches

221

GALILEE 1995

Faith burns brightly during the Jewish
holiday of Lag b'Omer when Hasidic
Jews light bonfires to honor Rabbi
Simeon, survivor of the Bar Kokhba
revolt of A.D. 132-35.

222

THE
INCANDESCENT
MOMENT

MARGARET BOURKE-WHITE • RUSSIA 1930s

Children in the village school in
Kolomna gaze solemnly into Bourke-
White's camera during her visit to
the Soviet Union.

PREVIOUS PAGES

JOANNA PINNEO • MALI 1998

Covered by a blanket of sand from
a dry lake bed, a family naps in the
middle of the afternoon.

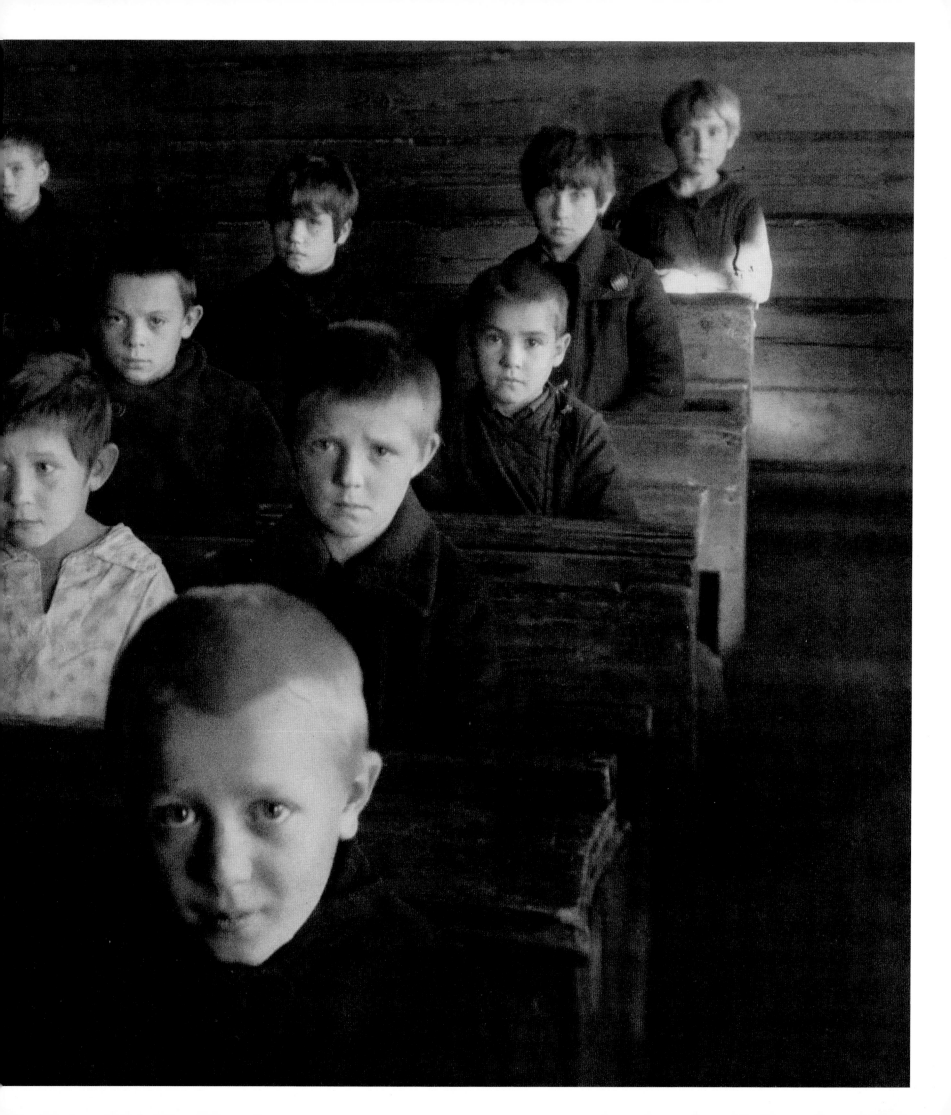

ALEXANDRA BOULAT • ALBANIA 2000

For a clean start on St. George's Day,
Arian Parllaku gets a traditional scrub,
with flowers and an egg rub for luck.

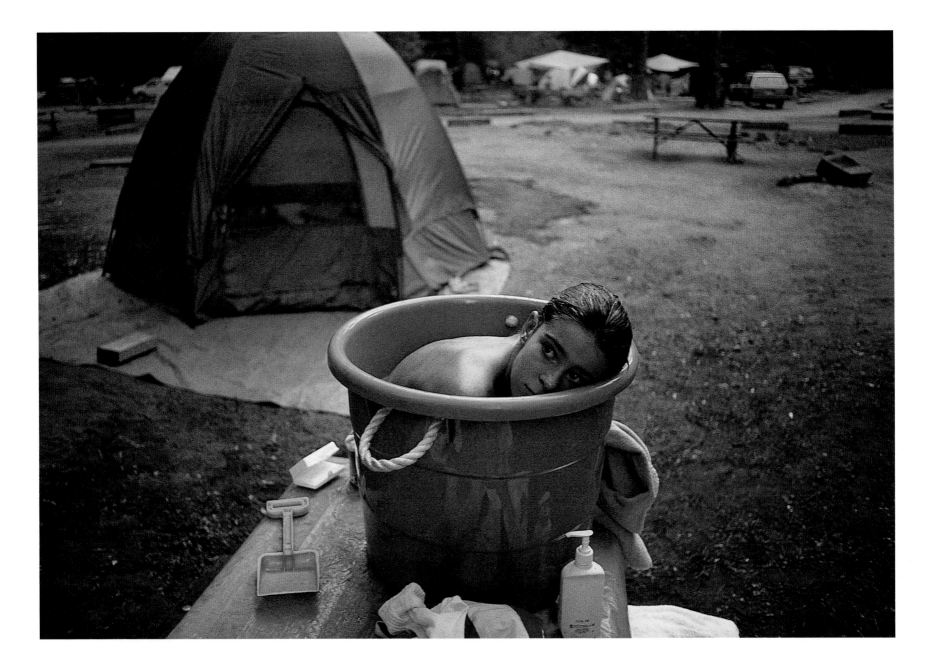

MELISSA FARLOW • YOSEMITE 1994

Snug in her tub, a young camper takes
an outdoor bath in Yosemite, one of the
treasures in the U.S. National Park System.

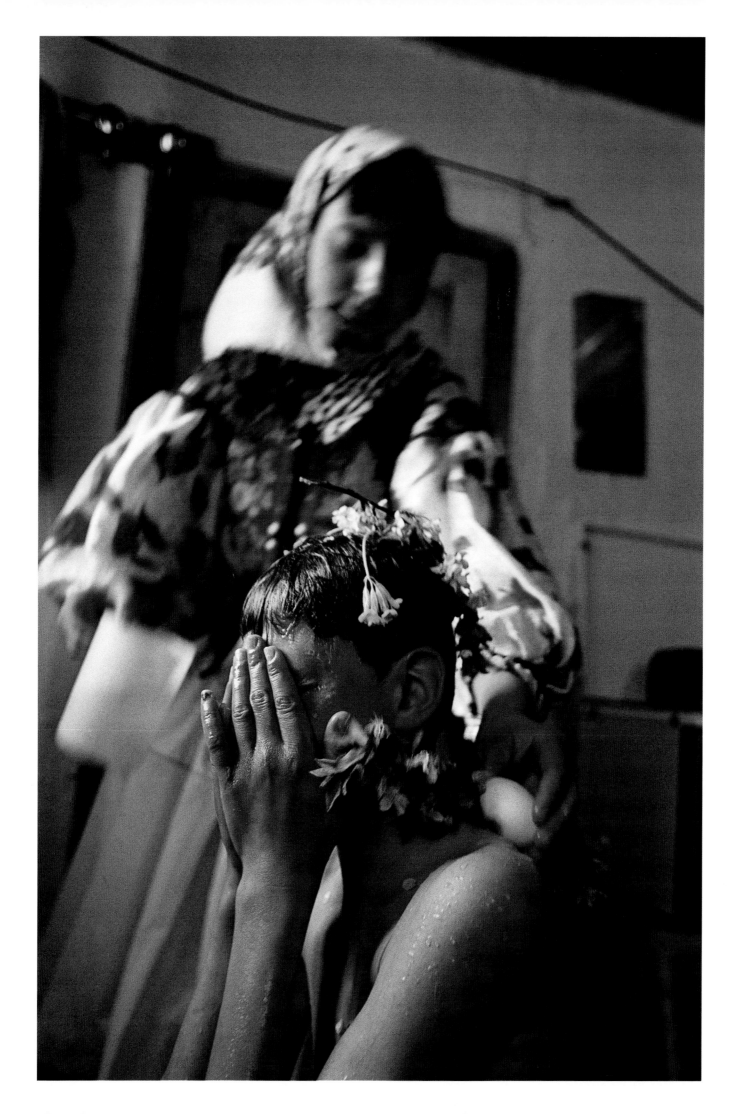

THERE'S A KNOCK ON THE DOOR of an apartment in Helsinki and Ella Eronen, one of Finland's most beloved actresses opens it and lets a photographer in. "Wait," she says to the photographer, who is unpacking a camera. "You don't want to photograph me; you want to photograph 'Madame.'"

She puts on the costume of "Madame," her most famous role, and poses with the theatrical flair of the actress she is, moving around and stationing herself at various spots in the living room. The shooting progresses, formal, posed, and then there is a pause as Eronen sits down on a snow-white couch for a brief rest.

She is in her 80s now. Her skin has the translucence of parchment, her face the delicacy of porcelain, with the fine cracks and traces aging imparts. A gilded wall clock hangs above her couch. Opposite that there is her portrait painted by her husband. In the painting, done decades earlier, she is also dressed in costume—an extravagant cascade of black silk and lace. It's the same costume she wears now, the costume of "Madame," an actress who felt lost unless she had a role to play.

As her younger self stares down with gentle irony from the portrait, Ella Eronen lifts a hand mirror to check her makeup. At that nanosecond, the camera clicks, recording the chimera of age seeking to recapture youth.

It's a magical photograph. To Jodi Cobb, the photographer, it's something more. It's that thrilling elusive "moment between moments," the culmination of hours with a camera trained on a subject, days of waiting for appointments to fall into place, weeks of preparation, months of separation from family and friends, and the eternity of angst that goes into putting together a story in pictures.

A photographer walks the narrow streets of Jerusalem, and comes upon a cobblestone square in the business district of the western part of the city. Young people sit on stone benches. Traffic whirls past; red lights blink on and off. In the middle of the flow, two lovers meet by a guardrail. She leans against him, head tilted up for the kiss. He cradles her head, his automatic rifle hanging by his side. As the kiss joins the lips, the camera clicks and records two people lost in each other, oblivious to a world around them that requires even amorous off-duty soldiers to carry weapons at all times. It's a photograph of intimacy in a totally public setting. Annie Griffiths Belt, who took the picture, had been seeking a human face for the young soldiers who live everyday lives in uniform in a city where war seems never to end. After weeks of searching, she found it in that fleeting instant.

Such pictures are a heartbeat in time. To seek out and pounce on those moments is the passion of photography. The women who have claimed this passion as their own approach their work in different ways. They may be driven to shoot for different reasons. They may be drawn to different subjects. Their styles may vary. But they pursue the same elusive goal: to preserve that instant when the stars align to make magic. Such moments are as incandescent and ephemeral as a dream.

"I remember being in Nigeria and entranced by this African woman's skin," says Joanna Pinneo. "It was like velvet. I looked at her eyes; she seemed to know me. I remember her turning and looking at me. I remember the light. Although I kept taking pictures, she didn't look startled; she just moved calmly on. I remember coming to the realization I hadn't had a conversation with her, but I *thought* I'd had a conversation with her, and I felt I knew her and she knew me. Not only the whole world of her beauty was open to me, but this wordless relationship we had experienced."

How do these things happen? Who knows? The goal is not to explain, but to capture.

"In Haiti, I would spend a lot of time in the slums," Maggie Steber recalls. "It is hell on earth, just endless garbage and filth. Then out of nowhere, a little girl in a tattered dress skips by. In her hair, she's wearing a new red bow that cost a penny. She's singing a song. If that's not confirmation of the human spirit, what is?"

The human spirit, perhaps, is photography's greatest subject. "To be good," Dorothea Lange said, "photographs have to be full of the world."

It's a world full of sadness and joy. Photographs record it all. They tell of birth and death and most things in between.

Much has been said about the aggressive, acquisitive language of photography. Photographers "take" a picture. They "get" this; they "capture" that. Photographers give, too. They illuminate the human condition. In doing so, they also give hope. "Photography can change people's ideas, can change their minds, can change their actions," says Jodi Cobb. "I guess that's one of the things that keeps us getting up in the morning and going out with our cameras."

There is an enchantment to photography: For every picture that gets away, something turns up in its place. Life balances itself. Equilibrium settles in. The passage of time smooths the rough edges. The world takes a quarter turn. The moon lifts into view. The impossible happens. Magic happens.

"There's not a trip that something miraculous doesn't happen," says Sarah Leen. "These are soul-changing moments. Whether it's being invited into a house. Looking at a vista. Seeing the light. That's when you think. That's when you know and can say: 'This makes it worthwhile.'"

Such incandescence can happen anywhere, anytime. It can happen almost without warning. "I just shake at new experience," says Annie Griffiths Belt. She describes the time a fisherman welcomed her to his waterborne realm on the Sea of Galilee. He made a place for her in his small wood boat. He made strong, dark coffee and offered it in a tiny cup. His graciousness overwhelmed her. "I had tears in my eyes," she remembers. Such moments of grace are one of the rewards of a photographer's life. There are the things that happen when you least expect them and they inspire, if not awe itself, then something close.

"The best moments are the surprises," explains Jodi Cobb. "The unexpected elements that slipped in from the side. Or how the film translates the colors and light. The way the light hits a surface and makes it sparkle. The way all the expressions of the people in a picture line up." There are many such moments in her photographs. The mysterious figure in black darting across the Saudi desert. The soft shimmer of white satin on a model's body. The vibrant, exclamatory red of a geisha's lips. They are wonderful images, but more than that, they are memorable.

"There's a photograph she did in Jordan in the early 1980s when she had access to the Royal family," recalls illustrations editor Kathy Moran. "It's a little red tricycle that belongs to one of the princes, and it is parked right at the bottom of a long sweep of red-carpeted steps. It's a small touch that most people wouldn't have noticed, and every time I see that photograph I laugh."

For Cobb, part of the joy of photography is that it is active, not passive. "It's the dance, the motion, the choreography I love—the sheer physicality of it," she says. "The moving around, the working with people; moving close, moving back, getting out of the way, and catching other people in

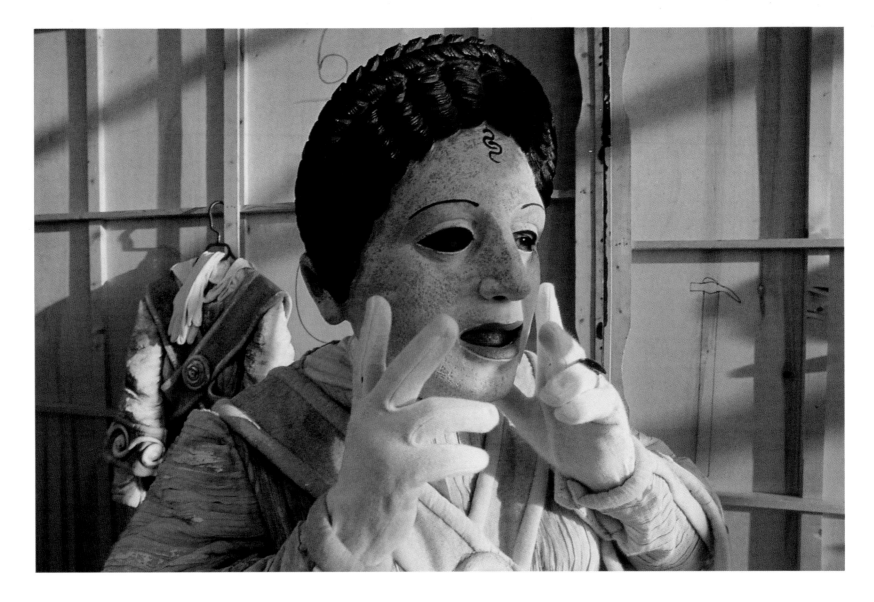

SISSE BRIMBERG • SICILY 1994

The drama of the past unfolds when actors like this one from the Classical Theater School of Syracuse take the stage of an
ancient Greco-Roman theater south of Palermo, Sicily. The ruin is open for performances 14 days a year.

movement. It's not standing behind a tripod, organizing everything in front of me. I want to surprise
myself, too."

Sometimes the joy comes from small, quiet moments. While covering a story on the
American poet Walt Whitman, Maria Stenzel immersed herself in the man's work, finding inspiration
for the photographs and for herself in the poems. She brought the poems to visual life with images of
the things Whitman wrote about: the blunt vitality of the New York skyline; the stormy swell of the
ocean; the soft summer light on dune grass. She carried Whitman's *Leaves of Grass* with her in the
field and would call a picture editor back at Society headquarters from a phone booth:

"Listen," she would say, and launch into a poem:

"Afoot and light-hearted I take to the open road,

Healthy, free, the world before me...."

Her voice glowed.

Sometimes that joy comes when, after many long, lonely hours of work, light, color and

composition suddenly come together and a photograph happens.

"I was on the Marquesas Keys, 30 miles west of Key West, trying to photograph frigate birds," recalls Bianca Lavies, a retired staff photographer who specialized in natural history subjects and worked for the magazine in the 1970s and '80s. "They were nesting there for the first time in the United States. The United States Fish and Wildlife Service was fussy about how long I could spend shooting them and had come along to monitor my work. I had to wade through waters frequented by sharks to get to them. I was allowed to have three sessions, a half-hour each, to photograph the birds. The first day nothing much happened, but the next morning I went back, and the rim light was great, and I knew I was getting something fantastic." That something fantastic—a mother frigate bird sheltering its nestling—ended up as a cover photograph on the magazine. "I was often cold. I was often wet. I was often tired," Lavies says, looking back on her 18 years on the magazine. "But I was always happy."

Life doesn't hold still. Time passes. Faces fade. Events grow dim. Only a photograph holds the moment in thrall. A photograph brings it back—real, vivid, immediate. We look at it and laugh or cry. Sometimes both.

Why take pictures? To preserve that moment. To hold fast to an instant that is scarcely a blink in eternity. "Photography documents history," Maggie Steber says. "I could almost weep about it. Sometimes I think the only important thing photography can do *is* document. I frankly don't care if anyone remembers me. But remember the pictures and remember the people in the pictures."

What motivates Maggie Steber to document history, or Jodi Cobb to wait for an aging actress to put down her mask, or Annie Griffiths Belt to capture a stolen kiss in the middle of a Jerusalem square? There are many reasons. Listen:

To peel back a curtain.

"I like intimate stories that show a closed world, whether it's Saudi women or the Japanese geisha," says Jodi Cobb. Her story on Saudi women was a near-miracle. Photography is taboo in that culture. The assignment was an unbroken litany of rejection and refused permissions. First she got stopped taking a picture of the outside of a building. Then the police stopped her and said it was illegal to photograph anything in Saudi Arabia, especially women. Then, the Saudi government withdrew her travel permissions halfway through the assignment. She ended up shooting indoors with the consent of her subjects ("The women didn't mind me photographing them, but they didn't want the men to see me photographing them.") or from the backseat of a car with a 400-millimeter lens. "It was the fewest number of rolls of film I've ever shot in my life," she says. "I didn't think I was going to pull it off up until I looked at the film afterward."

In her work on the geisha, Cobb penetrated the hidden world of women forced into their role by adversity or tragedy. Out of such stricture and sorrow, the triumph of the geisha was to transform themselves into living works of art. "The two cultures—Saudi and Japanese—are as different as you can get, but in their heart and soul women want the same things," Cobb observes. "They want dignity, they want respect, they want love, they want a sense of security, and they want personal freedom."

To bear witness.

"I covered the velvet revolution in Czechoslovakia, the fall of the Berlin Wall, the breakup of the Soviet Union," Alexandra Avakian says. "I was fascinated with what people will

do to change their situation. I was drawn to aspiration born of desperation. I felt it was important to be a witness."

To bear witness, even if it breaks your heart.

It was the period of the first elections in Haiti, in November 1987. "Every day 20 to 30 people were being killed to frighten people and keep them from voting," Maggie Steber says. "Every morning the journalists would get up and drive around and look for the dead bodies. We were driving around, looking; people would stop and pull you over to show you a body. One morning, I said to a Haitian friend who was with me, 'I can't do this again. I feel like a vulture.'

"Then my Haitian friend, said, 'Look Maggie, you *have* to photograph these people. You have to record that they lived and died. They died for a reason. You are their only voice, and if you don't record their death, you don't record their life.'

"I said, 'Beatrice you are right.' It was easier after that."

To find a connection between work and oneself.

"I wanted my work and my heart to be in the same place," says Susie Post. As a freelance photographer she worked for nonprofit groups, including a Baptist mission, and photographed stories about the orphaned children of parents taken by AIDS, the drought in Kenya, and migrant workers in Texas. Later, that same sense of purpose would carry over into her work at NATIONAL GEOGRAPHIC in stories on West Virginia's New River, the Aran Islands and a book on the Pan American Highway. "It is important that I do work that feeds the soul," she explains.

To find solid ground, perhaps, even, a home, for oneself.

"I feel as though the Wodabe nomads in Niger became my home and family," says Carol Beckwith. "I lived with them and learned their language. They became my roots. I was much happier living that life than I am living a Western life. I find the Western world more difficult. In Africa, you're always a part of the community; you don't feel the kinds of isolation you often feel in Western culture. Dealing with basic survival among the Wodabe has more immediacy for me than dealing with survival in the world of 20th-century London or New York. It gives me a greater sense of myself than paradoxically I could expect to find here."

For the experience.

To say you were there on the day a Maya tomb was opened. There for the fall of Duvalier in Haiti or the rise of Khatami in Iran. There the instant a shaft of sun touched a peak in Peru. There for shivery magic of the northern lights in Canada. "I'm like a collector," says French photographer Carole Devillers, who has covered stories on the Wayana Indians of French Guiana and Africa's Sahel for NATIONAL GEOGRAPHIC. "I don't want the past to go." A photograph is proof positive. You were there. You saw. You heard. You felt.

For the sheer pleasure of it.

Says a photographer of her discovery of the camera as a young girl of eight, "I loved having a camera in my hand and a pocketful of film. I shot cats, the way shadows fell on the ground, the life around me." There was excitement in her voice and a sense of urgency. It was as if there would never be enough film to capture everything she saw.

To change the world.

"I see photography as a crusade," says Lynn Johnson. "I'm not just here to hold up the

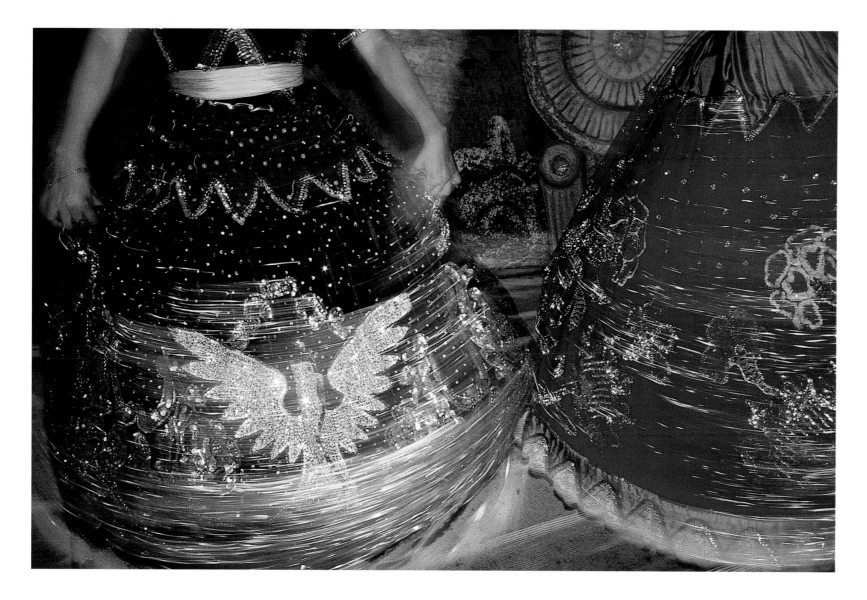

SISSE BRIMBERG • MEXICO 1990

A blur of sequins shimmer from swirling "China poblana" dresses worn by dancers in Acapulco.

mirror. I think we're supposed to improve the world. We're not just here to distill it down to color and composition. Editors have seen the extremes of the world. We are always being asked to come up with superlatives, to take the next step. It can corrupt the process. Every so often I talk to myself. I say, 'What is your intention?' It has to be right. It has to be true."

To show that people have the same needs; the commonality of joy, sorrow, hope, and fear.

"The more I travel, the more I see we're all alike, whether Bombay or Boston," says Karen Kasmauski. "We show who these people are...."

They're all of us, of course. Photography is biography, displaying humanity in all its joy and sorrow, glory and shame. Photography is a spreadsheet of nature, showing a world rich in diversity: animals, fish, birds, people. It is a historical record, confirming the reality of what was. Here is what your Aunt Nancy wore at cousin May's birthday party. Here is how your mother looked as a young woman. Look at how vibrantly yellow the wildflowers were that day in the mountains.

And in looking for the moment between moments there is joy.

"I find myself laughing out loud when I'm taking pictures," says Jodi Cobb.

235

"I find myself cheering sometimes," says Annie Griffiths Belt.

Crying, too. While in Uganda and the Ivory Coast for a story on viruses, Karen Kasmauski recorded the suffering of mothers and children with AIDS. "I wept every day," she says.

The camera, said the American writer Eudora Welty, is about "wanting to know." Photography, she reminds us, is more than technique. There is an internal lens at work and that is important. "We come to terms as well as we can with our lifelong exposure to the world," she writes. "Eventually, of course, our knowledge depends upon the living relationship between what we see going on and ourselves. If exposure is essential, still more so is the reflection. Insight doesn't happen often on the click of the moment, like a lucky snapshot, but comes in its own time and more slowly and from nowhere but within." To discover the world is often to discover oneself as well. There is outer light and there is inner light. A good photographer needs both.

"Is it worth it?" Lynn Johnson asks. "If you had asked me a year ago, when I was in the middle of a divorce—if I were sitting across the kitchen table from my husband—I would have given you a different answer." Johnson speaks so softly one strains to catch the words. She is the quiet one, watching, waiting. In the spaces between her words one senses a commitment of stunning ferocity and integrity.

"It's tough being in the field. It wrecks your life. Unless that is your life," one picture editor remarks.

This is the life photographer Lynn Johnson and others like her have chosen. There is, at times, an ascetic feel to their choices, a giving over not unlike the monasticism of some religious orders. As the conversation unfolds, Johnson sits on a couch, fingering a square silver ring inlaid with bits of lapis, turquoise, and coral—her divorce ring, she calls it. She bought it on a trip to Arizona the day she heard that her divorce had been finalized. It is, quite literally, the touchstone of the end of an 18-year-long marriage.

Marriage—any relationship, in fact—ends so easily. The rift is imperceptible at first. A hairline crack widens into a fissure; then, one day you stand on opposite sides of a canyon. Marriage requires work, commitment, and all the virtues advice columnists write about. Above all, marriage asks that both spouses be—at least a good part of the time—in the same place at the same time. For Johnson, the career meant being away from home 70 percent of the time. Under such a burden, the marriage could not and did not hold.

"Now I would say yes, it's worth it," Johnson reflects. "I fully expect to be alone 30 years from now. It's the choice I've made. But then I'm alone on planes, in hotels, and in restaurants.

"You have to be in love with your story," she says, "otherwise how could you leave your home, your husband, your child, your garden and cast yourself into the unknown? You don't know the people, the place, the language, or if you'll get sick—wait, you do know you'll get sick. If you hadn't been driven by passion you wouldn't do this. It's the love of the light; the time of day; of watching the moment unravel. It's not what's on the page, although of course, that's a part of it. It's going into a scene with my ego in the shadows. I'm following along in someone's wake."

The voice is quiet, yet forceful. There is an acknowledgement, an acceptance, really, of the road taken. Any regrets have been, for the most part, left behind. So much is unsettled, so much is obscure in our lives; moments of clarity are few. And then, one day, the tracery of threads so hopelessly

tangled for so long, suddenly comes into order and falls into a pattern as exquisite as lace.

"As a woman, it is not enough to have form and color and light," Johnson says, reflectively. "I want to stand in the middle of a room where people are laughing, crying, and dancing. I want immersion instead of arm's-length distance." The divorce ring gets touched again, almost absently.

She has taken many photographs that speak of immersion instead of arm's-length distance, and they have the power to reach into the cave of the heart and draw out humanity's deepest hopes and fears. There is the image of a dying woman in Missoula, Montana, taken for an unpublished magazine story on pain. In it a woman at the bedside of a childhood friend sobs with grief at the imminence of loss. Her hand clutches the motionless hand of her friend who, stricken by a brain tumor, lingers somewhere in the boundary between life and death. In the background, in shadows like a mirage, another woman plays the harp to ease the passage into death.

The photograph, a meditation on death, teaches a mirror-image lesson about life. "The way she touched her dying friend was so tender," Johnson says. "She screamed out her pain and loss and it was just a wail in the room. She cried and then they both cried and that is the moment when you know how precious life is and how precious a privilege it is to be there."

There is another photograph taken for a story on the Russian poet Alexander Pushkin. Two ballerinas sit in the backstage dressing room of a theater in Odessa. One sits and smokes a cigarette with one foot propped up on a bench, her eyes bright with amusement at the stolen pleasure. The other laughs exuberantly, her shoulders lifted in mirth; her legs splayed, feet wildly akimbo, as if grace and delicacy were the furthest thing from her mind. The scene has a locker-room feel: a wink of naughtiness from a pair of ballerinas-gone-bad. The dancers are vibrant, so alive, so full of joy and between these two images of living and dying there is a universe of laughter and tears.

Such photographs take an instant and broaden it into an eternity, connecting then with now and here with there. "We see a great deal of the world," wrote Margaret Bourke-White. "Our obligation is to pass it on to others."

So that we who view those pictures might share the moment between moments and laugh and cry and dance as well. ∎

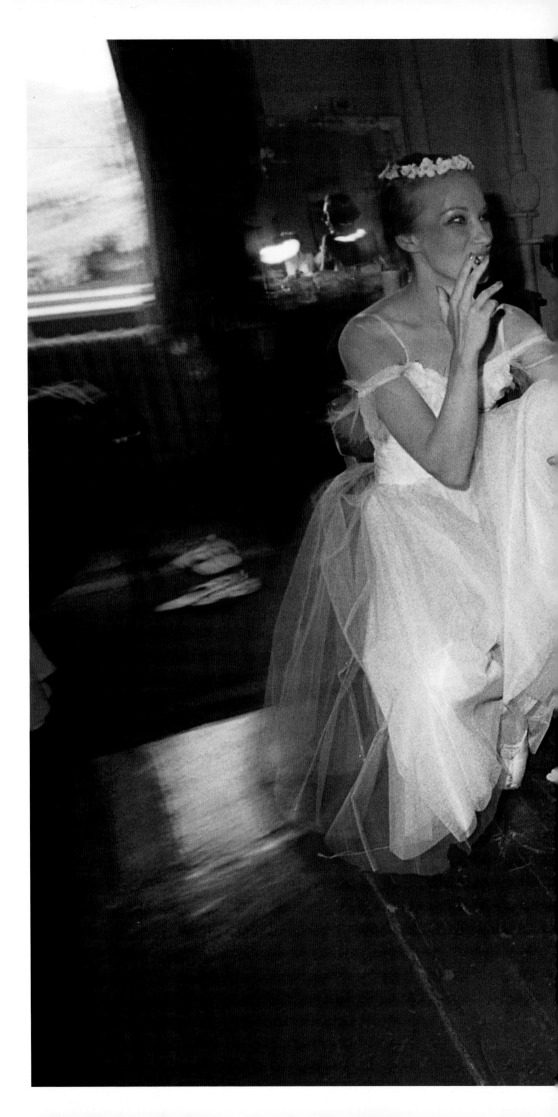

LYNN JOHNSON • ODESSA 1992

Offstage and in an offbeat mood, ballerinas in the dressing room of an Odessa theater enjoy a laugh and a smoke.

PREVIOUS PAGES

JODI COBB • TAIWAN 1993

In a shower of paper fireworks, Taiwan's 1992 baseball champs, the Brother Elephants, celebrate a winning season.

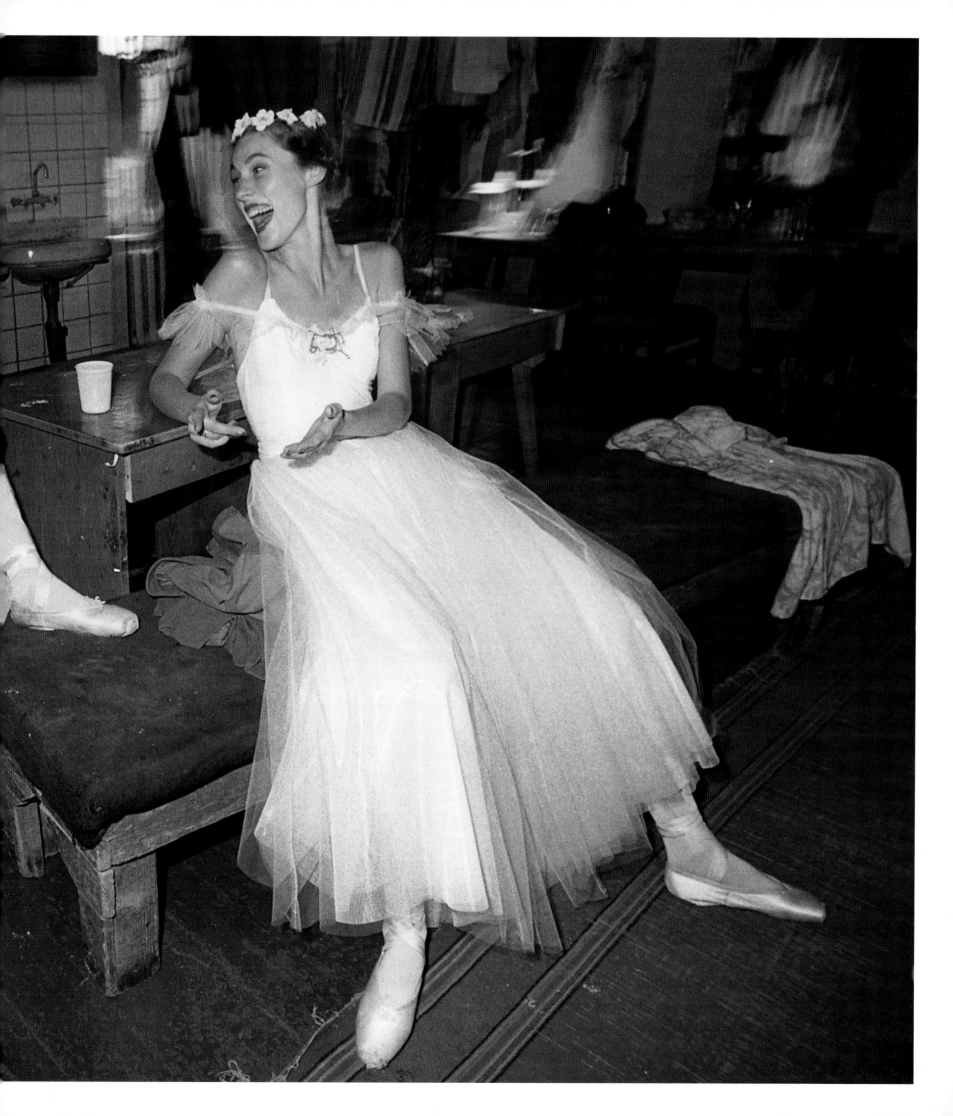

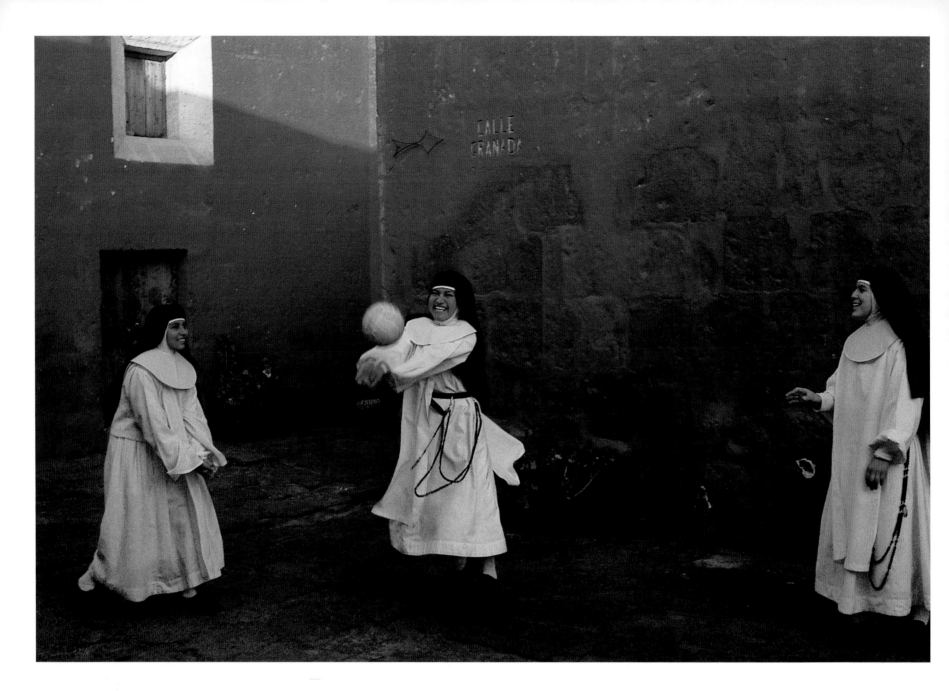

MELISSA FARLOW • PERU 1999

Moved by the spirit of play, novices at
Santa Catalina Monastery bat a ball in
the courtyard, an approved activity for
their transition to the cloistered life.

JODI COBB • THAILAND 1996

Before her job begins, a bar worker
on Phuket's nightlife strip pauses
to pay her respects to a shrine
honoring the spirits.

JODI COBB • BROADWAY 1990

Subway Santas do as every other New York commuter: They sit and wait for the next train.

SARAH LEEN • MEXICO 1999

Evoking the terror of the Spanish Inquisition,
a menacing figure rattles his chain at Carnival
in San Nicolás de los Ranchos.

LYNN JOHNSON • RUSSIA 1992

A delicate curtain of fish dries in a
window overlooking the Neva River
in St. Petersburg.

SARAH LEEN • RUSSIA 1992

In the greyness of dawn, Slava Basov
sets his nets as his ten-year-old son,
Tolya, pulls on oars in Lake Baikal.

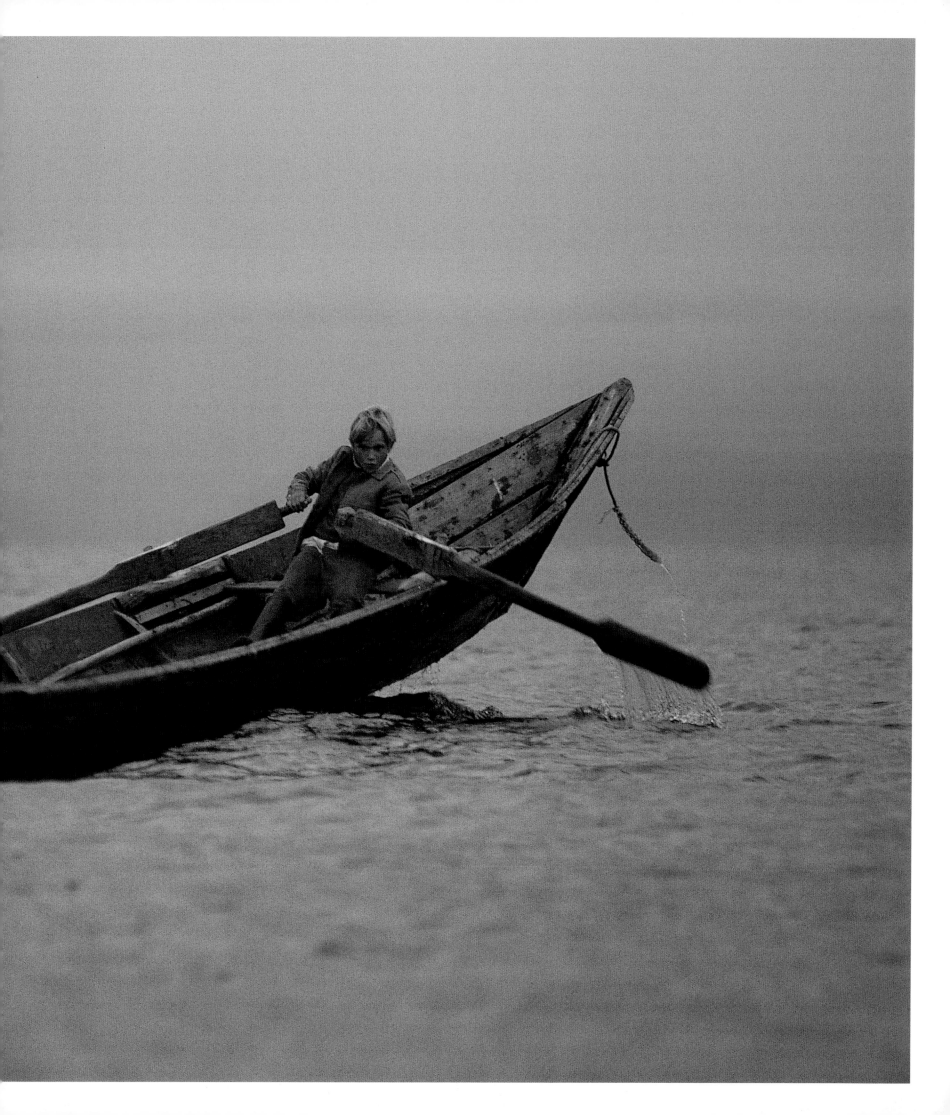

251

SISSE BRIMBERG • MANILA 1990

With shy grace, a young wedding
attendant poses before the ceremony.

FOLLOWING PAGES

JODI COBB • SAUDI ARABIA 1987

The citadel on Tarut Island houses a spring
used for bathing and laundry, where only
women may enter.

JODI COBB • THAILAND 1996

One of the many faces of gender,
a *katoey*, or transvestite, works at an
upscale cabaret featuring male performers.

JODI COBB • SAUDI ARABIA 1987

The enigmatic figure of a girl in a cloak
scurries along an oasis. "I was shocked to
see the cloak on girls so young," says Cobb.

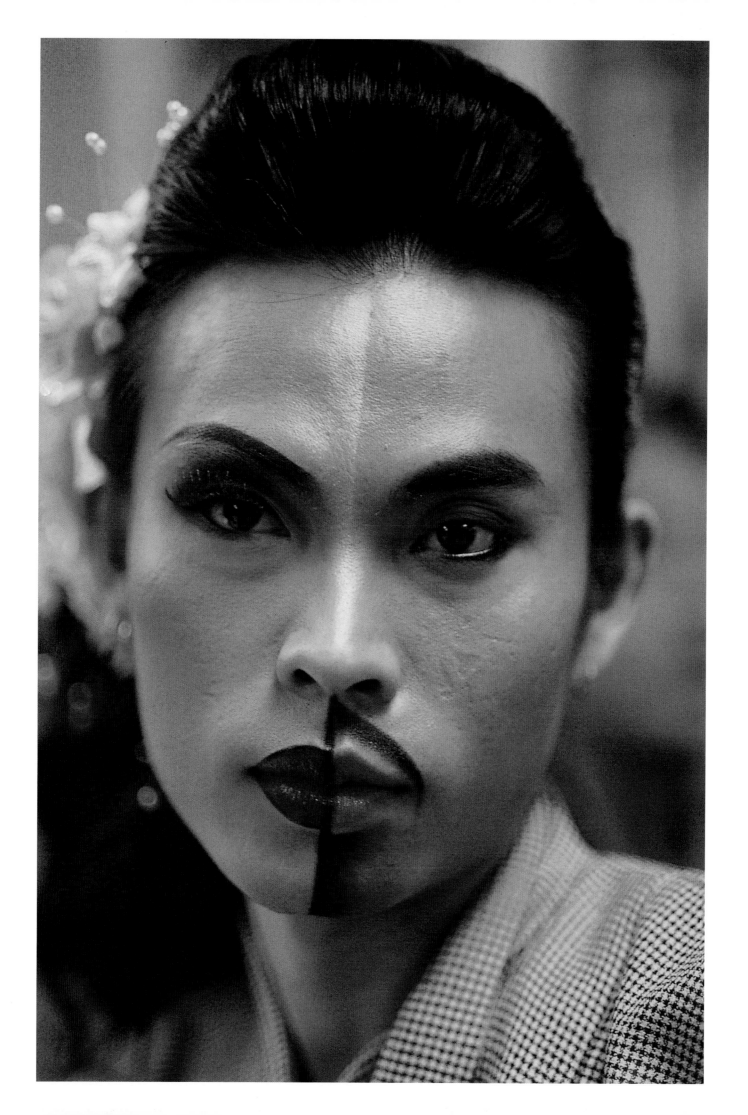

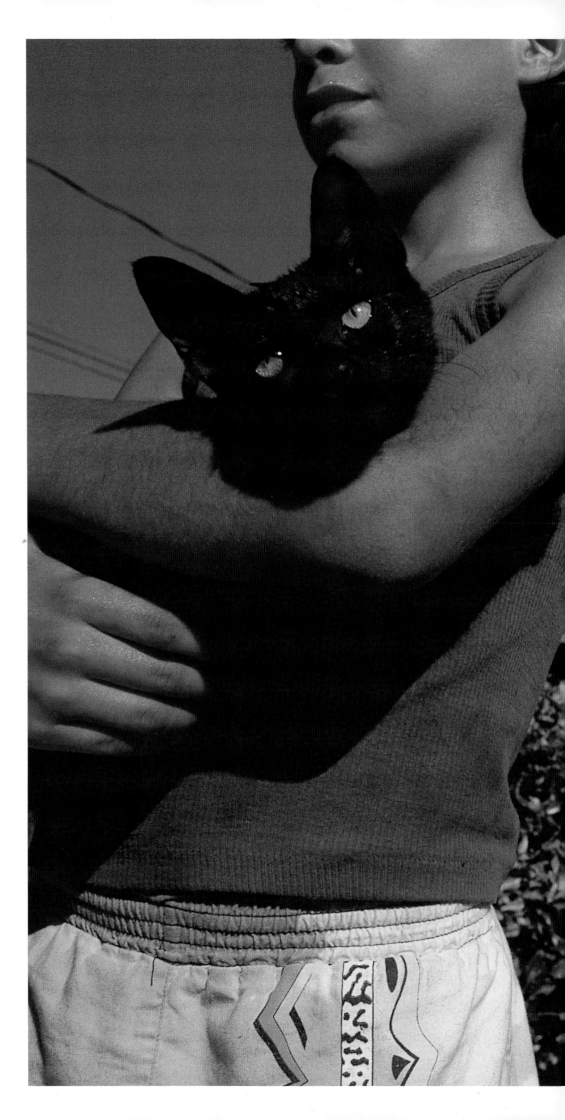

MAGGIE STEBER • MIAMI 1992

The drama of everyday unfolds before
Manuel and Ruben Rodriguez. Behind
them: a homeless man pushing his cart
of possessions. In front: a jitney bus in
flames. Neither seems odd.

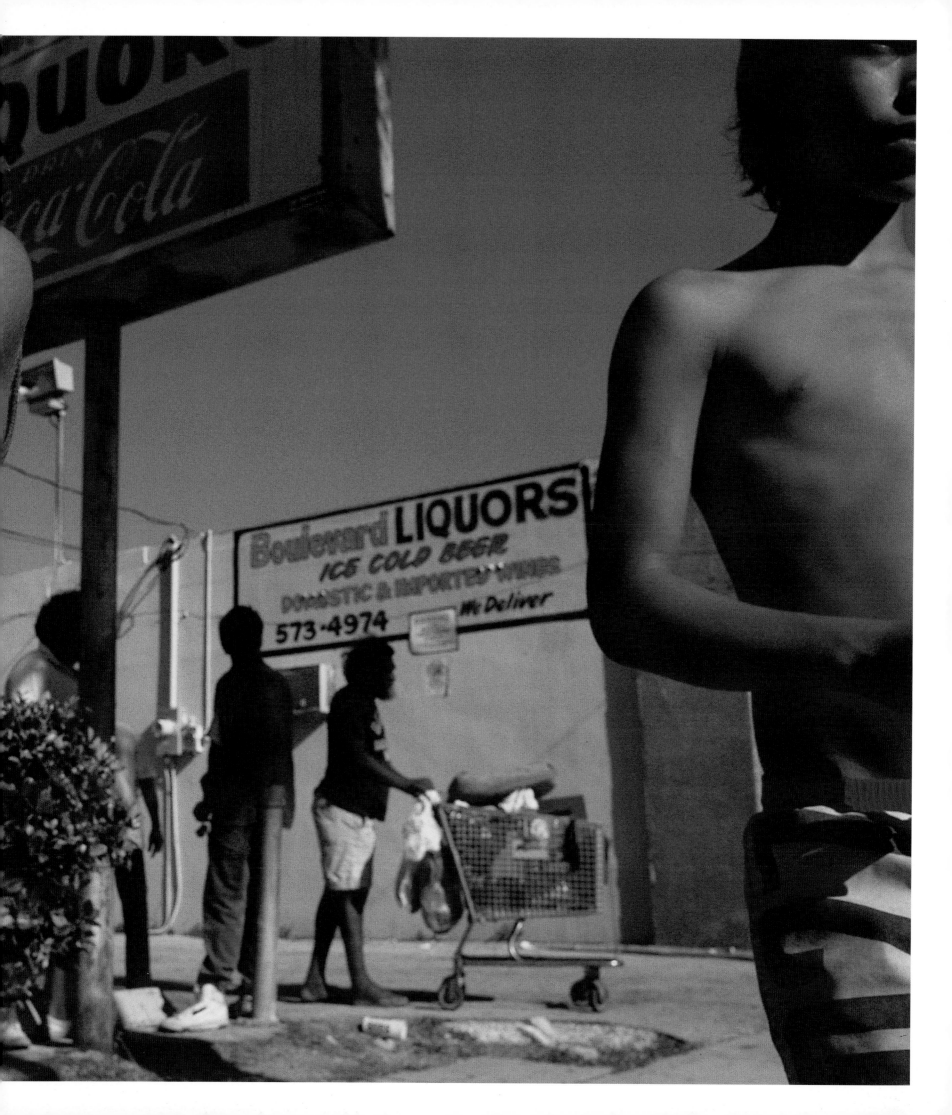

difficult situation into a tone poem of a picture. She also has a rare talent: the ability to do studio photography as skillfully as field photography. "She dismisses her talent at still-life photography," says a picture editor, "but it's a fine art to take a rock and make a beautiful image of it." Brimberg trained as a photographer in her native Copenhagen, and like many young hopefuls harbored the dream of working for NATIONAL GEOGRAPHIC. Unlike many others, she made it come true. "She wrote to me from Denmark, saying she wanted to work for NATIONAL GEOGRAPHIC," recalls Bob Gilka, the former director of photography who hired her in 1976. "I wrote back and said: 'There's not much chance,' What a sucker! One day I'm sitting in my office and get a call from the reception desk: 'There's a woman named Sisse Brimberg here to see you.'" She proceeded to talk her way into a job, and the rest, as they say, is history. Biographical subjects like "Catherine the Great," shown here, are particularly challenging. The photographer must feel her way into the shoes of the subject, then conjure the past with only imagination and serendipity as allies.

RUSSIA 1998 Two women nearing St. Basil's evoke the eve when a German princess, later Catherine the Great, arrived in Moscow with her mother.

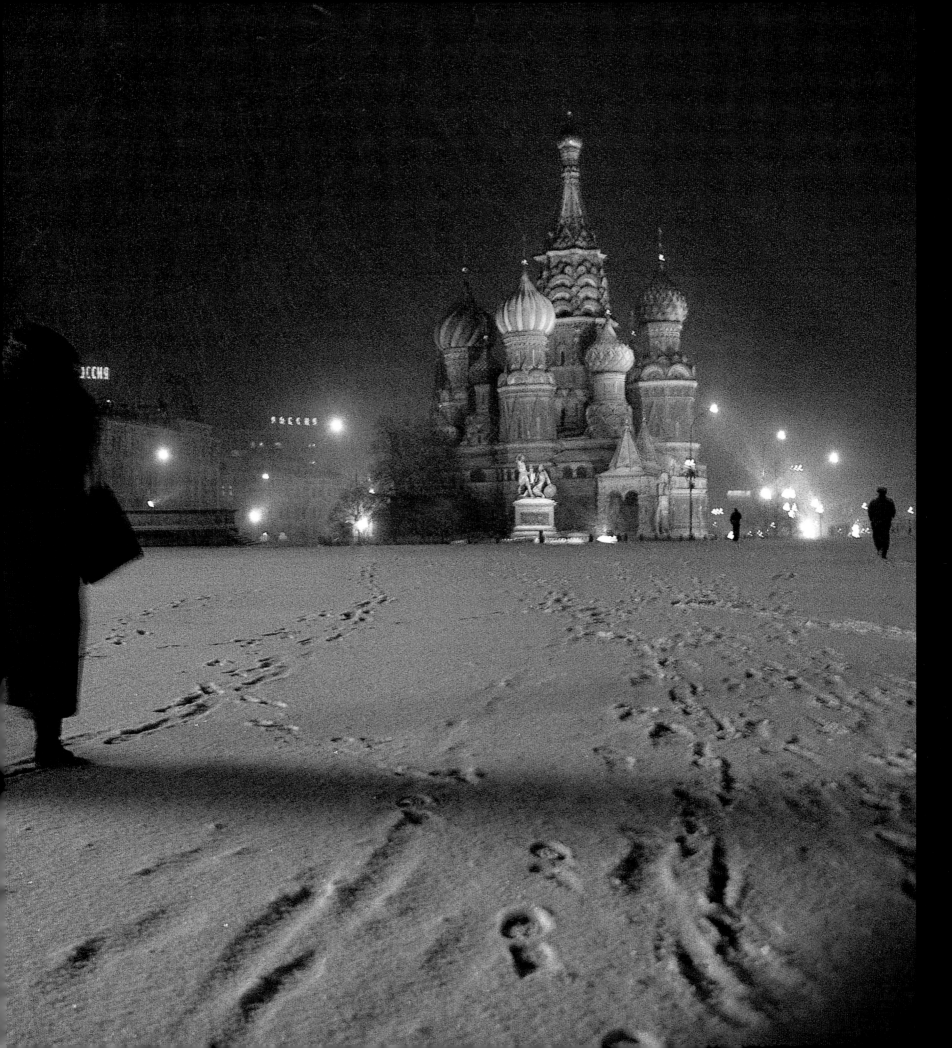

RUSSIA 1998

With her admiral grandfather, a young
girl watches graduation at a Russian
naval school.

RUSSIA 1998

With a bit of show-off self-mockery,
a sculptor displays his muscles in an
old Russian bathhouse.

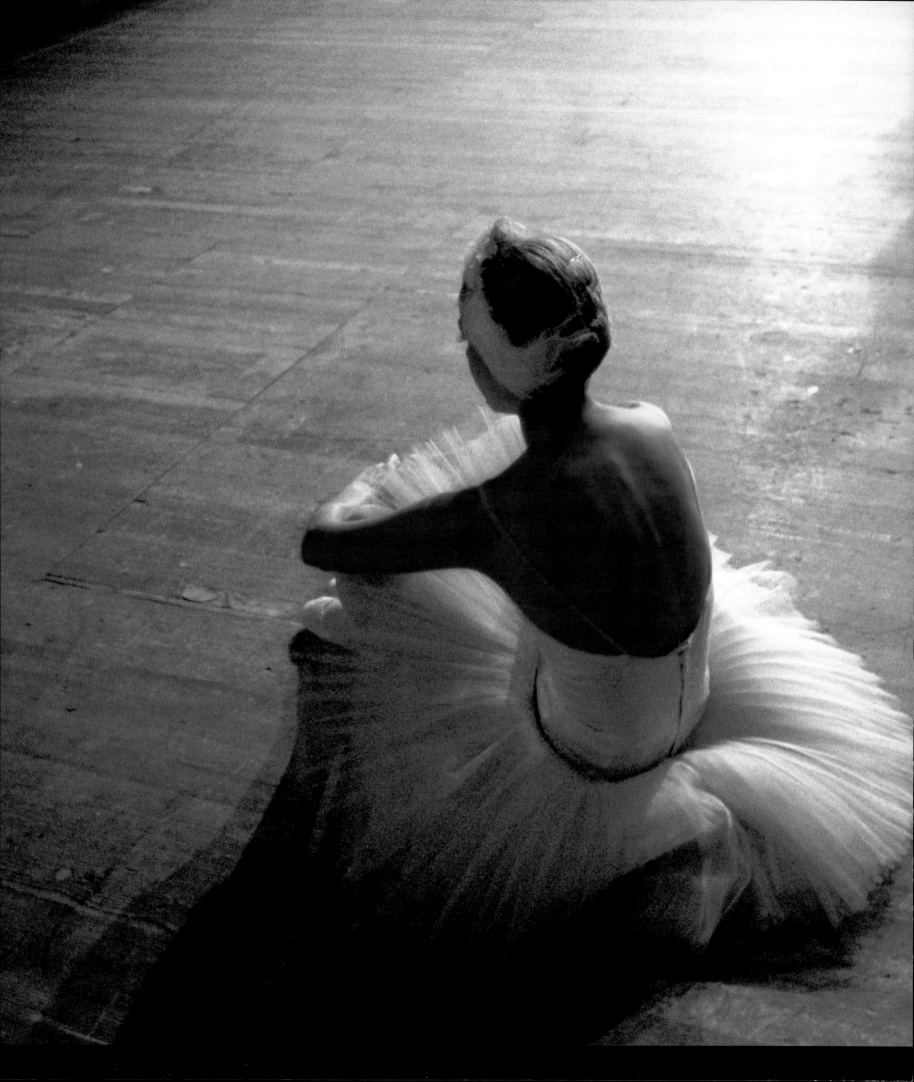

A ballerina sits in quiet solitude before
a performance of *Swan Lake* at the
Mariinsky Theatre in St. Petersburg.

INDEX

Boldface indicates illustrations; *boldface italic* indicates photographs by the person referenced.

WOMEN
PHOTOGRAPHERS
AT NATIONAL GEOGRAPHIC

Published by the National Geographic Society

 John M. Fahey, Jr. President and Chief Executive Officer

 Gilbert M. Grosvenor Chairman of the Board

 Nina D. Hoffman Senior Vice President

Prepared by the Book Division

 William R. Gray Vice President and Director

 Charles Kogod Assistant Director

 Barbara A. Payne Editorial Director and Managing Editor

 David Griffin Design Director

Staff for this Book

 Barbara Brownell Editor

 Marianne Koszorus Art Director

 Kathy Moran Illustrations Editor

 Mary Jennings Researcher

 R. Gary Colbert Production Director

 Richard Wain Production Project Manager

 Lewis Bassford Production Manager

 Janet A. Dustin Illustrations Assistant

 Peggy J. Candore Assistant to the Director

 Robert Witt Staff Assistant

 Elisabeth
MacRae-Bobynskyj Indexer

Manufacturing and Quality Management

 George V. White Director

 John T. Dunn Associate Director

 Vincent P. Ryan Manager

 Phil Schlosser Budget Analyst

Library of Congress Cataloging-in-Publication Data

Newman, Cathy
 Women Photographers at National Geographic / Cathy Newman.
 p. cm.
 Includes bibliographical references (p.)
 ISBN 0-7922-7689-2
 1. Photographs and photographers. I. Title.

00-037993

x

NOTES ON THE CONTRIBUTORS

CATHY NEWMAN began her career writing for the *Miami News* and joined the staff of NATIONAL GEOGRAPHIC magazine in 1978. As a senior staff writer, she has covered such diverse subjects as the Shakers, trout, beauty, the English Channel Tunnel, and Cape York Peninsula, Australia. Her first book, *Perfume: The Art and Science of Scent,* was published by National Geographic in 1998.

KATHY MORAN has picture edited a wide range of articles for NATIONAL GEOGRAPHIC magazine, from history to natural history to underwater adventure. She edited the book *Cats,* published by National Geographic in 1998, and co-edited *Odyssey,* by Thomasson Grant, in 1988.

TIPPER GORE is a photographer and author whose career began at *The Tennessean*. Her photographs have appeared in newspapers and magazines, including *Newsweek* and *American Photographer,* and recently were exhibited at the Corcoran Gallery. Her book *Picture This,* 1996, documents her life during her husband's first term as Vice President of the United States. Her images also appear in the multi-photographer book, *The Way Home: Ending Homelessness in America,* 1999.

NAOMI ROSENBLUM is an independent scholar and author of the acclaimed *World History of Photography, A History of Women Photographers,* and *Lewis Hine.* She lectures widely and has taught art history and the history of photography at New York's Brooklyn College and Parsons School of Design, as well as abroad. With Milton Brown and others she co-authored the *History of American Art,* and she has written in monographs, books, and periodicals on Adolphe Braun, Lewis Hine, Paul Strand, and other contemporary photographers.

ACKNOWLEDGMENTS

When Nina Hoffman, senior vice president of The National Geographic Society, proposed the idea of this book, it proved, among other things, that the politics of gender was alive, well, and kicking furiously. Thank you, Nina, for putting the subject of women photographers out there for discussion and for supporting this book through its journey into print. Much appreciation is also due Barbara Brownell, the project manager and editor, who, gracefully, but with great firmness, kept those of us who worked on this book on track and headed in the right direction. I am grateful to my colleagues who made this a collaborative project with a true sense of mission: Kathy Moran, illustrations editor; Marianne Koszorus, designer; and Mary Jennings, researcher. Additional thanks to Naomi and Walter Rosenblum, Bob Poole, Susan Smith, Mary McPeak, Mark Jenkins, Heidi Splete, and most of all to the women and men I interviewed who so generously and openly shared the joys and anxieties of their passion for photography.

Cathy Newman

Many thanks goes to the National Geographic Image Collection, whose staff worked steadily to retrieve the photographs for this book—especially Flora Davis, Hilda Crabtree, Steve St. John, and William Bonner. I am especially grateful to Al Royce for giving me the green light to work on this project and to Zain Habboo for always "jumping in"—to do a lab run, return transparencies, or to lend support in any number of ways.

Kathy Moran

The Book Division would also like to thank Martha Christian and Lyn Clement for their reviews of the text.

PHOTOGRAPHIC CREDITS

DUST JACKET: front cover, Joanna B. Pinneo; back flap, Sisse Brimberg; back cover, clockwise from top left, Hien Huynh, Kim Gooi, Jesus Lopez, Don Belt, Wade Davis.

FOREWORD & INTRODUCTION: 6, National Geographic Photographer Jodi Cobb; 8-9, Anna Susan Post; 10-11, Jodi Cobb, NGP; 12-13, Annie Griffiths Belt; 14-15, Jodi Cobb, NGP; 16-17, Jen & Des Bartlett; 18, Eliza Scidmore; 21, Harriet Chalmers Adams; 22, Margaret Bourke-White; 24, Ella Maillart; 27, Kathleen Revis.

INSIGHT: 28-29, Jodi Cobb; 30-31, Maggie Steber; 32, Jodi Cobb, NGP; 33, Lynn Abercrombie; 36, Karen Kuehn; 42-43, Alexandra Avakian/Contact Press Images; 44-45, Jodi Cobb, NGP; 46, Stephanie Maze; 47, Natalie Fobes; 48-49, Harriet Chalmers Adams; 50-51, Sisse Brimberg; 52, Lynn Johnson/Aurora; 53, Mary Ellen Mark; 54-55, Jodi Cobb, NGP; 56-57,Alexandra Boulat/SIPA Press; 58-59, 60, Jodi Cobb; 61,62-63, Sisse Brimberg; 64-65, Jodi Cobb, NGP; 66, Karen Kasmauski; 67, Edith S. Watson; 68-69, Karen Kasmauski; 70-71, 72-73, 74-5, 76, 77, Jodi Cobb, NGP.

BEYOND THE HORIZON: 78-79, Carol Beckwith & Angela Fisher; 80-81, Jodi Cobb, NGP; 82, Bianca Lavies; 83, Dr. Darlyne A. Murawski; 87, David and Carol Hughes; 90, Dieter and Mary Plage; 94-95, Beverly Joubert; 96-97, Joanna B. Pinneo; 98-99, Maria Stenzel; 100, Laura Gilpin; 101 Jinx Rodger; 102-103, Alice Schalek; 104-105, Carol Beckwith & Angela Fisher; 106-107, Melissa Farlow; 108-109, Sarah Leen; 110-111, 112, Dickey Chapelle; 113, Harriet Chalmers Adams; 114-115, Jean and Franc Shor; 116, Lynn Johnson/Aurora; 117, Stephanie Maze; 118-119, Jodi Cobb, NGP; 120-121, 122-123, 124, 125, 126-127, Maria Stenzel.

WOMEN'S WORK: 128-129, Annie Griffiths Belt; 130-131, Lynn Johnson/Aurora; 132, Lyda I. Suchý and Mišo Suchý; 133, Dorothy Hosmer; 136, 140; Karen Kasmauski; 144-145, Lynn Johnson/Aurora; 146, Marty Cooper; 147, Carol Devillers; 148-149, Belinda Wright; 150-151, Karen Kasmauski; 152-153, Jodi Cobb, NGP; 154, 155, Joanna B. Pinneo; 156-157, 158, 159, Alexandra Boulat/SIPA Press; 160-161, 162-163, Joanna B. Pinneo; 164-165, Lynn Johnson; 166, Sarah Leen; 167, Maria Stenzel; 168-169, Alexandra Avakian/Contact Press Images; 170-171, 172, 173, 174-175, 176-177, Karen Kasmauski.

BALANCING ACT 178-179, Anna Susan Post; 180-181, Joanna B. Pinneo; 182, Annie Griffiths Belt; 183, Vera Watkins; 187, Mary Ellen Mark; 191, Maggie Steber; 194-195, Karen Kasmauski; 196-197, Alexandra Avakian; 198-199, Sarah Leen; 200, Harriet Chalmers Adams; 201, Annie Griffiths Belt; 202-203, Karen Kasmauski; 204-205, Sarah Leen; 206, Lynn Johnson/Aurora; 207 Lynn Johnson; 208-209, Maria Stenzel; 210-211, Karen Kasmauski; 212, Melissa Farlow; 213, Yva Momatiuk; 214-215, Jodi Cobb, NGP; 216-217, 218, 219, 220-221, 222-223, Annie Griffiths Belt.

THE INCANDESCENT MOMENT: 224-225, Joanna B. Pinneo; 226-227, Margaret Bourke-White; 228, Melissa Farlow; 229, Alexandra Boulat/SIPA Press; 232, Sisse Brimberg; 238-239, Jodi Cobb, NGP; 240-241, Lynn Johnson/Aurora; 242, Melissa Farlow; 243, 244-245, Jodi Cobb, NGP; 246, Lynn Johnson; 247, 248-249, Sarah Leen; 250-251, Sisse Brimberg; 252, 253, Annie Griffiths Belt; 256, 257, Jodi Cobb, NGP; 258-259, Maggie Steber; 260-261, 262-263, 264, 265, 266-267, Sisse Brimberg.

Composition for this book by the National Geographic Society Book Division. Printed and bound by Cayfosa Quebecor, Barcelona, Spain. Color separations by North American Color, Portage, Michigan.

ADDITIONAL READING

Allen, Thomas B., ed. *Images of the World: Photography at the National Geographic.* Washington, D.C.: National Geographic Society, 1981; *American Photo.* Special Issue: Women in Photography. March/April 1998; Bendavid-Val, Leah. *National Geographic: The Photographs.* Washington, D.C.: National Geographic Society, 1994; Bourke-White, Margaret. *Portrait of Myself.* New York: Simon & Schuster, 1963; Bryan, C.D.B. *The National Geographic Society: 100 Years of Adventure and Discovery.* New York: Harry N. Abrams, Inc., 1987; Didion, Joan, *The White Album.* New York: Simon & Schuster, 1979; Fisher, Andrea. *Let Us Now Praise Famous Women.* New York: Pandora Press, 1987; Hendrickson, Paul. *Looking for the Light: The Hidden Life and Art of Marion Post Wolcott.* New York: Knopf, 1992; Hurley, F. Jack. *Marion Post Wolcott: A Photographic Journey.* Albuquerque, New Mexico: University of New Mexico Press, 1989; Livingston, Jane, Frances Fralin, and Declan Haun. *Odyssey: The Art of Photography at National Geographic.* Charlottesville, Va: Thomasson-Grant and Washington, D.C.: The Corcoran Gallery of Art, 1988; Moeller, Susan D. *Shooting War: Photography and the American Experience of Combat.* New York: Basic Books, Inc., 1989; Rosenblum, Naomi. *A History of Women Photographers.* New York: Abbeville Press, 1994, and *A World History of Photography.* New York: Abbeville Press, 1997; Sullivan, Constance, ed. *Women Photographers.* New York: Harry N. Abrams, Inc., 1990; Tucker, Anne, ed. *The Woman's Eye.* New York: Alfred A. Knopf, 1973; Whelan, Richard. "Are Women Better Photographers than Men?" Artnews, October 1980; Palmquist, Peter E. *Camera Fiends and Kodak Girls.* New York: Midmarch Arts Press, 1995.

BIOGRAPHIES

JODI COBB has been a staff photographer for NATIONAL GEOGRAPHIC magazine since 1977, and has worked in more than 50 countries, specializing in the Middle East and Asia. Cobb was one of the first photographers to cross China when it reopened to the West, traveling seven thousand miles in two months for the book *Journey Into China.* She covered Israel during Palestinian uprisings on the West Bank. And, as one of the few Westerners ever to enter the closed world of the women of Saudi Arabia, she photographed in the palaces of princesses and the tents of Bedouin for a landmark article in 1987. Cobb entered another world closed to outsiders, the geisha of Japan, for the book *Geisha* published by Alfred A. Knopf in 1995. She has most recently photographed an article, and is working on a related book, which examines notions of beauty and human adornment on every continent. She also recently photographed a project on homelessness in America. Cobb has photographed for seven books in the "Day in the Life" series, including *Australia, Soviet Union,* and *America.* She was a major contributor to a book on the Viet Nam Veteran's Memorial, *The Wall* (Collins 1987); and a book on Hong Kong, *Here Be Dragons* (Stewart, Tabori & Chang, 1992). Cobb's photographs have been in exhibitions at the International Center of Photography; the Corcoran Gallery of Art; the Neikrug Gallery; Visa Pour L'Image, at the International Photojournalism Festival in Perpignan, France; in Amman, Jordan, sponsored by Queen Noor; at the Jimmy Carter Presidential Library; at the Freer Gallery of Art; and in Steamboat Springs, Colorado. Cobb has taught at the Maine, Missouri, and Eddie Adams Photographic Workshops, and has lectured at the International Center for Photography and the Smithsonian. She was featured in the PBS documentary "On Assignment" and has appeared on segments of the *Today Show, Sunday Morning with Charles Kurault,* and *20/20.* She has won numerous awards, including White House Photographer of the Year, the first woman so honored; and the National Press Photographers Association and World Press awards. Cobb received the American Society of Media Photographers Special Achievement Award in 1996 for *Geisha.* Her slide show/video on the women of Saudi Arabia won a silver award at the Association for Multi-Image International Festival. Cobb received her Master of Arts and Bachelor of Journalism degrees from the University of Missouri. As a child, she traveled the world with her family, and grew up in Iran. She now lives in Washington, D.C.

MARIA STENZEL'S photographic career began with National Geographic in 1991. She has completed a dozen stories in less than a decade, including coverage of Antarctica, Las Vegas, and beyond. Stenzel began as a student of photography at the University of Virginia while pursuing her Bachelor of Arts in American Studies. She joined the staff of the National Geographic Society in 1980 as a member of the Photographic Division's Film Review Department where she examined film for technical flaws and delivered reports to photographers in the field. This allowed Stenzel to study the shooting styles of the world's top photographers from whom she sought advice and encouragement for her own work. She attended workshops and began producing stories for the *Washington Post* magazine. In November 1992 her first story, "The Lure of the Catskills," was published in NATIONAL GEOGRAPHIC. Her background in American Studies contributed to her early coverages of the Catskills, America's beekeepers, and Walt Whitman. Stenzel's transition from national to international photographer has helped establish her reputation for adaptability. She celebrated Christmas in a tent in Antarctica while on assignment for her October 1998 story, "Timeless Valleys of the Antarctic Desert." She has since traveled to Kenya, Argentina, Borneo, Bolivia, Tibet, and Hawaii. Stenzel's confidence in her travel skills and ability to grasp the illustrative requirements of a story have resulted in an ever increasing repertoire of published work.

Born and raised in Minneapolis, ANNIE GRIFFITHS BELT earned her Bachelor of Arts degree in photojournalism from the University of Minnesota. Her professional career began while she was still in school, working as a staff photographer for the *Minnesota Daily.* After graduating in 1976, she joined the staff of the award-winning *Worthington Daily Globe* in southern Minnesota. Belt began assignment work for the National Geographic Society in 1978. Since then she has worked on dozens of magazine and book projects for the Society, including NATIONAL GEOGRAPHIC magazine stories on Baja California, Israel's Galilee, Britain's Pennine Way, Vancouver, England's Lake District, Jerusalem, and Jordan. Her photographs have been exhibited in New York, Washington, Moscow, Tokyo, and France. She has received awards from the National Press Photography Association, the Associated Press, the National Organization of Women, and the White House News Photographers Association. She lectures and teaches workshops regularly and has been visiting professor of photography at Ohio University, a featured speaker on the National Press Photographers Flying Short Course, and the subject of a public television documentary about her work. Belt recently joined the National Geographic Book Division as a senior illustrations editor and is editing an atlas of exploration as well as a photobiography of Edward Curtis. With her husband and two children, Belt makes her home in Great Falls, Virginia.

KAREN KASMAUSKI has worked as a contract photographer for NATIONAL GEOGRAPHIC magazine since 1984. She also contributes to a range of other publications produced by the National Geographic Society, including TRAVELER magazine. Kasmauski's work covers a wide range of interests, from major worldwide science stories on radiation and viruses to a detailed examination of Japan, in coverages of Japanese women and Japan's economic role in Asia. Kasmauski has also looked at subcultures within the United States, such as the African-American culture of the Georgia-South Carolina Sea Islands, and the mountain people of Appalachia. Her work on the global effects of radiation won a first prize in the prestigious Pictures of the Year competition. Kasmauski is a frequent winner in POY as well as the White House News Photographers competition. She is a contributor to *Travel-Holiday* and the German magazine *GEO,* as well as to *Fortune, Forbes, Business Week, Time,* and *Money.* She has worked on several books in the "Day in the Life" series, including *Christmas in America, Baseball in America, Passage to Vietnam,* and *Seven Days in the Philippines.* Kasmauski's own book, *Hampton Roads,* is a photographic exploration of her hometown area, based on her first assignment for NATIONAL GEOGRAPHIC magazine. Prior to working for the Society, Kasmauski was a staff photographer for five years with the *Virginian Pilot/Ledger Star* in Norfolk. Her work at that paper brought her several awards in the Pictures of the Year competition, including a first in picture essay, as well as special recognition in the Robert F. Kennedy Awards for outstanding coverage of the disadvantaged. Kasmauski has degrees in anthropology and religion from the University of Michigan. She lives in Virginia with her husband and two children.

MARIE-LOUISE "SISSE" BRIMBERG was born in Copenhagen, Denmark, in 1948. While attending photography school, where she graduated cum laude, Brimberg worked as an apprentice in a commercial photography studio. After her apprenticeship, Brimberg established and managed her own photography studio for five years in Copenhagen. Using funds provided by a Danish grant, she came to the National Geographic Society to study photographic techniques and to manage the internal photo studio. Brimberg's hard work and dedication to developing her craft paid off. As a regular "shooter" for NATIONAL GEOGRAPHIC magazine, she has published more than 20 articles. From her work documenting the life of fairytale author Hans Christian Andersen, to her elegant and lyrical photographs in "The Magic of Paper," to her creative chronicling of the Viking culture, Brimberg's images are enchanting. In 1998, she documented the National Geographic Society's landmark 100th anniversary. Her work has also been featured in traveling exhibits: In 1996, a companion exhibit to "Track of the Manila Galleons" story traveled through public museums in Mexico. Her photographs from "The Magic World of Hans Christian Andersen," were exhibited in New York and Denmark in 1980. Her work has also been on display at the White House Press Photographers Annual Exhibition and with a National Geographic traveling audiovisual exhibit. Brimberg has participated in many educational seminars and served as a principal speaker at the Sociedad Mexicana de Fotograf Profesionales, the National Press Photographers Association Annual Conference, and the Bellevue School's Masters series. Her contributions to the field of photojournalism have been noted. Her story on migrant workers won first prize for Picture Story of the Year from the National Press Photographers Association. She is a member of the White House Photographers Press Association. Sisse Brimberg lives in Mill Valley, California, with her husband and two children.

The world's largest nonprofit scientific and educational organization,
the National Geographic Society was founded in 1888 "for the increase and diffusion of geographic knowledge."
Since then it has supported scientific exploration and spread information
to its more than nine million members worldwide.

The National Geographic Society educates and inspires millions every day through magazines, books,
television programs, videos, maps and atlases, research grants, the National Geography Bee, teacher workshops,
and innovative classroom materials.

The Society is supported through membership dues and income from the sale of its educational products.
Members receive National Geographic magazine — the Society's official journal — discounts on
Society products, and other benefits.

For more information about the National Geographic Society
and its educational programs
and publications, please call
1-800-NGS-LINE (647-5463),
or write to the following address:

National Geographic Society
1145 17th Street N.W.
Washington, D.C. 20036-4688 U.S.A.

Visit the Society's Web site at
www.nationalgeographic.com.